The Art
of
John Biggers

✳

View from the Upper Room

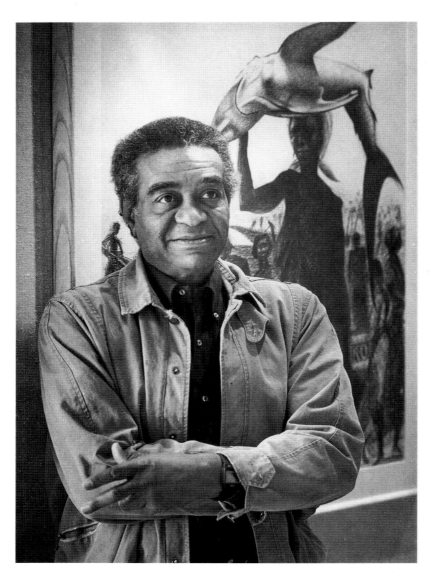

John Biggers
Photo by Earlie Hudnall, Jr.

The Art
of
John Biggers

✳

View from the Upper Room

By Alvia J. Wardlaw

with essays by Edmund Barry Gaither, Alison de Lima Greene,

and Robert Farris Thompson

HARRY N. ABRAMS, INC., IN ASSOCIATION WITH THE MUSEUM OF FINE ARTS, HOUSTON

Sponsor Statement

As this inspiring retrospective shows, John Biggers is one of the most accomplished artists in the United States today. Biggers was an early pioneer in translating the rich heritage of African life into American art. Over the course of half a century, he has developed powerful spiritual symbols and geometric techniques to create a unique but universal mythology. As an artist and educator, he has stood firm in his dedication to art, serving as an exemplar and mentor for countless students.

It is a pleasure for us at Philip Morris Companies to build upon our relationship with John Biggers, who was among the innovative artists featured in our 1989-91 exhibition *Black Art—Ancestral Legacy*. We are particularly pleased to work once again with Houston's Museum of Fine Arts and to join Hampton University in celebrating Biggers's remarkable achievements through this important touring exhibition.

R. William Murray
Chairman
Philip Morris Companies Inc.

PUBLISHED ON THE OCCASION OF THE EXHIBITION

The Art of John Biggers: View from the Upper Room

ORGANIZED BY THE MUSEUM OF FINE ARTS, HOUSTON
AND HAMPTON UNIVERSITY MUSEUM

*The exhibition is sponsored by Philip Morris Companies Inc. The exhibition and catalogue have also been made possible
by generous grants from the National Endowment for the Arts and the
National Endowment for the Humanities, federal agencies;
the Richard A. Florsheim Art Fund, the John S. and James L. Knight Foundation,
and the Rockefeller Foundation.*

The Museum of Fine Arts, Houston	EXHIBITION	Hampton University Museum
Houston, Texas	ITINERARY	Hampton, Virginia
April 2-August 28, 1995	✸	October 6–December 20, 1996
North Carolina Museum of Art	Wadsworth Atheneum	Museum of Fine Arts, Boston
Raleigh, North Carolina	Hartford, Connecticut	Boston, Massachusetts
October 15, 1995–January 14, 1996	May 19–August 25, 1996	January 24–April 20, 1997

EDITOR: ELAINE M. STAINTON
DESIGNER: RAYMOND P. HOOPER

Library of Congress Cataloguing-in-Publication Data

Wardlaw, Alvia J.
The art of John Biggers: view from the upper room/by Alvia J.
Wardlaw with essays by Edmund Barry Gaither, Alison de Lima Greene,
and Robert Farris Thompson.
p. cm.
Catalog of a traveling exhibition first held at the Museum of Fine
Arts, Houston, Apr. 2–Aug. 28, 1995.
Includes bibliographical references and index.
ISBN 0-8109-1956-7 (cloth). —
ISBN 0-89090-061-2 (mus. pbk.)
1. Biggers, John Thomas, 1924- — Exhibitions. I. Biggers, John
Thomas, 1924- II. Museum of Fine Arts, Houston. III. Title.
N6537.B52A4 1995
759. 13 — dc20 94-26005

Photographic materials have been graciously supplied by the owners of works except as listed below.

Alinari/Art Resource, New York; John Biggers; Gay Block; Thomas R. DuBrock; Earlie Hudnall, Jr.; Tom Jenkins; Kino International
Corporation; Lloyd Koenig; Manu Sassoonian; Diane Sibbison; Jackson Smith; and Scott Wolff

In the Upper Room with Jesus
Sitting at his blessed feet
Daily there my sin confessing
Begging for his mercy sweet.

Trusting in his grace and power
Seeking there his love and prayer
It is there I feel the spirit
As I sit with him there.

"Upper Room"
African-American Spiritual

Contents

Lenders to the Exhibition

The ADEPT NEW AMERICAN Museum, Mt. Vernon, New York

African American Museum, Dallas

Ed Anderson Collection

Ms. Maya Angelou

Mr. and Mrs. Michael Archey

Mr. and Mrs. James Arnold

Atlanta University Collection of Afro-American Art at Clark Atlanta University

Mr. and Mrs. Kenneth Bacon

Ida Baird

Alva Baker

Bickerstaff, Heath, and Smiley

John and Hazel Biggers

Mr. and Mrs. James Biggers

Brandywine Graphic Workshop, Philadelphia, Pennsylvania

Dr. and Mrs. Warren Brooks

Mrs. Gloria J. Coleman

The Collection of the City of Houston, Texas

Lowell Collins Gallery, Houston

Columbia Museum of Art, South Carolina

Dallas Museum of Art

Diggs Gallery, Winston-Salem State University, North Carolina

Ryan Adrian Fitzgerald

Dr. and Mrs. Robert Galloway

Golden State Mutual Life Insurance Company, Los Angeles

Dr. Rahn Hall

Hampton University Museum, Hampton, Virginia

Harry Ransom Humanities Research Center, The University of Texas at Austin

Dr. and Mrs. William Harvey

Sarah Blaffer Hrdy

Dr. Edith Irby Jones

Samella Lewis

Richard A. Long

Clarice Pierson Lowe

McAshan Foundation, Houston

V. Michael McCabe

Dr. F. B. McWilliams, Dowling Animal Clinic

Mr. and Mrs. Herbert Mears

Rev. Douglas Moore

The Museum of Fine Arts, Houston

National Museum of American Art, Smithsonian Institution, Washington, D.C.

Paris Public Library, City of Paris, Texas

Dr. and Mrs. Joseph A. Pierce, Jr.

Private collections

The Paul Robeson Cultural Center, Pennsylvania State University, University Park

Jan Campbell Rothrock

Jackie Kimbrough Ryan

Mani Jasiri Short

Mr. and Mrs. Gerald B. Smith

Department of Fine Arts, Texas Southern University, Houston

Wadsworth Atheneum, Hartford, Connecticut

Winston-Salem Delta Fine Arts, Inc.

Foreword
by Peter C. Marzio
Director, The Museum of Fine Arts, Houston

John Biggers is a poet, philosopher, teacher, draughtsman, painter, sculptor, muralist, and, above all, an inspirational leader. He leads us with his powerful imagery, his impassioned discourse, his intense energy, and his all-consuming belief in the human community and its mystical interaction with the natural world. John Biggers is a passionate man who wants to touch and reveal what it is that makes life so special.

Our current vocabulary does not help us to understand fully John Biggers's profound significance to the world today. Words in our everyday idiom such as "multicultural" and "ecology" touch the edges of his vision, but they do not tell us much about the man himself. He is a stout defender of human equality and the preservation of nature, as his art so clearly demonstrates, and his paintings teem with images that reflect his beliefs. But there is a structure to his work that derives from his artistic training and his desire to show us the interrelationships of past, present, and future, and of human beings to the natural world. The works are powerful syntheses of myriad ideas and philosophies, so intensely expressed that they seem to be searching beyond the two dimensions of the canvas, beyond linear perspective. They almost demand a fourth dimension to let us experience everything that is in the artist's heart and mind.

When I first met John Biggers in Houston in 1982, it struck me instantly that this was an important American artist who had not yet received the national and international recognition he deserved. This exhibition and its accompanying publication will, I hope, correct that oversight.

Yet even this retrospective cannot give John Biggers a full viewing. This is not only because of his energy, genius, and determination, but also because, at age 71, he is continuing to grow as an artist, and he is painting the best work of his long and productive career. He is an inspiration to all of us who hope to remain creative throughout our lives.

It was a great honor to work with John Biggers on this project and to collaborate with his colleagues at Texas Southern University in Houston and with Hampton University in Virginia. The Hampton University Museum, which is a major repository of the artist's works, co-organized this exhibition with the Museum of Fine Arts, Houston, and a special salute of thanks and admiration goes to Jeanne Zeidler, whose directorship of the Hampton University Museum is the envy of many museums.

The Museum of Fine Arts, Houston is particularly grateful to Philip Morris Companies Inc. for serving as the national corporate sponsor of this exhibition. Their generous and enthusiastic support demonstrates a continuing commitment to the celebration of American culture. For the Museum of Fine Arts, curator Alvia J. Wardlaw has worked tirelessly, contributing her considerable expertise to make the exhibition and this publication a success. Alison de Lima Greene, Curator of Twentieth-Century Art, has skillfully coordinated and supervised the project in all its phases. They deserve our gratitude.

Introduction
by Jeanne Zeidler
Director, Hampton University Museum

Several years ago, while describing his evolution as an artist, John Biggers spoke of the goal of his life's work as achieving unity, in the sense of the wholeness and harmony reached after transcendence and transformation. For this artist, who has created a vast vocabulary of symbols and metaphors, Hampton University represents his success in achieving the unity that he has sought both in his art and in his life.

For more than fifty years, Hampton University (formerly Hampton Institute) has retained the memory of the exciting atmosphere of artistic creativity that flourished here in the early 1940s. During this remarkable period, dedicated faculty and gifted students produced a body of work that drew national attention at the time, and that has remained important to the history of twentieth-century American art. From this milieu many students went on to pursue careers as artists, art historians, and teachers. John Biggers is among the most distinguished of this group.

As a student at Hampton, Biggers began his exploration of the meaning of family and community, examining the roles of elders and young people, and of men and women. Here, also, he created his first mural, *Dying Soldier,* in 1942. Hampton was truly, as he was later to say, his "place of initiation."

In 1989 John Biggers returned to Hampton for a week-long visit, at which time he spoke often with the university's president, William R. Harvey, about the mission of the school. One of the results of this visit was a gift to Hampton of more than one hundred paintings, drawings, and sculptures from the artist's private collection. Hampton thus became the major repository of John Biggers's work, with examples from all periods of his career. However, there was one obvious gap in the university's holdings: there was not a single mural to represent the achievement of this man, who had learned the art of mural painting at Hampton, and who had gone on to build a formidable reputation in that field. To remedy this, John Biggers was commissioned to create two murals for the new Hampton University Library, scheduled to open in January 1992.

John Biggers arrived at Hampton in September 1990, and promptly set to work. Soon, his studio was filled with enthralled students, alumni, faculty, and staff, not to mention equally fascinated art dealers, curators, and collectors. Thus from September 1990 to January 1991 John Biggers's presence, so much a part of the legendary Hampton of the 1940s, generated another intensely creative environment at the school. Moreover, with the painting of these murals, *Tree House* and *House of the Turtle* (Figs. 23 and 25), the artist closed a circle begun fifty years earlier when he had come to Hampton as a student. The paintings, an homage to his "place of initiation," also signaled his personal renewal as an artist through his return to his origins and early inspiration.

This retrospective exhibition documents John Biggers's development as an artist, from his earliest drawings at Hampton to his most recent paintings. Today his quest for unity has moved to another level with his return to his beloved native countryside and his childhood home in Gastonia, North Carolina.

Acknowledgments

There are many individuals, organizations, and institutions to thank for their support and cooperation in making this catalogue and exhibition a success. Documenting the career of John Biggers is no small task, for he has lived a full and rich life as both an artist and an educator, and he has touched the lives of so many. When growing up in Houston, one of the first works of art I encountered was Biggers's *Fishing Village*. Exhibited in the Student Union Building of Texas Southern University, the work gave me a new and distinctly different image of Africa to hold in my mind for years to come.

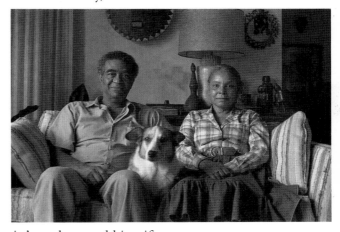

I would like to thank first and foremost John and Hazel Biggers for the selfless participation in what has been an ongoing dialogue for many years. For the sharing of their time, thoughts, books, photographs, and memorabilia, I shall always be grateful. The hours spent talking with the artist in his studio have provided me with insights I might otherwise not have had, and these have helped to shape this exhibition and catalogue in fundamental ways.

Ferrie Biggers Arnold, the artist's sister, graciously shared her thoughts and her memories of her brother, her family, and Gastonia, North Carolina. She and her husband James Arnold were a great help in securing family photographs while I visited them in Florida. Similarly, James Biggers, the artist's nephew, and his wife Ina have repeatedly extended hospitality and guidance during my visits to Gastonia. They introduced me to many of John Biggers's childhood friends, and through them I was able to learn much of what Gastonia was like during the 1930s.

John and Hazel
Biggers with their dog,
Hapi, ca. 1978
Photo by Gay Block

Hampton University has played a key role in the organization of this exhibition. Through the acquisition of a major body of John Biggers's works in 1990, Dr. William Harvey, Hampton's president, and Jeanne Zeidler, Director of the Hampton University Museum, have made a firm commitment to the preservation and interpretation of the art of one of Hampton's most distinguished alumni. The institution's conservation of early student works has allowed viewers to fully comprehend the range of style and subject matter that Biggers's art embraces. Pamela Randolph of Chesapeake Paper Conservation, Ron Cunningham of the Conservation Analytical Laboratory at the Smithsonian Institution, and Larry Berker of the Virginia Museum of Fine Arts are to be applauded for their conservation of Biggers's works at Hampton. Ron Cunningham's restoration of two major murals by Biggers in Houston, *Web of Life* and *Quilting Party*, represents in itself a significant contribution to the preservation of the artist's public art commission.

For the past few years, Jeanne Zeidler and her staff have answered my many questions, both large and small, about works at Hampton. My visits to the museum and archives have also been productive and inspiring. I wish to express special thanks to Mary Lou Hultgren, Curator, and Jeffrey Bruce, Assistant Curator, for their hours of assistance in making individual works available to me. Regina Jennings and Patricia Savor were always available to respond to my myriad requests, and the Hampton archival staff, led by director Fritz Malval, has always been efficient and deeply interested in making this project a success. Furthermore, by commissioning Barbara Forst and Sherri Fisher Staples to document the creation of the Hampton murals, Hampton University has now preserved a visual record of one of the artist's most important commissions.

For many years generous and foresighted patrons have supported the art program established by John Biggers at Texas Southern University. All of Houston is indebted today to the early patronage of Nina Cullinan, Jane Blaffer Owen, the late Camilla

Trammell, and John and Dominique de Menil, who provided major support of programs and exhibitions for Biggers, the TSU art faculty, and students. These individuals acknowledged and supported the efforts of Dr. Samuel Nabrit, second president of Texas Southern University, to establish at the college an atmosphere which celebrated the humanities and in turn fostered an appreciation of African-American culture. The support of Mrs. Susan McAshan, in particular, has served as a constant source of inspiration. Without her enduring interest in the art of John Biggers and more generally in the cultural profile of Houston, the scope of this exhibition would not have been possible.

I am grateful for the vision and support of Dr. Joann Horton, President of Texas Southern University, who has further established at the school an atmosphere in which the arts are celebrated and the cultural history of the institution is cherished and carefully preserved. Dr. Sarah Trotty, my colleague and friend, with the support and encouragement of former president Dr. William Harris, helped to acquire works by the artist for the university's permanent collection, and subsequently to make their works available for the exhibition. Her dedication in developing tours on campus of students' murals serves to complement the substance of this exhibition and catalogue in an exciting way.

Dr. Merline Petrie, dean of the College of Arts and Sciences, contributed great effort and thought to the development of special programs in the humanities, focusing on Biggers's murals as well as those of his students. To Dr. Joseph Jones, dean of the graduate school, and Dr. James Race of the Title III project, I owe thanks for providing me with the opportunity to complete my dissertation and plan this exhibition. The support and encouragement of Beverly Hinkle and Justina Austin of the Title III office have been immeasurable, as have been the assistance of Mrs. Charlesetta Cannon and Mrs. Dorothy Nelson.

Bonnie James, assistant professor of sociology at Texas Southern, worked with me for months on the oral history project, interviewing numerous individuals on and off campus who were influenced by John Biggers and the TSU art department.

I cannot thank enough my many students of art and art history who have volunteered time over the past three years to work on the artist's files. Alesha Chellum, Steven Cole, Jamal Cyrus, Dalayha Jackson, Cherie Jones, Margaret Shelton, Anthony Thibodeaux, and Austin Williams have devoted endless hours of research and assistance. Mrs. Dorothy Chapman at the Heartman Collection of the Robert J. Terry Library at TSU directed me to valuable information on the history of Houston and the university.

To photographer Earlie Hudnall, I owe special thanks for permitting me to freely examine his archival photographs of John Biggers at work in his studio and in TSU's art center. Hudnall's documentation of some of Biggers's earliest works allowed me to examine images that in some instances are no longer available. Many of these images, along with later works, appear in this catalogue.

There are many staff members at the Museum of Fine Arts, Houston who have helped me immeasurably. Alison de Lima Greene, Curator of Twentieth-Century Art, has served as an expert resource for completing many aspects of the work required for an exhibition and catalogue of this scope. Alison wrote an insightful essay on the contribution of John Biggers to the American mural movement, and her preparation of the chronology of the artist's life provides a useful means for examining the complexity of Biggers's own life as it related to parallel events across the world. I also would like to thank Shannon Halwes, Joey Kuhlman, and Kathleen Robinson for their help with research, William R. Thompson for his assistance in the later stages of the exhibition, and Clifford Edwards, curatorial secretary.

I wish to thank preparators Chris Ballou, Kathleen Crain, Peter Harvey, Richard Hinson, and Bert Samples for their efficiency, energy, and professionalism. To Thomas Chingos, I owe a debt of gratitude for his development of the exhibition's checklist and his supportive interaction with the lenders. Wynne Phelan has provided expert work in the area of conservation; her response to the works and to the artist has been a joy to

witness, and her coordination with Ron Cunningham of the restoration of the murals *Quilting Party* and *Web of Life* contributes a major new chapter to Houston's history of art preservation.

Suzanne Decker of the museum's photographic services department and Thomas R. DuBrock, photographer, had the daunting task of photographing more than one third of the works in the exhibition, which are so beautifully reproduced in this catalogue. To this task they brought immense care and concern and an enthusiasm for what the art reveals. I believe this sensitivity is reflected in the photographs.

Margaret C. Skidmore, Associate Director, Development, and Barbara Michels, Deputy Development Director, have succeeded brilliantly in their efforts to secure major funding from corporations, foundations, and individuals. The extensive phase of grants writing enabled me to give thematic form to the exhibition early on, and Barbara was particularly helpful at this time. The grants writing staff of Ursula Banks, David Connelly, Bonnie Kastel, Kathy Kelley, and Michelle Love provided unstinting support during the writing of the Biggers grant. I also wish to extend my gratitude to Gwendolyn H. Goffe, Associate Director, Finance and Administration; Jack Eby, senior designer; Alison Eckman, Director of Public Relations and Advertising; Beth B. Schneider, Education Director; and Jennifer F. Stephens, senior graphic designer, and Julie Graf, associate graphic designer. Karen Bremer Vetter, curatorial administrator, and Valerie Headrick, administrative secretary, have also provided invaluable assistance.

No one has worked on this catalogue with more seriousness of purpose and dedication than Diane Lovejoy, Publications Director. I have appreciated her clear vision of the scope of this project, her tireless efficiency, and her sensitivity as an editor. Her support from the very beginning has been gratifying. Christine Manca, Tracy Stephenson, and Engeline Tan of the publications department all helped to give this catalogue its shape and form.

The contributors to this catalogue deserve special recognition. Edmund Barry Gaither has provided a comprehensive look at John Biggers, and he brings to his essay years of personal association not only with the artist but with most African-American artists working today. Robert Farris Thompson has submitted a provocative examination of a key work by John Biggers that ultimately asks us to reexamine our interpretation of American art. Dr. Maya Angelou has introduced us to John Biggers the artist as only she, a friend and poet, can do.

Elaine Stainton, Senior Editor at Harry N. Abrams, Inc., deserves much praise for her meticulous editing, and I have greatly appreciated her enthusiasm and her sensitivity to the material which creates this catalogue. Raymond Hooper has brought to the task of designing this book a sure eye, and a keen awareness of how images and words combine to give a book its character. We are lucky to have had his talents directed towards this catalogue. It has been a pleasure to collaborate once again with Abrams Art Books.

I want to thank especially Dr. Peter C. Marzio, Director of the Museum of Fine Arts, Houston, for having the vision to organize such an important exhibition and for writing such an eloquent foreword to this catalogue. My participation in this project represents the culmination of years of research, and it will stand as one of the most challenging, rewarding, and enriching phases of my life.

Finally, I wish to thank the lenders to this exhibition once again for their generosity in sharing these works with the world. And I thank my family and friends, for their enduring love and support.

Alvia J. Wardlaw
Curator

REFLECTION

BY MAYA ANGELOU

The matter of art is inevitably the matter of life. That is to say, art reflects life, influences and creates life. No soul lives long or fully without art. No life knows its precious worth without art. Every world culture celebrates its uniqueness in artistic expression. From Japanese haiku to the Zulu gum boot dance, from African-American spirituals to the Italian opera sung at Milan's La Scala Opera House, human beings live for art and live because of art.

John Biggers, one of America's most important artists, leads us through his expressions into the discovery of ourselves at our most intimate level. His pen and pencil and brush take us without faltering into the individual personal world where each of us lives

privately. As he has limned the petty peculiarities of the African American, he has also shown us the phenomenon of one species in one world.

Biggers's portraits of the majestic African-American woman are portraits of all women. The Eskimo mother creating fur mukluks for her family and the young bride in the highlands of Scotland are all to be found in the aspect of Biggers's work. His vision and creation of the African-American man at work or at rest include a recognition and respect for the Russian miner and the Englishman with his brolly in Trafalgar Square.

John Biggers shows his people as distinct, yet will not allow them the self-consciousness of being distinct from other human beings.

Biggers's art functions as delight and discovery. Viewers of Biggers's monumental work are made to celebrate the circumstance of life, individual and particular, and to cherish life as wondrously homogeneous.

Biggers sees our differences and celebrates them, and in doing so he allows the clans of the world to come together with deliberate respect and respectful appreciation.

Metamorphosis:
The Life and Art of John Biggers
by Alvia J. Wardlaw
Assistant Professor of Art History, Texas Southern University

It was the atmosphere in our homes which was most important, that we respect ourselves and other people too; the insistence on standards; the unwavering belief in right; in the truly Christian way of life. In these things I perceive the basic impulse for creativity.

—*John Biggers*[1]

I. ORIGINS

One of the most beautiful vistas in the United States can be found on the road that leads to the artist John Biggers's home near Highway 74 in Gastonia, North Carolina. Suddenly, turning a bend on the heavily tree-lined Sparrow Springs Road, the visitor encounters the majestic sight of Crowders Mountain rising to meet the sky. The sun falling on the mountain colors the grassy terrain that surrounds the dense trees a glowing yellow-green, a hue that John Biggers has seen nowhere else in his lifetime. Elizabeth Finger Whitworth, the artist's "Grandma Lizzie," once lived within view of Crowders Mountain, and on its slopes John Biggers, as a youth in preparatory school, began to gain a sense of himself. Fifty years later, the artist and his wife Hazel returned to Gastonia to live and to work. Much has changed and much has remained the same. The mountain still stands there, with the sun casting patterns of dappled light upon its side.

John Thomas Biggers was born to Paul and Cora Biggers on April 13, 1924, the youngest of seven children. His siblings were Paul Sylvester, born in 1910; James Converse, born in 1912; Ferrie Elizabeth, born in 1914; Lillian Cora, born in 1916; Sarah Juanita, born in 1918; and Joseph Calvin, born in 1921. The Biggers family decided not to join the Great Migration to the North. Although it was difficult for a black family to maintain a stable and prosperous life in the rural South, Paul and Cora Biggers remained in North Carolina, staying close to their extended family.

Paul Biggers and his twin brother Saul were born on a plantation in South Carolina in 1881. The sons of a white plantation owner, they were raised by their mother and stepfather, Sarah and Thomas Britt. Given the poverty of their circumstances, the boys assumed adult responsibilities early in life. At the age of six, Paul was already working full-time in the plantation sawmill, where, as a result of an accident, he lost his right leg. So that he would still be able to contribute to the plantation's economy, he was taught shoemaking by one of the older men on the plantation. In 1899, Paul had the opportunity to enroll at Lincoln Academy, a school for freed slaves and their children, where he met his future wife, Cora Finger. They were married after graduation, and settled near Cora's mother's farm in nearby Gastonia.

Like many black men in the postwar South, Paul Biggers was resourceful and hardworking. With his education, he became a schoolteacher, and eventually, the principal of a three-room school. He supplemented his income from this by running a shoe shop, farming his own land, and making many of his family's necessities himself. He was also a Baptist minister, although he never accepted money for this, only gifts of eggs, produce, or livestock.

John Thomas was born in the house that Paul Biggers had built for his family on Davidson Street, directly across from the home that Paul Biggers's brother Saul had already built. The image of these two frame houses facing each other in perfect symmetry has remained with Biggers throughout his life.

One of the artist's strongest memories of Gastonia is of the feeling of interconnection among the black residents. The Biggers family lived in a close-knit community of

Opposite:
Fig. 1. Ma Biggers Quilting,
1964 (Cat. no. 35)

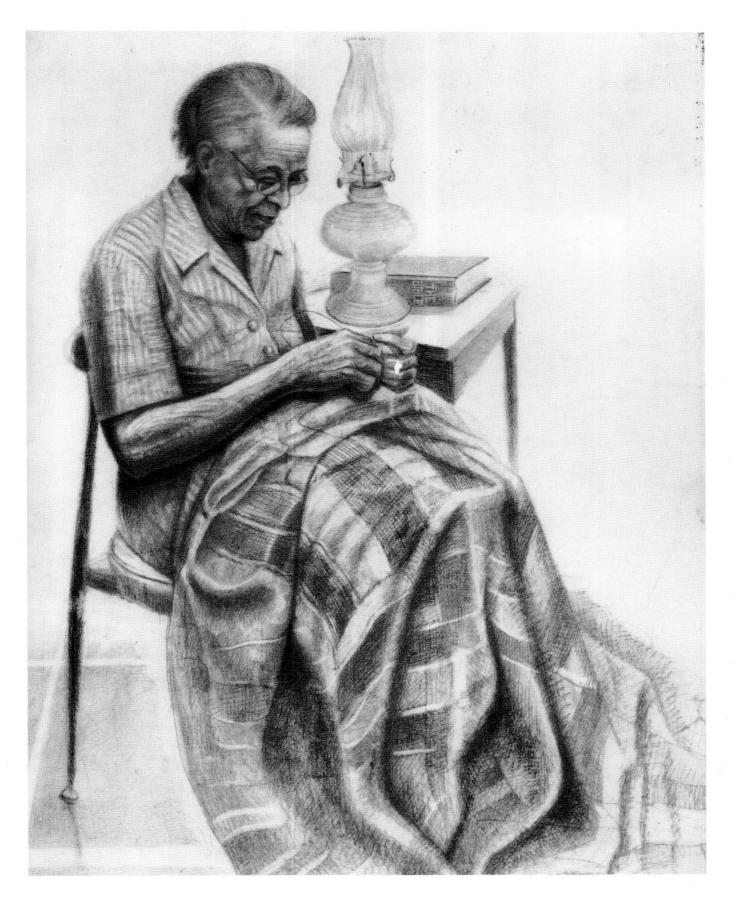

17

family, friends, neighbors, fellow church members, and business associates. A number of businesses in the town were owned and operated by blacks, including a laundry and dry cleaner, a small grocery store, a hotel, a beauty shop, Paul Biggers's shoe shop, a dance hall, and a theater. In the late nineteenth century, blacks had opened their own school for a time, and this venture, largely ignored by the whites, fueled later successful efforts to create a strong base of black self-reliance and mutual support.

By the time of John Biggers's birth, Gastonia had developed into a thriving mill town, comprising three separate and distinct communities. Uptown Gastonia was inhabited by the whites who ran the city, many living in large, well-built older homes on tree-lined boulevards. Some of these had been built before the turn of the century and required several servants. In contrast, the mill villages, erected by the textile companies for transient workers' families, were small cities unto themselves, providing housing, health care, and schooling. Black Gastonia was segregated from both uptown Gastonia and the mill villages, but it was close to both, enabling its residents to provide domestic work and day labor to the whites.

In tobacco towns such as Durham, many of the workers were black, and as a result, there was a large black middle class. Indeed, the activists E. Franklin Frazier and Booker

John Biggers at approximately three years of age

T. Washington both considered the tobacco towns models for race relations. Gastonia, however, was a textile town, and few, if any, blacks were employed in its mills. In 1930, there were only 477 black textile workers in North Carolina out of a total of 100,000.[2] The few blacks who were employed by the mills held janitorial or other menial jobs.

In 1929 Gaston County was rocked by a major labor conflict: the Loray Mill Strike. Although the strike involved white laborers and labor organizers, the potential threat to the black working community was immense, as the possibility of hiring blacks to replace the strikers was a tactic frequently mentioned by strike busters to frighten the white workers.

Northern union organizers had criticized Gaston County's mills for their long hours, low wages, and the poor living conditions in the villages. The dispute came to a head with the arrival of two Communist party labor organizers, Fred Beal and George Pershing. By January of 1929, Beal and Pershing had enlisted new members for a branch of the National Textile Workers Union (NTWU) at Loray Mill. On April 1, all NTWU members walked out of Loray in protest of the dismissal of five workers who had requested improved conditions. The strike persisted and grew violent. On June 7, a huge crowd gathered at the strikers' tent city to hear Beal speak. Protesters began marching toward the mill gates while guards and police attempted to drive them back. In the melee, Police Chief O. A. Aderholt was killed. Gastonia's citizens responded by charging the tent settlement and driving out the strikers. Eventually Beal and his associates were arrested, tried for second-degree murder, and sentenced to various jail terms.

To maintain control over the white workers, mill owners threatened to hire black strike breakers, who, it was said, would work for lower wages and longer hours.[3] These threats were enough to keep the mill workers on the job, but they also heightened resentment of poorer whites against blacks, fanning the flames of hatred and fostering the growth of white supremacy groups such as the Ku Klux Klan.

Not wanting to be drawn into the conflict on either side, blacks in Gastonia tried to avoid the Loray Mill altogether. However, there was always the possibility that frustrated whites would unleash their anxieties upon an innocent black man or woman. The hostility that union organizers could incite is reflected in this statement from the Gastonia newspaper during the Loray Mill dispute:

Do you want your sisters or daughters to marry a Negro? This is what this Communist controlled Northern Union is trying to make you do. We know that no red-blooded white man is going to stand for anything like that, and when these foreign agitators come down here to insult us with such a policy, our answer to them should be in the good old Southern Fashion of riding them out of town on a rail.[4]

The African-American citizens of Gastonia responded to the violence of the strike by withdrawing into their own community. Fortunately, their solidarity and self-sufficiency, which grew from their support of black businesses, allowed them to emerge relatively unscarred from this tense period.

The Loray Mill Strike was set against larger social developments affecting African Americans across the country in the 1920s. Thousands of southern blacks were joining the Great Migration to the industrial North. In New York, where the Harlem Renaissance was gaining momentum, black intellectuals were living side by side with southern laborers who had only recently arrived. Alain Leroy Locke, a prominent black philosopher and the first black Rhodes scholar, often called the Father of the Harlem Renaissance, had just written his watershed book, *The New Negro*, published in 1925. Locke professed that blacks should pursue an artistic interpretation of their own culture. In a more political arena, the social theorist W. E. B. DuBois had begun publication of the *Crisis*, the official journal of the National Association for the Advancement of Colored People. The *Crisis* reported regularly on the lynchings that were occurring with alarming frequency in the South, and it documented the progress of African Americans in various professions.

The Jamaican social activist Marcus Garvey, espousing a pan-African philosophy in his United Negro Improvement Association, promoted the idea that blacks should move "back to Africa" and resettle in their homeland where, presumably, the problem of racism would not exist. Garvey's message had special resonance for blacks during the Depression, when, after leaving their homes in the Carolinas, Georgia, and Alabama, they found that often the North offered only new frustrations and hardships.

This burgeoning of political activity and philosophy among African-American intellectuals on the East Coast made its way south to the Carolina mountains by word of mouth and also via black publications. African-American weeklies such as the *Pittsburgh Courier* and the *Chicago Defender* could be found in the smallest southern black hamlets; educated and informed African Americans like Paul and Cora Biggers were well aware of the issues facing blacks beyond the town where they lived.

In black Gastonia, societies such as the Elks, which had a large and active chapter, helped organize the black community in aiding their neighbors during socially and politically turbulent times. Other organizations, including the Masons and the Woodsmen, sponsored church picnics and other community activities. These men's organizations also raised funds to send the most promising high school students to colleges such as Johnson C. Smith University and Barber Scotia College, both in North Carolina. In the town's three largest black churches, St. Paul's Baptist Church, Zion African Methodist Episcopal Church, and Mt. Calvary Baptist Church, the congregations often heard sermons in which their pastors invoked Biblical passages drawing direct parallels with the many racial problems facing African-American communities throughout the United States.

During this period of tense racial relations, the black family was crucial to the psychological and social survival of all African Americans. For the young John Biggers, the family provided a sheltered inner circle of warmth and protection, which was supported in turn by institutions that enabled it to evolve and endure. This inner circle of family and community, however, was surrounded by an outer circle, one whose Jim Crow racism manifested itself daily in white Gastonia. It was critical that even the youngest black child should understand how these circles functioned and interacted.

As the youngest child in his family, John Biggers has distinct memories of each of his sisters and brothers. Biggers clearly remembers that Ferrie, his oldest sister, and the only

The artist's sister,
Ferrie Biggers Arnold

one of his siblings still alive, paid a great deal of attention to him. She would "pack [him] on her hip," much to the concern of the adults in the neighborhood, who scolded her for weighing down her posture by carrying the young boy. Ferrie remembers a precocious, emotional baby brother who at age two would go to the outhouse and loudly "preach," waving and gesticulating forcefully like the preachers that he saw at church.

Biggers's oldest brother, Paul Sylvester, is remembered for his meticulous appearance and his insistence on precise grammar and speech. Later in life, Sylvester graduated from Shaw University in Durham, North Carolina, and became a minister there, following in his father's footsteps.

The second brother, James, or Jim, as he was called, was the "backbone of the family." After Paul Biggers became seriously ill with diabetes, Jim became the principal support of the family still at home: John, Joe, Sarah, and his parents. Jim first became a chauffeur, then a "classer" who graded cotton. He also worked as a janitor, a cook, and a waiter at a summer resort near Penland, North Carolina. Jim continued with these jobs until 1937, when Paul Biggers died, delaying his own marriage so that he could help his mother. John Biggers's earliest memory of seeing an artist at work was observing Jim copying a picture of one of the "Petty girls," the popular pinups depicted by the artist George Petty, in *Esquire* magazine.

John Biggers's second sister, Lillian, died of diabetes at the age of ten in 1926. Although he was only two years old, Biggers still remembers his mother instructing him to be quiet in the house because his sister was so sick. Lillian's mother and aunts prepared her body for burial themselves, and the wake was held at home. Biggers vividly recalls an aunt lifting him at the wake so that he could see his sister one last time. Lillian Biggers is buried near St. Paul's Baptist Church in Gastonia.

Above:
John Biggers (left)
with his brothers. Left to
right: Joseph, James,
Sylvester

Below:
The artist's mother,
Cora Biggers

Sarah, the "moonchild," as her father called her, was considered the smart one in the family. She taught John to read when he was a child, and as adults they remained close. According to Biggers, Sarah had the best gift for foreign languages and for mathematics of anyone in the family, and she often played the piano for the church choir. One of Biggers's memories of Sarah is of her playing "The Old Rugged Cross" on the piano while their father hummed and plucked his guitar.

Joe, whom Biggers describes as being streetwise from an early age, also liked art. He painted decorations on coconuts and, for a small fee, made religious pictures for neighbors and church members. While a student at Lincoln Academy, Joe became chauffeur to the president of the school. Highly intelligent, he was voted "most likely to achieve" in his class. At age eighteen, Joe volunteered for the Coast Guard. During the height of the civil rights movement, he was appointed one of the first black U.S. marshals in the country by Attorney General Robert Kennedy. After his retirement, Joe Biggers collected broken toys, repaired them, and gave them to needy children. While pursuing this hobby, Joe would also search for toys that his brother John could use as models in his art.

John Biggers recalls how his family's household was run with cooperative organization and responsibility, beginning with the youngest child. Each person in the house, old and young, had a particular job to perform. Biggers's account of a Monday morning wash day describes the finely tuned working order of the Biggers home:

While adults Mama and Grandma would be cleaning up after breakfast, we children had to get the water from the well, build those fires under the washpots, get water boiling, and dump the dirty clothes into that. Also, we could all wash clothes, we all could scrub clothes on a rub board, we could

all run the clothes through the three waters—in the tub, in the bluing, in the rinse. They would test you [and say] "You wring that out tight"—you had to learn to grip this [cloth]. You learned how to hold clothespins in your mouth.[5]

Another family responsibility was the younger children's task of building fires in the hearth.

All of the young children had to build the fires; as soon as I became old enough not to set the house on fire, and that was four or five years old . . . we had to build fires in each fireplace, that was three fireplaces in the house—then the kitchen stove. We had to get that done first. *When the adults hit the floor it was* warm; *we had to get that done.*[6]

Spring was a very happy season for the Biggers children, for it meant planting time. Besides the large family garden where sweet potatoes, tomatoes, and corn were grown, each child had a plot of his or her own near the house. At an early age the children learned how to plant, how to sow seeds, and how to grow slips from potatoes. They also grew food for the rabbits, pigeons, and chickens that the family raised for food, and popcorn for themselves. Biggers remembers that every family in the community also had a cow for milk and most kept two hogs for meat.

Each day, after completing their chores, the Biggers children would sit by the fire and listen to their father reading while the women made quilts:

At evening time at fireside, the background behind the circle, around the fire, we'd be with the quilts. Yeah, the quilts would be stretched in the back behind us—we were in a semicircle around the fire. There behind us were the women quilting. So you felt the color and the warmth of the cotton and the wool. You felt all of this around you while the people still read, people told stories. There was such a wonderful quality of family and community.[7]

John Biggers's earliest memories of artistic creation center around these activities. His family worked together to foster a home environment that was orderly and rich with tradition. With extended family nearby, including his grandmother, aunts, and uncles, Biggers experienced the linking of generations through work, play, and worship. Family unity was crucial to the Biggers clan, and this would manifest itself decades later in much of John Biggers's art.

Grandma Lizzie, Cora Biggers's mother, was a woman of immense strength and independence. In her nineties she still lived alone on her small farm, and she plowed her own land. She could use a shotgun as well as any man in the area, but her routine also included reading the Bible, taking an occasional sip, and smoking her corncob pipe. There was a spring near her house where her grandchildren would play. A snake in the spring was referred to by Grandma Lizzie as "her" snake, and she would warn the children not to disturb it as they played. This remarkable woman became one of the archetypes for Biggers's later work; she was also to be the inspiration for his figures of Harriet Tubman and Sojourner Truth.

Art became a source of creative pleasure for Biggers early in life, always associated with happy times and the family. Beginning every

Above. The artist's father, Paul Biggers, as a young man

Below: The artist's maternal grandmother, Elizabeth Whitworth ("Grandma Lizzie")

spring, his brothers, with help from their sister Sarah, would build a miniature replica of Gastonia—complete with livestock and houses—underneath their house.

Cora Biggers elevated the maintenance of order and a positive attitude to a high art in her home. For her, cooking, sewing, and especially quilting were expressions of personal creativity. The children were taught early to do the preparatory work for quilting; whenever clothes were patched beyond wearability, they were placed on the "quilt pile." One of Biggers's fondest memories of childhood is of sleeping while the women made quilts by the fireplace.

Artistic creation as a part of daily life prepared Biggers for a time when he alone would have to develop his own artistic philosophy. Drawing from these early beginnings, he has always sought to convey through his art the depths of human emotions and values.

The balance and order that the Biggers family maintained against the larger odds of failure so common in the violent South created an atmosphere of progress and possibility for John Biggers. His father, Paul Biggers, knew that the family was the first center of learning for black children, where they acquired verbal skills through the traditions of oral history, informal debate, and religious study. Every child had the opportunity and obligation to read from the scriptures, a practice firmly woven into family life. Each day concluded with the family's gathering together to hear the sacred word. As an adult, Biggers has upheld this balance between daily toil and intellectual and spiritual pursuit.

Paul Biggers was a strong moral force in the life of his children. He taught them the value of learning and hard work, and the central importance in life of personal integrity. As a young man, he had endured many hardships, and, determined to raise his children to be independent, he never made allowances for himself or for them. Although Paul Biggers had lost his right leg, John Biggers once remarked that his father "was more active than any two-legged man I ever knew."

John Biggers and his brother Joe often traveled with their father to the various towns in which he taught. These were enlightening trips for the young Biggers boys. The principal and teacher in a three-room schoolhouse, Paul Biggers encouraged his students to learn from one another, and the younger children, especially, learned by listening to their older schoolmates recite their lessons. Paul Biggers laid particular stress on the importance of legible penmanship, often saying to his students, "Your handwriting represents you when you are absent." He believed that good handwriting was like a good footprint, a symbol of character.[8]

In addition to his education, Paul Biggers had considerable skill in many crafts. He was an expert carpenter, gardener, cobbler, and basket maker. The boys often accompanied their father to a nearby creek, where they gathered willow switches to make baskets and woven chair seats, and larger pieces of wood for the frames. Paul Biggers taught the children to split the willow carefully so that it was uniform in thickness, and then to smooth the surface with a knife, piece of metal, or broken bottle. Skills like these were common in black Gastonia. All the men knew how to make their own chairs, and the more talented ones could make rockers. Many also made their own wagon wheels and then took them to the town blacksmith to be wrapped in iron rims.[9]

The artistic and practical skills that the Biggers children learned at home were part of a larger moral framework. The children were taught how to live responsibly and how to treat others. Each of them had to be prepared to deal effectively with the inequities and dangers of life in a racist society. This was an extremely complex and delicate balance to maintain, and success was an indication of the strength of the family.

There were many challenges to this sense of order. Even delivering laundry to white homes for their mother became a turf war for John and Joe Biggers. When the boys crossed into the white area of town, the youths who lived there would ambush them with rocks and sticks. The brothers had to protect not only themselves but also the clothes from this violence, an important duty, because the laundry was part of the family's livelihood. This was one more adult responsibility that they accepted, even as children. Most

important of all was the maintenance of unity and self-respect within the family and throughout the larger community.

II. LEAVING HOME: LINCOLN ACADEMY AND HAMPTON INSTITUTE

The death of Paul Biggers in the winter of 1937 caused Cora Biggers to make a very difficult decision: she accepted a job at the Colored Orphanage in Oxford, North Carolina, and enrolled her sons Joe and John in Lincoln Academy in nearby Kings Mountain. Thus, at a time when many black parents tried to protect their children by keeping them close at home, Cora sent her sons away to school. She was determined that they should receive a solid education, and she knew that this would be difficult in Gastonia. The boys would not be entirely alone at Lincoln, since they would have each other, a thought that no doubt gave her some comfort.

John and Joe were already familiar with Lincoln Academy. Their older brother Sylvester and their sister Ferrie had attended, and their parents had met there as students. Like many of its graduates, the Biggers family was proud of its tradition at the school.

Founded in 1892 by the American Missionary Association, Lincoln Academy was originally established to teach freed slaves and their children. The school educated its students as teachers and ministers, and also trained girls in the art of homemaking. Cora Finger and Paul Biggers had enrolled in the school in 1899 and were among its first graduates.[9]

The Negro Division of Education Act had been passed in North Carolina in 1921. The state was attempting, within the constraints of segregation, to "strengthen high school training in urban centers as well as continue its work of raising the standards of rural schools."[10] This was a step forward for African Americans, since until the 1920s there were no high schools for blacks in the state. However, this "slow but deliberate" process seemed too much like happenstance and neglect to Cora Biggers. A report published by the Department of Education in 1935, titled "Availability of Education to Negroes in Rural Communities," concluded, among other things, that black children in rural areas lacked adequate educational opportunities.

Highland High School in Gastonia had been established for black students, and Sarah and Jim Biggers had both attended the school. Although confident that her two youngest sons would receive a good education there, Cora worried that she could not shield them from the turf fights and other difficulties that might arise in the town. Her older children now had families of their own, so the responsibility of protecting Joe and John from racial conflicts rested with her. A private school where the boys could board full time seemed a good solution to the problem.

Sylvester and Jim Biggers agreed; in fact, it was Sylvester who had learned of the job at the Colored Orphanage at Oxford and had encouraged his mother to apply for it. The orphanage had been founded in 1882 to shelter homeless and neglected black children, many of whom were the products of the Civil War's aftermath. The students themselves had made bricks and built new buildings to replace the original frame ones, creating a protective environment on the forty-acre grounds. Her new job would free Cora from the increasingly difficult burden of earning her living as a launderer, and she would be able to see John and Joe on weekends.

Private academies such as Lincoln, which were sometimes called "normal schools," became a critical bridge linking black children to higher education. Without these schools and their dedicated teachers, many young African Americans would have been limited to lives of hard labor in the fields or menial jobs in town. The academies were directly responsible for the development and expansion of a powerful black middle class. Through their emphasis on the training of teachers, they reached new generations of students. Recognizing the crucial importance of education, many black parents made sacrifices so that their children could attend these schools.

When John Biggers enrolled at Lincoln Academy, its principal was Dr. Henry C. McDowell. Dr. McDowell's positive view of African culture, the result of twenty years in West Africa, where he had been a missionary, had a lasting impact on Biggers. It was Biggers's first opportunity to learn directly about the richness and complexity of African civilization, for among the students enrolled at Lincoln were the first African-born blacks that he had ever met. More immediately, John Biggers experienced hard work in a new context. To pay for their tuition, John and Joe took jobs at the school. Joe Biggers was articulate, self-possessed, and particular about his appearance. He had the perfect bearing and personality for the job of principal's chauffeur. John, however, who was less inter-ested in his personal presentation, took a more modest job. Each morning at 4:00, he had to start the fires in the eleven dormitories and teachers' cottages. His experiences at home in Gastonia, where he had started fires for his parents, prepared him for this larger, more soli-tary task. Today, Biggers can still cite without hesitation his wages in increments from freshman to senior year. He earned $7.50 a month working as a janitor in elementary schools during his freshman year; in his sophomore year he earned $12.50 a month as assistant to fireman Frank Suddereth; and during his junior and senior years he earned $15.00 a month as head fireman.

The work and the wages were important to John Biggers's developing sense of self. By providing heat to the school, he was an essential contributor to this new black community. He was doing a man's work and being paid a man's wages, and his fellow students were benefiting from his efforts. Furthermore, there were no white men standing over his shoulder telling him what he was not doing or what he should be doing differently. Like Biggers's own family unit, Lincoln offered an experience of African-American autonomy.

Within Lincoln's protective environment, Biggers had the opportunity to expe-rience something rare and invaluable for a black male: complete solitude. After starting and stoking the fire, the young fireman had the boiler room to himself—unless it was being used for trysts between courting couples. He could revel alone in the room's warmth and isolation, and sense the power emerging from the boil-ers. For Biggers, it was a perfect place to contemplate his future and his past, and to listen to the guiding voices of his ancestors. Biggers would often spend time simply looking into the fire trying to see visions in it as his father had:

My Daddy, see, he was a person who could see visions in the fire. . . . I was never sure . . . and I would go down there and get the steam up and red fire would be there and red coals, and I'd sit there and try to see visions. I don't think I ever saw them but I was trying because I knew he could do it.[11]

Sitting in an armchair, Biggers would pour over the copies of the *New York Times Book Review* that were kept in the boiler room, absorbing Western literary thought, pondering the reflections of American intellectuals, and examining the images of American artists. Biggers remembers copying these black-and-white engravings, just as he and his broth-ers had copied drawings from the Bible for their neighbors. Alone in the heat of the boiler room, silent but for the roar of the fire and the sound of pencil against paper, John Biggers was secretly and quietly nurturing his creative spirit.

Not only could you read them, but those engravings, I'd sit down and make copies of those engrav-ings. All the papers were put in the boiler room to burn. Already strong black-and-white engravings had meaning to me . . . that's what I loved to copy. I'd sit right there and draw. I had me some paper down there. Plus see what we did, we had us two comfortable chairs in the boiler room, and see this was a nice place to sit and talk, it was nice and warm and quiet. And any time we could get a girl to come in the boiler room, we weren't responsible.[12]

John Biggers
as a student at Lincoln
Academy, ca. 1939

Though mischievous and highly intelligent, Biggers was something of a loner. He takes pride in noting that at Lincoln he always made the honor roll, despite always being in trouble. He loved his work as fireman and reflects wryly on the differences in style between himself and his clean-cut, gregarious brother Joe. John was always seen on campus in overalls covered with coal dust, totally immersed in his work.

In the fall of his freshman year, John Biggers faced a major crisis. Earlier, he and a classmate had been punished for taking chickens from a neighboring farm for the junior class barbecue fund-raiser; now he was accused of being too familiar with a female student. The administration was considering expelling him from school, and they were about to decide the matter without even hearing his side of the story. At this moment, Jim Biggers arrived on campus to address the administration in his brother's defense, speaking eloquently of the opportunities that his brother would be denied if he were unable to finish his schooling at Lincoln. Swayed by these words, and taking note of John Biggers's honor roll standing, the principal allowed him to stay in school. It was later learned that a staff member had completely fabricated the charges to divert attention from his own affair with a female colleague.

While completing his studies at Lincoln, John Biggers applied to Hampton Institute in Hampton, Virginia. Although Biggers's original object in going there was to learn a trade, it is interesting to note that he submitted several of his boiler room drawings with his application. Biggers particularly remembers a drawing of a Chinese face and a portrait of George Washington. A Hampton recruiter, who encouraged Biggers to apply for an art scholarship, believed that his talent for drawing was a measure of his intellectual ability and an indication that he was a student of well-rounded capabilities. Although the scholarship was denied, the drawings were evaluated by Viktor Lowenfeld, a man who would come to have almost as much impact on Biggers's life as his own father.

In 1941, John Biggers entered Hampton with the intention of becoming a plumber. He was inspired by the success in that trade of his cousin, Nolan Brooks, whose business in Gastonia had prospered even during the Depression. Entrepreneurial talent was taken seriously in southern black communities, and Gastonia was no exception. In the shifting and uncertain climate of Jim Crow, it was important for a black person to perform a job well and to be able to earn a living from it.

Hampton Institute, now Hampton University, was one of a number of schools established after the Civil War to provide higher education to African Americans. Its founder, General Samuel Armstrong, had been raised in Hawaii by missionary parents, and his distinctive vision of higher education for African Americans was grounded in his experience as the child of impassioned reformers. This vision was upheld by one of Hampton's most famous graduates, Booker T. Washington, who founded Tuskegee Institute. A quotation from General Armstrong that appeared in Hampton's magazine, *The Southern Workman,* reveals his philosophy and how important it was to the development of Booker T. Washington's self-help doctrines:

Be thrifty and industrious. Command the respect of your neighbors by a good record and a good character. Own your own house. Educate your children. Make the best of your difficulties. Live down prejudice. Cultivate peaceful relations with all. As a voter act as you think and not as you are told.[13]

Hampton's campus was a source of great inspiration to Biggers and his fellow students. Even today it retains a beautiful sense of quietude. Its location along the shore of Hampton Roads, a channel flowing into Chesapeake Bay, provides a perfect setting for its majestic buildings. Inspired by these orderly and imposing nineteenth-century structures, Biggers considered studying architecture.

General Armstrong wanted Hampton to maintain as much autonomy as possible through student labor, and he realized that former slaves had no money and little education.[14] Armstrong saw in the Puritan work ethic a spiritual basis for working that was

described simply as "learning by doing." Booker T. Washington had worked as a house-boy all of his life, and the janitorial labor that he performed on campus helped to pay his expenses. More than six decades later, John Biggers was admitted to Hampton on the condition that he work in the plumbing department to pay for his education. Biggers speaks of the time when he had to remain on campus through his first Christmas away from home: "I sat in that plumbing office for two weeks all day every day, and that phone didn't ring one time."[15]

The "head, hand, and heart" ethic was an essential tenet of Hampton's philosophy of teaching. Many students, both in the days of Booker T. Washington and in earlier times, had worked their way through college as janitors, waiters, groundsmen, and laundry workers. The emphasis on work committed students to Hampton in a fundamental way. By helping to erect and maintain their buildings, and by providing services to their class-mates, students felt a vested interest in the well-being of the college. Hampton's philos-ophy also promoted an ideal of the dignity of labor. Pride in the accomplishment of hard work, no matter how lowly, prepared the school's graduates to accept without destruc-tive anger the often menial jobs that were sometimes all that was open to them.

Hampton was always a complex intellectual community. Although the school empha-sized the need for blacks to acquire a trade or skill by which they could earn a living, it also promoted in its students an awareness of their rich African heritage. In the outside world, the African diaspora was rarely discussed without derision. On campus, it was seen in both positive and negative lights, as there were some factions of the fac-ulty that were uncomfortable with the subject. Nonetheless, African culture was a strong presence at the school.

Viktor Lowenfeld and
John Biggers at Pennsylvania
State University, ca. 1946

The architecture and natural environment of Hampton are themselves echoes of Africa. The campus chapel is lined with a frieze of carved heads of Africans and Native Americans. These heads remind all who enter of the first students enrolled at the school, many of whom were members of those two cultures. The Emancipation Oak, an important symbol on campus, is said to have been the spot where the Emancipation Proclamation was first read to Virginia slaves. Even Hampton's location on the bay is a continuous if subtle reminder of the transatlantic crossing survived by many of the fore-bears of Hampton students.

Hampton permitted considerable intellectual freedom in its classrooms. At the 1875 commencement—Booker T. Washington's graduating class— Joseph B. Towe presented a speech titled "Old Time Music," in which he argued that southern black plantation songs were derived from African music. This presentation, complemented by Mr. Towe's own singing, was described in the *New York Times* as the most interesting of the occasion. Remarkably, at the end of the nineteenth century black students in the South were already beginning to examine and celebrate, without hesitation or fear, their African heritage.

Viktor Lowenfeld, the renowned educator and artist, came to Hampton with his family in 1939 after escaping Nazi Europe. At the invitation of psychologist Gordon Allport, Lowenfeld spent a year at Harvard University as a guest lecturer. Through the assistance of Allport and a group called Friends of Refugee Teachers, he obtained a posi-tion at Hampton as associate professor of industrial arts.

Lowenfeld encouraged his students to record in their art the disappointments and joys of life in the southern black community—or the northern black ghetto—that they knew. Having survived Nazi persecution, Lowenfeld had an immediate sense of the hor-ror of violence, prejudice, and racism. As a survivor of the Holocaust, he could well understand the psychological pain that was a legacy of black slavery. Biggers recalls the moment when Lowenfeld received a letter from the United States Department of State, informing him that members of his family had died in Nazi concentration camps. The

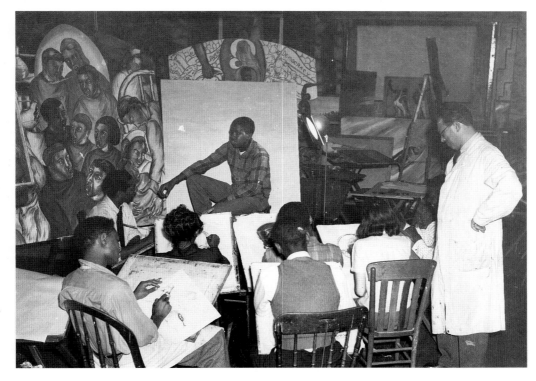

student would never forget the enormity of the pain that he witnessed in his teacher.

Lowenfeld's passion and vision inspired his students to produce excellent work. He created a strong curriculum that addressed many different aspects of visual expression. The *Hampton Bulletin* of 1943 presented the philosophy of the art department:

Culture has never developed without unity of life and art. [Teaching art is only justified] if it makes a definite contribution to Negro life and culture, in spreading art into community life, homes, and schools, and in making the campus art conscious.[16]

The art department began to attract students from other areas of the college—John Biggers among them—and by 1941 young men and women from as far away as New York and Ohio were applying for art scholarships. Everyone who remembers Lowenfeld describes him as a man of tremendous energy and enthusiasm. Biggers vividly recalls the teacher instructing him to draw a man carrying all of his belongings on his back, and to "imagine what it feels like carrying everything that you own on your back."

By showing his students works by European artists who worked in a genre tradition, Lowenfeld broke down the stereotype of European art as rarefied and intellectual. Biggers remembers the first time he saw a copy of Jean-François Millet's *The Gleaners*. This work inspired his own painting of the same name. In Biggers's painting, however, the women are collecting coal from the railroad tracks rather than wheat from the harvested fields. In the commonality of these humble figures scouring the ground for usable materials with which to sustain their families, the artist embraced Millet's vision. Pieter Bruegel's lively scenes of peasant life in northern Europe also struck a chord with Biggers, and the powerful prints of Käthe Kollwitz had a profound influence on him. In Kollwitz's strident lines and heavy black wedges of form, Biggers found a new language of pathos, anger, and deep emotion not often seen in the work of European modernists.

Lowenfeld also introduced his students to the work of the American Regionalist artists Thomas Hart Benton, Reginald Marsh, Ben Shahn, Harry Sternberg, and Grant Wood. For Biggers, perhaps the most emotionally connotative works he studied were by the Mexican muralists Diego Rivera, José Clemente Orozco, and David Alfaro Siqueiros.

In their work he recognized a commitment to depict the real truth of the history of a people. Years later, Biggers traveled to Mexico to see these works firsthand.

Lowenfeld actively used Hampton's collections of art from Africa and other cultures. It was the African works of art that most sparked Biggers's imagination. He recalls that the first time he saw these sculptures he was repulsed and could not understand why Lowenfeld "wanted us to look at the ugly stuff!"[17] At the time Biggers could not fully appreciate the bridge to African heritage that former Hampton student William Sheppard had hoped to build by donating Kuba and Central Kongo art to Hampton. But Lowenfeld insisted on exposing his students to these objects, believing that in studying them they would discover a direct and palpable link with their African heritage.

While teaching in Vienna, Lowenfeld had served as head of the city's African art and pottery museum, where he had gained a deep appreciation of the genius of black culture. His involvement in the activities of the Bauhaus had put him at the forefront of European modernism, and he fully understood the indebtedness of modernism to the aesthetics of African art.

The atmosphere of cultural pluralism at Hampton was a wonderful complement to Lowenfeld's deep interest in African culture. Hampton had always enjoyed a strong enrollment of African, Native American, and Asian students. As a member of the college roster of the American Missionary Association, one of the school's primary goals was to train people of color to return to their native countries and to educate them in a Christian and ethical manner; among these students were Africans who were learning farming and trade skills to take back to their countries. This brought African culture to Hampton in a personal and direct way. The sight of African pageants with African students dressed in their traditional costumes was not unusual at the school. Dr. Marjorie Stuart, a Hampton graduate and future colleague of Biggers's at Texas Southern University in Houston, remembers being taught dance by an African instructor, Frank Richards, who took his students on tour to New York, Boston, and other East Coast cities to perform traditional African dances.

In 1942, Viktor Lowenfeld was invited to organize exhibitions of student work at the Museum of Modern Art in New York and at the Virginia Museum of Fine Arts in Richmond. One result was *Young Negro Art,* an exhibition of seventeen student works at the Museum of Modern Art. That such serious attention was focused on student art, especially black student art, was—and still is—a rare expression of interest in African-American culture by a major museum. In the Museum of Modern Art press release for the show, Victor D'Amato, the museum's Director of Education and a personal friend of Lowenfeld's, credits him with recognizing the creative potential of his students:

Dr. Viktor Lowenfeld, head of the art department at Hampton Institute, is a teacher who understands and is able to draw out the creative gifts of the Negro. The exhibition illustrates his power to do so and is a commendable effort. It represents, however, only the beginning of a complex and difficult problem. There are indications in the exhibition of the struggle of the Hampton student in finding his own expression as opposed to imitating the traditional schools of art and contemporary artists. Occasionally one senses an influence from a European school or a favorite master in the painting, but this should eventually disappear as the student gains confidence and the ability to express his own ideas. This exhibition is, therefore, more important as an indication of the creative potentiality of art in the American Negro and as a wholesome and intelligent approach in training him, than as a collection of finished works of art.[18]

The exhibition, which was held in October and November, 1943, and which included Biggers's mural *Dying Soldier* (Fig.2; p. 130), was met with mixed reviews. *Art News* expressed the prevailing attitude of modernism at the time, praising the understated work of Hampton student Junius Redwood while condemning heightened emotion as a weak and unsophisticated element in contemporary art. The works were described as:

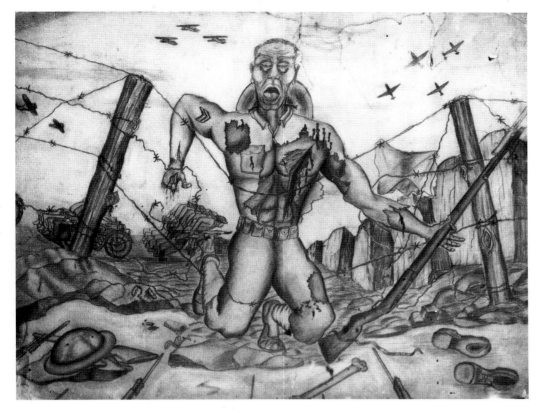

a form of race and social consciousness utterly incompatible with sincere artistic expression. In one picture only, that of Junius Redwood, do we find the great gifts of color, dignity, and sincerity which are the Negroes' natural heritage. Of the screaming propaganda of John Biggers's picture, the less said the better. One cannot help feeling that this is the work of heavy-handed teachers with over-plastic material.[19]

Such criticism was discouraging to the students, but the experience of participating in a group exhibition at a prestigious museum provided an extraordinary firsthand introduction to the professional art world.

Although it is difficult to overstate the impact that Viktor Lowenfeld had on hisstudents at Hampton, other influences were also at work. There were other inspirational teachers at the school, including Nathaniel Dett, chairman of the music department, and a number of African-American artists, writers, and performers active in New York during the Harlem Renaissance, who came to Hampton to teach. William Artis, a Rosenwald Fellow, was one such artist. The muralist Hale Woodruff also visited Hampton as a guest lecturer after completing for Talladega College in Talladega, Alabama, a series of murals depicting the mutiny on the nineteenth-century slave ship *Amistad,* and the subsequent trial and return of the mutineers to Sierra Leone (Fig. 34).

Another visitor who made a keen impression on Biggers was Dr. Alain Locke of Howard University. The author of *The New Negro* was so impressed by the work of the young Biggers that he commented on its excellence and gave the artist an autographed copy of his book. Locke's essay, "The Legacy of Ancestral Arts," encouraged young black artists to look to their African roots for inspiration, just as their European contemporaries were doing. Locke subsequently purchased two drawings by Biggers, one of a black man and another of a black laundry woman, for the Barnett-Aden Collection in Washington, D.C. This was another professional experience through which Biggers began to define himself as an artist.

The dynamic group of artists studying alongside Biggers at Hampton brought different experiences to their work, but all shared a common bond of seeking individual

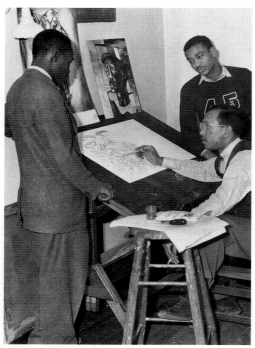

Above:
Hazel Biggers

Below:
The muralist Charles White
with Joseph Mack (left)
and John Biggers (right) at
Hampton Institute

expression. Among them was John Bean, who created a mural of the black Christ for the Academy Building. Junius Redwood's work *Night Scenes* was purchased by the Museum of Modern Art from the exhibition *Young Negro Art*. Samella Lewis, a talented painter, went on to distinguish herself as a gifted art historian who, following in the path of James Amos Porter, set out to chronicle African-American art in her publications. Michael Portilla, one of the few abstractionists in the group, painted in a distinctive architectural style. Annabelle Baker, undoubtedly the most individualistic of the group, had won a number of prizes for her art before she came to Hampton. She arrived without having formally applied, and convinced the faculty to admit her to the work-study program. Persis Jennings, who came to Hampton from New York, was one of the most prolific artists of the group and later taught in the Hampton area for many years. Joseph Gilliard, another talented student, was to teach at Hampton for more than forty years. This remarkable group of gifted young African Americans flourished at Hampton, and their achievement is only now fully appreciated.

John Biggers and his friends share vivid memories of their time at Hampton. Samella Lewis recalls that Viktor Lowenfeld was a father figure to Biggers, who was struggling to find his identity as a black male in a country that was at war overseas and experiencing strife at home. Biggers recalls the daring spirit of Annabelle Baker, who lived by her own rules, wearing her hair naturally long before it became fashionable, and let no one, not even Hampton administrators, dictate what she could and could not do.

Hampton student Hazel Hales, an accounting, major from Fayetteville, North Carolina, was fascinated by the camaraderie that existed among Hampton's art majors. She was especially intrigued by the talent and intensity of the young artist John Biggers, and their friendship evolved into courtship, and eventually, into marriage.

The artist's wife recalls how firmly united the group was by their deep commitment to art. She remembers accompanying her friend Frank Steward, another art major, when he worked in the studio, and that it was not uncommon to see John Biggers asleep on one of the tables there, recuperating after long hours of work: "He would paint all night. You'd go in there and he'd wake up. A lot of the students would work all night. He was painting the *Dying Soldier* then." Hazel Biggers particularly remembers her future husband's passionate portrayal of the black struggle: "It was revolutionary, and he was more bitter and intense about things then, because of how he'd grown up, and what he saw his mother go through." This deep resentment often expressed itself in paintings like *Mother and Child* (1944; Fig. 12), a gripping portrayal of a black mother nursing her baby on the steps of a shotgun house.

Mother and Child was one of the artist's earliest portrayals of a shotgun house, an architectural form that would become increasingly important in his art. A southern shotgun house is built with each room behind the next, the term "shotgun" suggesting that one could fire a rifle from the front door straight through to the back without hitting a wall. Besides this characteristic arrangement of its rooms, the shotgun also has a shallow front porch. Because of the African origins of this house type, Biggers would later use it as a symbol of the continuity of African-American culture.

John Biggers was also inspired by the presence at Hampton of Charles White. In 1942, White was awarded a Julius Rosenwald grant to paint a mural at the black college of his choice. He chose Hampton because of its reputation as a center for the study of art education for black students. Having this renowned artist on campus was a major inspiration

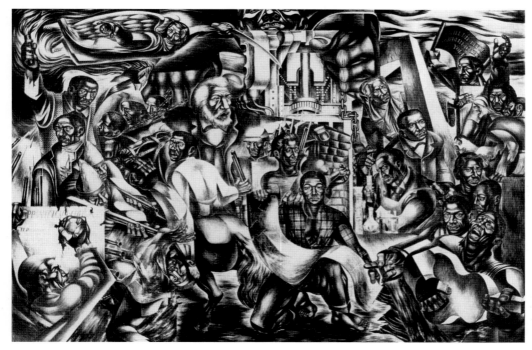

to the students, and they observed him closely as he prepared to create *The Contribution of the Negro to American Democracy* (Fig. 3):

Before beginning his painting on an 11 x 17' area of a wall in Clarke Hall, White produced a series of working drawings based on his concept for the mural. He had come to believe that in textbooks the story of blacks' role in the development of democracy had been neglected. His goal was to

produce a powerful illustration of black Americans who had made more significant historical and cultural contributions to the United States. After doing the working drawings, he sketched the outline on the wall and finally the painting began.[20]

Biggers was inspired by White's creative power. He went to White's studio whenever he could "make himself useful," as he put it. He often swept the studio floor just to be near the artist at work. Cora Mae Reid, another student, sometimes separated the eggs for White's tempera color. Biggers also helped prepare colors, and at one point was rewarded for his interest by being asked to pose for White as a runaway slave. It seems fitting that Biggers assumed the role of such a rebel, for in so many ways his career would express a similar independent spirit. By the time the mural was dedicated on June 25, 1943, Biggers had absorbed all of White's drawing and painting techniques and made them his own. In particular, the monumentality of White's work had a lasting effect on Biggers. On a more personal level, Biggers had found his first mentor in the art world who was also a black man.

Charles White's wife, Elizabeth Catlett, taught sculpture during the time that she and her husband were at Hampton, and it was she who approved of the portrait head of General Samuel Armstrong, Hampton's founder, that Biggers was commissioned to create in 1943, the seventy-fifth anniversary of the school's founding. The dedication of the portrait of General Armstrong was a moment of great pride for both the young John Biggers and Hampton Institute.

At Hampton, Biggers emerged as both a sculptor and a painter. His confident use of strong forms is evident in both the bust of General Armstrong and in his drawings. However, perhaps Biggers's best sculptural achievement of this time is *Pregnant Prostitute* (Fig. 4), a work inspired by a personal encounter that the artist describes as a very "human

Above, left: Fig. 3.
Charles White,
The Contribution of the Negro to American Democracy,
1943. Egg tempera (fresco secco). Clark Hall, Hampton University. Courtesy, Hampton Univeristy Museum

Above, right:
Fig. 4. Pregnant Prostitute,
1943 (Cat. no. 39)

experience." In this work, the exaggerated volumes of the figure heighten its psychological impact. Biggers's volumetric painting style developed largely as a result of his temperament and experience as a sculptor.

Until the disruption of World War II, Hampton provided Biggers with time to create and to think. He also discovered the lifelong camaraderie of other committed artists. As a muralist and a sculptor, he was able to grace the Hampton campus with his own works. Under Viktor Lowenfeld's tutelage, he learned something of the art world beyond the campus and gained a sense of the responsibilities and consequences of being an artist. It was during his time at Hampton that Biggers began to develop in his art the themes that would remain with him for many years to come: the black family, the black woman, the black man, man's connection to nature, the working community, and spiritual renewal. These themes, singly and in various combinations, would characterize the future work of John Biggers.

III. On His Own: The Navy and Penn State

In the autumn of 1942, the war had an abrupt and sobering impact on Hampton Institute. The quiet and contemplative atmosphere of its waterside setting gave way to rush and urgency, as courses were taught year-round to move students through the school as quickly as possible. As the bay at Hampton was given over to preparations for war, the education of black students was suddenly incidental to the purposes of the United States military. When the students were asked to share their accommodations with enlisted men, this disruption was felt almost as a violation. Though the official communications bore a veneer of patriotism, the reality was that white men, uninterested in the mission of Hampton Institute, were suddenly everywhere on campus.

Biggers was drafted in May, 1943, and received four months of basic training at Great Lakes, Illinois, where the black artist Edsel Cramer was also stationed. Cramer remembers Biggers walking around the base with a book on Diego Rivera tucked under his arm. The two artists were assigned the project of creating a mural depicting the contribution to the navy of blacks, such as Robert Smalls, one of the first black commissioned officers in the service; however, Biggers did not remain in Illinois long enough to work on the project with Cramer. As fate would have it, Biggers was sent back to Hampton because of his scores on the coxswain's exam. Under the guidance of artist Joseph Gilliard, who supervised the naval model shop at Hampton, Biggers assisted in the painstaking work of making models for parts of military machinery. At the same time, Biggers and his fellow student Samella Lewis illustrated the book *Seven Day Leave,* written by Viktor Lowenfeld, which instructed soldiers on teaching the skills of reading and writing.

Biggers still recalls angrily the irony of being enlisted in a segregated navy and watching white officers invade the sacrosanct atmosphere of Hampton. The male students who had been drafted resented having their on-campus drills conducted in segregated units. Even worse, they witnessed German POWs being served at white cafés in town, while blacks were sent to the back window to claim their food.

This double standard made it very difficult for many young black enlistees to assume the role of proud soldier or sailor. It was impossible not to remember what had happened to the black soldiers of their parents' generation, who had fought in World War I in a segregated army. Many had lost their lives for the United States, and those who had returned were greeted not with a hero's welcome, but with the same old inequities of the Jim Crow South. W. E. B. DuBois's eloquent argument that black soldiers had proven themselves on the battlefield and were due the same respect that all American soldiers should receive—good jobs upon their return, the right to vote in their own communities—had fallen upon deaf ears. It was fine for a black soldier to serve as cannon fodder

on the battlefield, but he still had to collect his food from the back window when he came home. Speaking of this period, Biggers recalls that "a consciousness came at that time that I have never lost."

Fortunately, there were still some opportunities for the artist to follow his calling. Biggers's fellow student, Samella Lewis, had painted a mural, *Return Home of the Soldier,* for the dining hall at nearby Fort Eustis, and so Biggers was asked by the commander at Hampton to provide similar decorations for the walls of the officers' training mess, formerly the campus boathouse. Although the murals are now lost, the preparatory drawings for them still exist. The style of these drawings is much more geometrized than that of *Dying Soldier,* but their content is equally intense. Row after row of soldiers are shown marching forward, their identities lost behind their monstrous equipment. The murals themselves, which were painted directly on the walls, invoked a sense of technological horror reminiscent of the work of Siqueiros. Not surprisingly, the officers preferred Lewis's touching depiction of a black family at their dinner table, welcoming their young son home from battle.

Biggers, however, refused to take a sentimental view of his subject. He was convinced that the war was pointless violence, and he wanted to convey that message to the soldiers who were about to fight in it. In his view, this was no time for pretty pictures. Unfortunately, the murals were destroyed when the boathouse was torn down after the war, and preparatory drawings are all that remain. Luckily, Joe Gilliard was able to rescue Samella Lewis's Fort Eustis mural from destruction, and it now belongs to Hampton's permanent collection.

In January, 1945, Biggers was shipped to the naval base at Norfolk. He found the black sailors there almost totally demoralized. Although they were put on dangerous details—loading explosives onto ships, for example—they had little else to do, and they were not allowed visitors. As a result, they were bored and depressed, and often drank too much. When they noted that the white sailors were spared the dangerous jobs, had good recreational facilities, and could entertain their parents and girlfriends, the black sailors were angry and resentful, as well.

Deeply depressed after months on the naval base, Biggers went on leave in October, 1945, traveling to Philadelphia to visit his brother Joe, who had just completed a tour of duty with the Coast Guard. The war was now over, and he saw no point in returning to Norfolk. Joe, alarmed at his brother's demoralized state, convinced him to enter the naval hospital in Philadelphia, where he was admitted to the psychiatric ward for observation. During his stay at the hospital, one of the doctors supplied him with a drawing pad and pencils. At the end of thirty days, Biggers had completed a series of drawings describing his state of mind.

These drawings, which were given to the psychiatrist, are now lost; however, Biggers recalls them vividly:

I made some drawings. You know the first drawing I made was a white man with his mouth open the size of this table and he was swallowing all of the niggers. . . . No, I drew that shit. I gave myself therapy. All that crap I was going through down there, I did some things that Pieter Bruegel and them hadn't done. I showed that whorin' den. I drew everything. I drew it. I drew the whole damn mess. . . . I showed men marchin' who didn't have no damn head.[23]

After a month in the hospital, Biggers was given an honorable discharge from the navy, and the medical board pronounced him temperamentally unfit for service. Released in December, Biggers traveled for two weeks with his brother Joe, selling beauty products to black salons on the eastern seaboard. He then returned to Hampton, where the idyllic prewar atmosphere had been extinguished. The school was permanently altered by the war. The camaraderie that had been shared by Biggers and his fellow art students was nowhere to be found. Hampton's new administration was unsupportive of the teaching

methods of Viktor Lowenfeld, who in June 1946 accepted a position in the art department at Pennsylvania State University.

Biggers decided to follow Lowenfeld to Penn State. Once there, he felt completely alone. The poverty among blacks that he witnessed during his weekend visits to Pittsburgh—scarce food, substandard housing, and rampant unemployment—seemed much worse than what he had experienced in the South, for there the black community was at least able to maintain a sense of autonomy. Southern blacks cultivated their own land, built their own homes, and made their own clothing, and their self-sufficiency gave them an integrity that Biggers could not find in the northern ghettos. In his isolation, Biggers relied increasingly on Lowenfeld's friendship.

In striking contrast to what Biggers observed in the black ghettos of Pittsburgh, Penn State provided an insulated environment for its students. Football weekends, fraternity parties, and campus raids and pranks were the rule of the day. Such frivolity probably reminded Biggers of Norfolk and the lighthearted atmosphere of the naval officers' recreation center, across the street and yet worlds apart from the black sailors' barracks. At Penn State, Biggers remained silent and invisible. Here he again felt the heavy weight of white dominance on his shoulders. Although the university campus was less overtly racist than the naval camp, there was nonetheless considerable prejudice, an undeniable attitude that made him feel inconsequential. He had been raised to believe that education held the key to change in the black community, but at Penn State, the black community of his youth seemed far away indeed.

Biggers's experience recalls that of W. E. B. DuBois, who attended Harvard after graduating from all-black Fisk University. DuBois wrote of being "at" but not "of" Harvard.[24] Similarly, Biggers remembers going for several weeks at Penn State without speaking, literally, to anyone. What chiefly sustained him at this time were his letters from Hazel. Although he also visited the Lowenfelds frequently and found some solace in their company, he was still not interacting with people his own age. Finally he met some young intellectual Jewish activists on campus who befriended him, and he became part of their group.

His new friends asked Biggers to explain his work to them, and their intensive questioning forced the artist for the first time to articulate clearly and publicly what was important to him about his art. Preparing for these discussions was one of Biggers's most important experiences at Penn State.

The group did more than discuss intellectual and artistic issues. For example, they protested at a barber shop that had refused to cut hair for Biggers and other blacks. Although discrimination was becoming an increasingly important social concern in the postwar period, Biggers tried to deal with the issue through his art, rather than overt social protest. In the works that he created at Penn State, he depicted the realities of ghetto life, a world that he had not previously known. His paintings and drawings of street people from this period reveal his trenchant perceptions of northern ghetto life.

In the North, people were forced to rely on overpriced corner groceries for food. Tenement living deprived its inhabitants of land to cultivate, or for the more fortunate provided only a tiny patch of land wedged between miles of concrete. In winter protection from the bitter cold was a constant battle. Many blacks relied on public transportation to commute to their jobs, and this dependency was an additional burden. Although many positive values of the South had survived the migration to the North, there was also a coldness and a competitiveness there that Biggers had not experienced before.

Biggers's works such as *Victim of the City Streets #2* (Fig. 6), *The Garbage Man* (Fig. 7), *Coming Home from Work* (p.117), *Night of the Poor* (p. 119), and *Day of the Harvest* (Fig. 8) reflect the primary issues of urban poverty. His major mural of a sharecropper distilled the themes of black life that Biggers had explored while at Hampton. The mural brings together these themes in a unified composition in which a black family is framed by scenes of baptism and rebirth. These scenes would reappear in the artist's later works. The

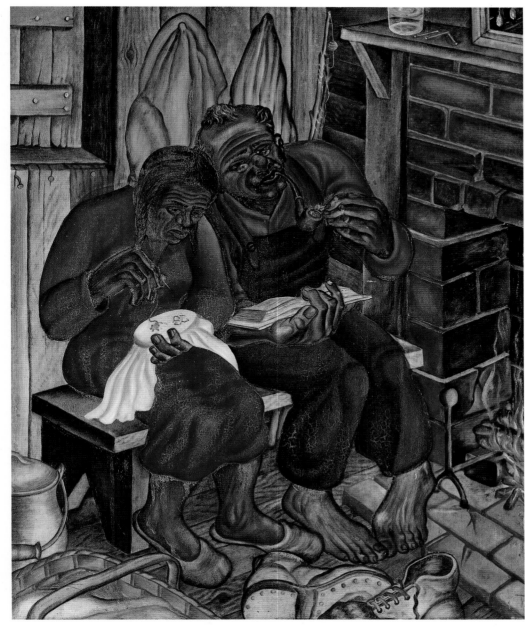

images in Biggers's *Victim* series, which depict the isolation imposed by urban poverty, still ring true today as cities are increasingly faced with the tragedy of homelessness.

To compensate for his lonely existence at Penn State, Biggers traveled several times to New York to visit his other mentor, Charles White, and White's wife, Elizabeth Catlett, in their small apartment in Greenwich Village. There he found the two artists so deeply engrossed in their work that they barely had time to eat or to see their friends. Biggers made himself useful by running errands and washing dishes for them. During his visits, the three discussed at length what it meant to be a black artist, and what goals they shouldwork toward. While in New York, Biggers also visited the Metropolitan Museum of Art and other museums. Ultimately, the negative reviews of the New York critics of the *Young Negro Art* exhibition made him reluctant to move to the city. In many ways, New York was for Biggers an extension of his experience at Penn State.

One very special event occurred during Biggers's years at Penn State. Two murals that he had completed at Hampton, *Country Preacher* (p. 118) and *Dying Soldier* (Fig. 2; p.130),

Right: Fig. 6.
Victim of the City Streets, # 2,
1946 (Cat. no. 40)

Opposite: Fig. 7.
The Garbage Man, 1944
(Cat. no. 20)

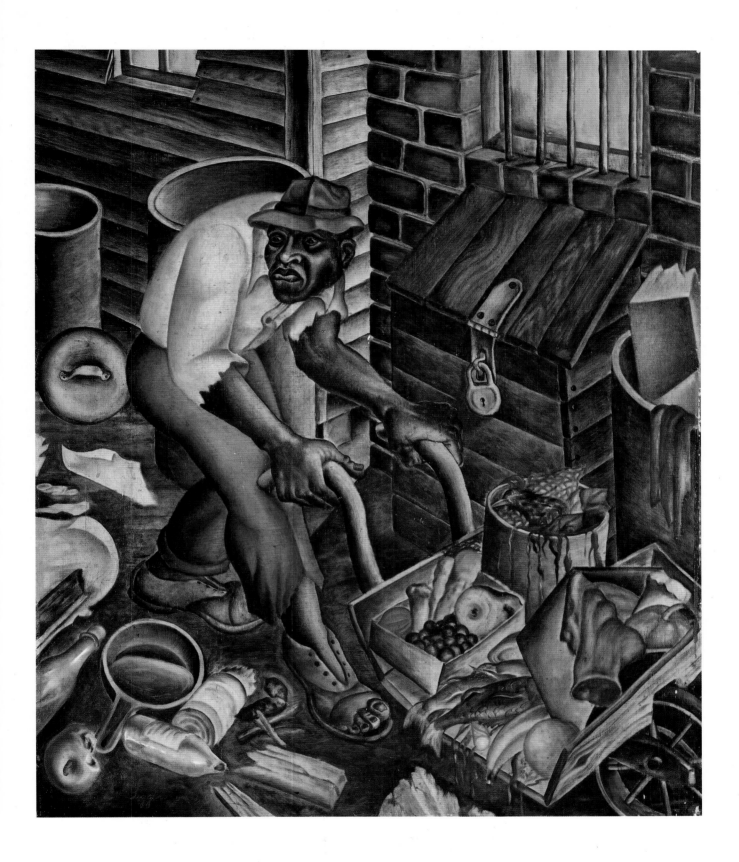

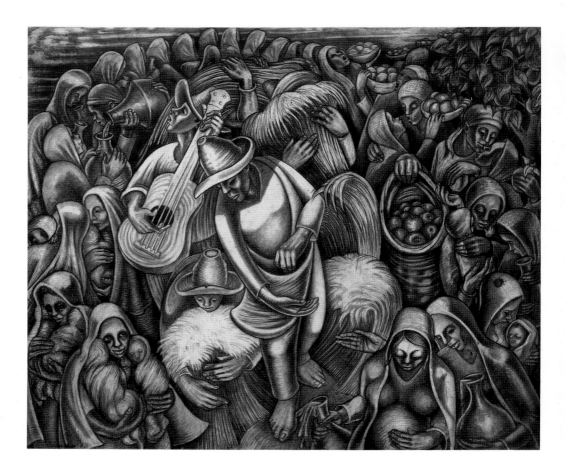

the latter of which had been included in the Museum of Modern Art exhibition, were acquired by United Transport Service Employees, CIO (UTSE, CIO), for installation in its center at 3452 South State Street in Chicago. As stated during the dedication on November 3, 1946, the acquisition of the murals marked the beginning of an education program in which union members would be shown "how to play a dynamic role in a highly complex civilization."[25]

The installation of the murals represented a major endorsement by Chicago's business and labor leaders, by the black press and other African-American social institutions, and by the art establishment, including the Art Institute of Chicago. The theme of the dedication ceremony was "Art in Its Relation to Social Progress." Moderated by Enoc Waters, Jr., a correspondent for the African-American daily newspaper the *Chicago Defender,* the panel consisted of Michael Brack, a businessman; Margaret Goss, an artist; Katherine Kuh, curator of the Gallery of Art Interpretation at the Art Institute of Chicago; and David D. Ross, Jr., director of the South Side Community Art Center. William S. Townsend, the international president of UTSE, CIO, unveiled the murals. John H. Sengstacke, editor and publisher of the *Chicago Defender* and president of the Hampton Alumni Association of Chicago, introduced Biggers, who commented on the creation of his murals.

It is noteworthy that Chicago, a city built on the strength of its labor unions, chose to ignore the critical attacks on Biggers's work during the MoMA exhibition, and embraced these murals embodying the struggle of the common man.

IV. TEXAS: A NEW FRONTIER

After teaching for a summer in 1949 at Alabama State University, where he enjoyed his first autonomy as an artist and educator, John Biggers was contacted by Dr. A. R. O'Hare Lanier, the first president of the newly established Texas State University for Negroes in Houston. This school had been founded in 1947 in immediate response to the appeal of Heman Sweatt, a black honors graduate of Wiley College and the University of Michigan, to the higher courts of Texas when he was denied admission to the law school of the University of Texas at Austin. Rather than desegregate the law school, the state voted to create a separate institution of higher learning for its black citizens.[26] The irony of the state's decision was that the resulting flood of scholars to the new university profoundly changed the profile of Texas intellectual life. A number of highly educated blacks, many of whom had successfully desegregated graduate programs in universities throughout the country, came to Houston ready to break new ground in education. Among them were John and Hazel Biggers, who had married the previous year when the artist had completed his work at Penn State.

In Houston, John Biggers had come to the attention of Susan McAshan, who had seen an exhibition of his work at Hester House, a community center in the city's Fifth Ward, during the summer of 1949. Mrs. McAshan had recommended to Dr. Lanier that he interview the young artist for the position of chairman of the art department at the school, which was renamed Texas Southern University in 1951. Mrs. McAshan's family, especially her father, had been instrumental in the development of an administrative structure and plan for TSU, and she had the ear of the newly appointed president. As a patron of the arts in Houston, and as a member of one the city's most prominent families, Susan McAshan would become a longtime ally of John Biggers and the TSU art department. Dr. Lanier, himself a graduate of Hampton, already knew and admired Biggers's work, and he was eager to hire him, as well as Joseph Mack, another Hampton graduate, for TSU. Lanier envisioned creating a "museum of Negro culture" for the university.[27] He felt assured that Biggers and Mack would share his philosophy of the importance of the arts, especially with regard to black cultural heritage.

Texas Southern University is located in the Third Ward of Houston. The Third, Fourth, and Fifth Wards represent the earliest settlements of black communities in the city. The Fourth Ward, originally called Freedmanstown, is the oldest. The Fifth Ward was the city's first major middle-class enclave of blacks. Members of this community established a base of economic support through the railroad, the Port of Houston, and other organizations that paid good salaries to skilled laborers. They became homeowners, built churches, and developed their own businesses. Prior to the establishment of Texas Southern, the Fifth Ward was the heart of economic activity in Houston's black community. With the opening of the university, the Third Ward became a new center, represented by a strong group of professionals—educators, physicians, postal workers, ministers, and members of the arts community. The Third Ward existed like an overlay upon the older fabric of black life in Houston. Within this rich and intricate merging of old and new, John Biggers continued to develop as an artist.

The first few years of establishing an art department for Texas Southern were characterized by constant frustration, which had to be countered with continuous innovation. As was often the case in higher education, the arts were given low priority in the allocation of funding. Equipment was practically nonexistent, and the faculty had to make do with inadequate facilities. This meant teaching painting in classrooms without sinks, and teaching drawing without paper or crayons. Often the faculty had to procure materials for themselves and their students, once embarking on a five-hour drive to San

John
and Hazel Biggers
on their wedding day,
Philadelphia,
December 27, 1944

Antonio in a truck to dig clay for Professor Carroll Simms's sculpture and ceramics class-es.[28] Despite these hardships, the art department established itself in a small building, the "quonset hut," where studio and art history classes were held. The first classes were primarily filled with women studying for their teacher certification, for which art education was a requirement. These women—Willie Lee Thomas, Ethel Sands, and Fannie Holman among them—were instrumental in providing support to the art faculty, and many of them became early champions of John Biggers and his talented young colleagues. Because they went on to teach in public high schools, they confirmed the quality of the art education program at Texas Southern, sending their own talented art students to study under Biggers and Simms. Since public schools in Houston were segregated at the time, it was important that black teachers could represent Texas Southern as a premier institution of higher learning. Indeed, the art department was rapidly developing a reputation for training excellent art teachers.

As chairman of the art department at Texas Southern, Biggers encouraged students to look to their own communities and to their African heritage for inspiration. At the same time, he was establishing himself as an artist of considerable importance. In the early 1950s Biggers accepted major mural commissions within Houston's black community, and he also won several important prizes. The Dallas Museum of Art and the Museum of Fine Arts, Houston, both sponsored competitions for Texas artists. At the Museum of Fine Arts, Houston, he won a purchase prize for the drawing *The Cradle* (Fig. 9) in 1950, and at the Dallas Museum of Art, he won the Neiman Marcus Company Prize for his drawing *Sleeping Boy* (Fig. 10) in 1952. The museums had organized these competitions to highlight regional talent, and to create simple and immediate ways of adding works to their permanent collections. By winning the prizes, Biggers's works automatically entered the collections of each museum. In both cases, the awarding of the prize to a black artist created unexpected confusion for the museum administrators, whose trustees and patrons were not expecting a black artist even to enter the competition, much less to win it. The directors of the two museums, James Chillman in Houston and Jerry Bywaters in Dallas, were put in the awkward position of having to uphold the segregationist policies of the museums while acknowledging the talent of the gifted young black art professor.

In Dallas, a reception that was planned for Biggers was mysteriously canceled. When the artist arrived at the museum, a representative asked him if he were John Biggers, silently handed him his purchase prize check, and then coldly turned away. Biggers vowed never to return to the museum.[29] In Houston, recognition of Biggers as the prize-winning artist highlighted the museum's long-standing racist

Below: Fig. 9.
The Cradle, 1950
(Cat. no. 41)

Bottom: Fig. 10.
Sleeping Boy, 1950
(Cat. no. 21)

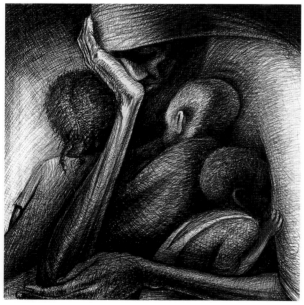

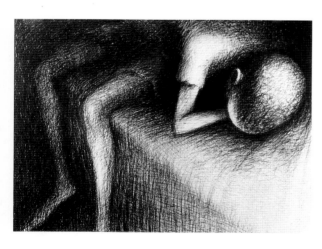

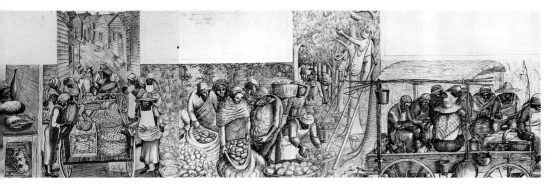

admission policy. Blacks were allowed to visit the museum only one day a week. Because the reception for the award had been scheduled for another day, the prizewinner could not in fact attend the function honoring him. Instead, Biggers and a colleague from the university were invited to a private viewing of the exhibition by the director. In the months following, Chillman was successful in abolishing the museum's segregationist policies, and in increasing its accessibility to the black community.[30]

Biggers also won a purchase prize awarded by Atlanta University for his 1953 sculpture *Kneeling Man.* The annual juried competition, organized by art department chairman Hale Woodruff, was created to provide an opportunity for professional African-American artists to compete nationally for prizes, and to offer the possibility of their works being acquired for major permanent collections. National museums generally excluded African-American artists, making only a few exceptions for such talents as the nineteenth-century European expatriate Henry Ossawa Tanner and the New York-based artist Jacob Lawrence. Black artists therefore had little opportunity for their works to be judged and exhibited on a national level. The Atlanta University competition provided them with an opportunity to have their work seen in another part of the country, and to see the work of other black artists. On a more personal note, it created for the artists an important network of professional contacts and friends within a larger art world that was often indifferent and unsupportive. The competition enabled the university museum to develop one of the most important collections of African-American art in the country.

These three prizewinning works reveal Biggers's extraordinary skills as a draughtsman. In *Sleeping Boy,* the young child is depicted in a fluid, dreamlike state, bathed in gently graduated tones of ever richer blacks and grays. Within this rich atmosphere of darkness, the boy's languid frame seems about to slide off the page. In *The Cradle,* Biggers uses the same drawing techniques to create a quite different atmosphere. A mother bends protectively over her child, cradling her from the dark unknown that surrounds them both. The darkness of the drawing, made deeply black by intensive crosshatching, underscores the sense of aloneness suggested in the figure of the mother. This drawing repeats the theme of the *Mother and Child* (Fig. 12) that Biggers had created at Hampton, but the image is now rendered more simply and yet more powerfully. *Kneeling Man* forcefully conveys the same emotional state. The figure suggests the weight of an emotional and psychological burden, yet from his hands and limbs emanates an enduring strength. Biggers was maturing as an artist and the intensity of his vision was increasingly expressed in universal terms.

During his early years in Texas, John Biggers faced numerous challenges. While he was establishing a new department, and attempting to convince a new administration that visual art should be an integral part of the education of young black students, he was also moving into new creative territory in his own work. Balancing these important responsibilities was no small feat, but Biggers was determined to allow himself time to pursue his creative work. His best teaching was by example.

One of the most important events to occur in the first decades of the Texas Southern art department was its hosting of the annual meeting of the National Conference of

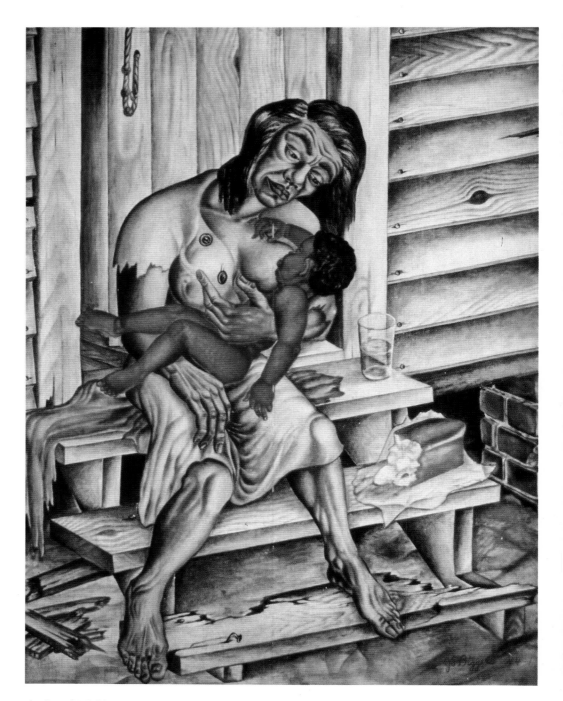

Artists (NCA) in 1965. Organized in 1959, the NCA was the first professional group of black artists to exist on a national scale. Hosting the NCA meeting signaled the department's arrival as a new and vocal component of the black art world, and was a momentous professional milestone for Biggers, Simms, and Mack. Although he had already attracted the attention of the region's mainstream museums, recognition within his own community was for Biggers the true validation of his work as an artist and educator.

Viktor Lowenfeld and Alain Locke attended the conference. Locke, who was still teaching at Howard University, spoke on the importance of cultural heritage, and Lowenfeld delivered the keynote address on art education. Houston had never before witnessed such a prestigious gathering of black artists and educators. Student displays of art, together with performances by music and voice students, demonstrated the success

of the school's program. Very evident in the display of artwork was the philosophy that Biggers had acquired at Hampton and brought to Texas Southern: students should be encouraged to draw upon their African-American cultural heritage rather than look to European history for inspiration.

The treatment of commonplace aspects of black southern life as artistic subject matter was confusing even to many black viewers, who criticized Biggers for encouraging his students to create "depressing" art instead of pleasant still lifes or gentle landscapes. Although this criticism continued for many years, Biggers, Joseph Mack, and Simms were undeterred in their pursuit of African-American cultural awareness. The 1950s were years of immensely painful self-consciousness for blacks, many of whom felt that they had to prove themselves to society at large. The discussion of whether African-American artists should exclusively portray the black experience was not limited to Houston. This dilemma was as old as the Harlem Renaissance and lives on today.

While working to establish the art program at Texas Southern, Biggers was also busy creating murals for various organizations in the Houston community. His work had come to the attention of the Reverend Fred T. Lee, whose late wife, Dora, had been active in the Blue Triangle YWCA, which served the black women of Houston's Third Ward. Reverend Lee wanted a portrait of his wife to hang in the YWCA building in her memory. Biggers, however, convinced Lee that a mural depicting the history of black women in America would be a much greater tribute. He created *The Contribution of Negro Women to American Life and Education* (1952–53; pp. 66-69), a monumental statement of the struggles and achievements of black people as evidenced through their women. The mural was painted during an era in which black history was virtually ignored in public-school textbooks. Many of the women of the Blue Triangle YWCA were teachers, and they often supplemented their history lessons with information about black heroes and heroines.

Biggers's boldly conceived work, which featured such pioneering women as Harriet Tubman and Sojourner Truth, was so powerful that it made some of the refined ladies of the YWCA uncomfortable. The mural's larger-than-life figures told the story of a difficult history, and for many of the women it was too painful to accept.[31] For Biggers, however, *The Contribution of Negro Women* was the watershed work that saw the transformation of his earlier depictions of black men and women into heroic images of struggle and survival. The mural established the foundation for all of his images of black women and their communities that Biggers would create during the next forty years.

In preparing for the mural, Biggers had conducted extensive research into the history of black women in American society. Viktor Lowenfeld was so impressed that he suggested to Biggers that the project was worthy of a doctoral dissertation. Biggers's research and written presentation of the mural made his first major academic statement on the uncelebrated role of black women in American life, and earned his Ph.D. in education at Pennsylvania State University. The documentation of the mural project leaves no doubt that Biggers saw the work as a means by which African Americans could better understand their own history. Biggers intended his mural to inform and inspire its viewers, just as the frescoes of Raphael, Michelangelo, and Leonardo had enlightened a largely illiterate audience in Renaissance Italy.

The earlier *Negro Folkways* murals for the Eliza Johnson Home for the Aged (Fig. 11), completed in 1951, developed in a similar fashion. The owners of the nursing home, Mr. and Mrs. C. A. Dupree, wanted to decorate the large day room where residents received their meals and engaged in various recreational activities. Biggers agreed to create a cycle of murals relating to the seasons of the year and of life. Scenes of harvesting, quilting, logging, and fishing evoked familiar memories in the men and women who lived at the home, many of whom had grown up in rural East Texas. Biggers's murals created an inspirational visual dialogue, with much of their imagery, for example, the scene of children sleeping by the fireplace while women make quilts, reflecting Biggers's own childhood experiences. These genre scenes formed a basis for Biggers's later interpretations of black life.

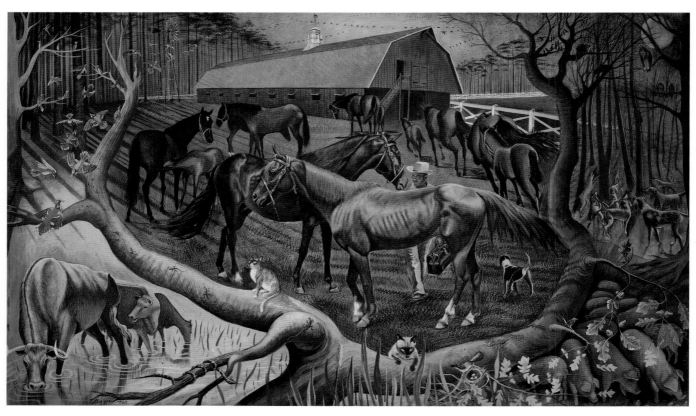

In addition to his work at the YWCA and the Eliza Johnson Home, Biggers also received commissions for murals for the Longshoremen's Association and for Dr. F. B. McWilliams, the first black veterinarian to practice in the city. For Dr. McWilliams's office, Biggers created *Red Barn Farm* (Fig. 13), a pastoral scene filled with animals and rolling countryside.

One of Biggers's most important collaborations at this time was with Vivian Ayers, a poet whom he had known in North Carolina, and then one of the few serious creative writers working in Houston. Biggers made a series of pencil drawings for Ayers's masterpiece *Hawk,* which was nominated for a Pulitzer Prize. He later said that this experience had introduced him to the power of mythology. The hawk in the poem is, in its efforts to fly, an allegory of man's creative spirit. Biggers's drawings for *Hawk,* geometric and abstract in form, demonstrate his ability to convey the energy of the universe. Many of these futuristic designs, filled with rays and arcs of light and dark, would be repeated years later in his critical work *Midnite Hour* (p. 158). For Biggers and Ayers, the collaboration, which lasted several months, represented the spirit of a young, exciting, creative Houston. The courage and determination of these two black artists to break new ground was extraordinary. Ayers recalls with delight their staying awake until 4:00 a.m., matching words with imagery.[32] Their art elevated them beyond the boundaries of segregation into a new arena of creativity.

Biggers's participation in community projects stood well with Dr. Samuel Nabrit, the second president of Texas Southern, who brought an era of humanism to the campus. Trained as a marine biologist, Nabrit had attended Morehouse College in Atlanta and Brown University in Providence, Rhode Island. He recognized Biggers's excellence as a teacher, and he believed that it was important for students to experience such a passionate instructor.[33]

Inspired by the art collection established at Atlanta University by Hale Woodruff, Nabrit built a cultural program, the Lyceum, at TSU, which, under his guidance, brought such renowned performers as classical pianist Phillipa Schuyler and jazz artist Don

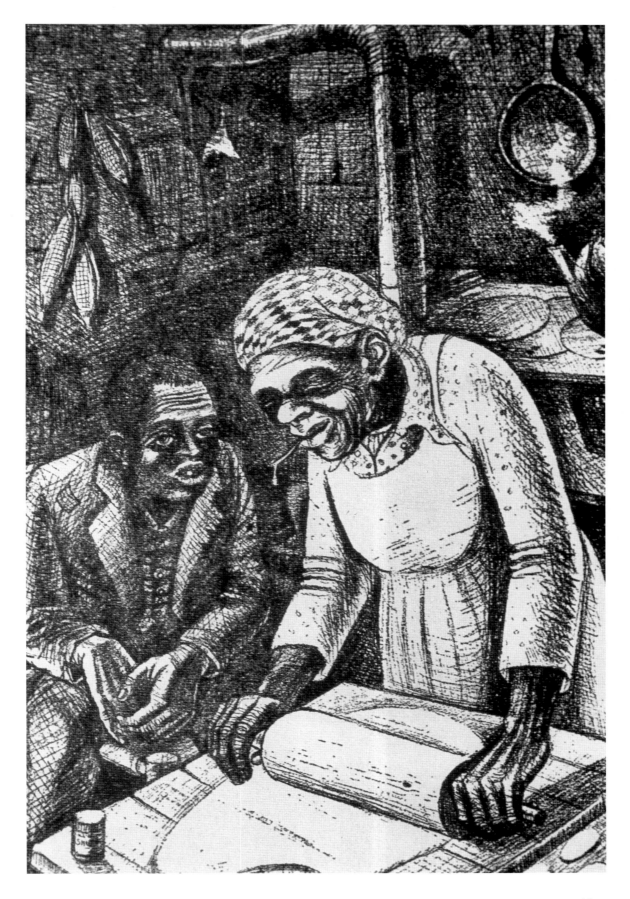

Cherry to campus. It was also a venue for speeches by Dr. Martin Luther King, Jr., Whitney Young, and Thurgood Marshall. Writer Toni Morrison also taught briefly in the English department during these early years.

In addition to the encouragement and assistance of Nabrit and McAshan, Biggers was supported early in his career by John and Dominique de Menil, Houston's now legendary art patrons and political activists. Mrs. de Menil brought Max Ernst to the art department when the famous Surrealist asked to meet Biggers during a visit to Houston, and Biggers presented him with a drawing. Biggers and the de Menils shared a common goal for Houston of a heightened knowledge and awareness of art.

Another notable collaboration occurred in 1956 between Biggers and the Texas folklorist J. Mason Brewer. Brewer collected many of the traditional folk tales found in East Texas. Like Biggers, he was ahead of his time in comprehending the importance in American society of southern black material culture. For a collection of folk tales, Brewer had created a feisty old woman named Aunt Dicy, whose earthy wisdom and spirited personality made her someone to reckon with. Biggers's drawings for Brewer's book *Aunt Dicy Tales* (Fig. 14) evoked the female archetypes in his own community. In his illustration of Aunt Dicy at the polls, Biggers shows her casting her vote while reviewing the political scene. He also created a terra-cotta sculpture of Aunt Dicy. Biggers's collaboration with Brewer continued through the illustration of Brewers's anthology *Dog Ghost and other Texas Negro Folktales* in 1958.

During the 1960s, John and Hazel Biggers traveled to Mexico together with Dr. and Mrs. F. B. McWilliams, where they spent time with Elizabeth Catlett and her second husband Francisco "Pancho" Mora. Biggers was finally able to view firsthand the murals of Rivera, one of his favorite artists. He also saw works by Orozco and Siqueiros, but it was Rivera's interpretation of Mexican peasant life that most impressed the artist. Like Hale Woodruff, who had also traveled to Mexico to study, Biggers was particularly interested in Rivera's use of color and his inclusion of the human body as an architectural element in his compositions.

For Biggers, seeing Rivera's work and its relationship to the artist's Mexican homeland affirmed and underscored his need to continue the art program at Texas Southern University. He believed that students from small rural towns in Texas, Louisiana, Arkansas, and Mississippi should use art as a means of expressing their own cultural heritage.

V. AFRICA: THE POSITIVE SHOCK

John Biggers had long thought about traveling to Africa. Since his days at Lincoln Academy, where he had met African students, and at Hampton Institute, where he had learned to take pride in the rich heritage of African art, Biggers had been eager to learn more about his African antecedents. Such a desire was revolutionary in the mid-1950s. For most Americans, even for blacks, Africa was the Dark Continent, and their image of it had been filtered through the warped lens of Hollywood. As W. E. B. DuBois explained in his 1947 book *The World and Africa,* the nineteenth-century cotton industry's dependence on slavery had led to a long campaign to undervalue African civilization.[34] In the twentieth century, these attitudes were only slowly beginning to change.

In this atmosphere of ignorance and prejudice, it is remarkable that Biggers should want to visit Africa, however, his enlightened interest is at least partly attributable to his education. While still at Hampton, Biggers had begun reading the works of DuBois, who in 1921 had held pan-African conferences in London, Paris, and Brussels, and he was well aware of the global perspective of the gifted actor Paul Robeson, who in 1939 had formed a Council on African Affairs. Encouraged by Viktor Lowenfeld, he had also developed a passionate interest in his own ancestral roots. At Texas Southern University, he was

further encouraged by Dr. Nabrit, who recently had been to Africa on behalf of the school's department of education. Nabrit had seen firsthand the positive energy of the "new" Africa in this period just prior to the decolonization of many West African countries.

Biggers may also have been inspired by the nineteenth-century travels of former Hampton student William Sheppard, who had donated much of the art from the Congo in Hampton's permanent collection. Traveling as a missionary through central Africa, Sheppard had been able to establish a rapport with the Kuba people that white missionaries could not hope to achieve. His extraordinary ability to master African languages and his personal warmth had so impressed one chieftain in the Congo that he had adopted Sheppard as his son and showered him with gifts.

Biggers's combination of global and personal awareness led him to seek a UNESCO fellowship in 1957. He also applied for travel grants from as many foundations as possible. Until this time, very few black artists had traveled to Africa to study. In the late nineteenth century, Henry Ossawa Tanner made an extensive trip to North Africa and the Holy Land. Although Tanner completed sketches and watercolors in Morocco during this journey, these works served primarily as reflections of his interest in early Christianity. He was concerned with Africa as a place of transition for religious groups abandoning the Islamic faith and embracing Christianity. Later, in the United States, some artists of the Harlem Renaissance, including Palmer Hayden and Malvin Gray Johnson, had incorporated images of African art— a Yoruba mask, a Fang ancestral figure—in their own compositions. Other African-American artists, such as Aaron Douglas and Charles Alston, had taken this a step further and, informed by their own connoisseurship and study, developed an intellectual context for the objects and images. Such examinations, however, could not fully represent a living African culture. Of all these artists, only Tanner had actually been to Africa. It was not until Elton Fax published his book *West African Vignettes* in 1960 that an African-American artist was able to relate firsthand impressions of his motherland.

Biggers was awarded a UNESCO fellowship to Africa, and in 1957 he and his wife made the trip. During their months abroad, John and Hazel Biggers traveled to Ghana, Togo, Dahomey (now the Republic of Benin) and Nigeria. Although they had spent considerable time reading in preparation for the journey, they had not anticipated the enormous impact that Africa would have on them. Biggers refers to it as a "positive shock." The vastness of the continent, the warmth of its people, and the vitality of its cultures had not been conveyed to them by anything that they had read in the United States. Biggers felt so inadequate to the task of documenting the richness and complexity of African culture that when he returned to America he waited months before beginning this project.

Biggers's travels began with a search for *maamé,* a word in Akan, one of the principal languages of Ghana, for the Great Mother, the maternal spirit in all things. He found references to *maamé* everywhere, in the shrines to her throughout the countryside, in the women themselves, and in the music of Africa. What struck Biggers almost immediately was how much the continent's people, especially its women, reminded him of the women he had known in Gastonia.

Simultaneously, he encountered African leaders, such as the *Timi* (ruler) of Ede, men of position and stature in their communities, who were respected by people of all ages. To see black men assuming command in this unself-conscious way was a revelation.

During his time in Ghana, Biggers took little interest in the political

Above:
John and Hazel Biggers
in Ghana, 1957

Below:
Elder, Ghana, 1957
Photo by
John Biggers

metamorphosis of the newly independent nation, which was now led by its first president, the charismatic Kwame Nkrumah. It is difficult to imagine how Biggers could have ignored the political shifts that were happening around him, and which so intrigued other African-American travelers, such as Richard Wright. However, Biggers was fascinated by the everyday life of the country, and it was on this that he focused his attention.

Biggers eventually documented the journey in the book *Ananse: The Web of Life in Africa,* published in 1962, which combines eighty-three drawings with text describing the sights and sounds that he encountered there. Ananse, a spider who appears in West African folk tales, is gifted with great intelligence, but he can sometimes be "too smart" for his own good, and his skill in weaving his web is often countered negatively by his greed. Biggers divided his drawings into three separate geographic groups—savannah, forest, and coast—in order to document the aspects of African life that are characteristic of each region. Thus the book is an extraordinary record of the timeless traditions of Ghana's people.[35]

The artist made many friends in Africa. One of the most important of these was the Ghanaian scholar Patrick Hulede, who believed strongly in the preservation of traditional customs. In the company of Hulede, Biggers had the freedom to explore the traditions of daily life in Ghana. He visited yam farms and village marketplaces, and witnessed the great harvest festival, the *durbar,* in southern Ghana. This moving celebration provided the inspiration for *Jubilee: Ghana Harvest Festival* (pp. 126-128), one of Biggers's most beautiful paintings. During the festival Biggers had moved among the celebrants, becoming part of the unified rhythm and energy of the occasion. As the women danced to the beat of the drums and sang in Akan, they had explained to the artist that their song was about the balance of nature, the seasons, the tide, the sun (personified by the king in red and gold), and the moon (personified by the queen in blue and silver). The painting itself vividly captures the excitement and movement of the festival. At the left, drummers move in procession across the village ground, as the king and queen are carried in on great palanquins. In the background, royal figures walk beneath great umbrellas, while the water, always in motion, moves along the coast.

Over the years, Biggers had developed a system of visual icons, embracing familiar objects in the African-American community that conveyed symbolic meaning. Thus, the washpot represents the womb, the source of spiritual waters and rebirth; the scrub board represents a ladder, a symbol of ascension; the anvil represents community organization, and the transformation of natural resources (metals) into tools and weapons. During his travels in West Africa, Biggers developed an additional and related repertoire of African motifs, including the comb, the mask, and others. In *Jubilee: Ghana Harvest Festival,* Biggers expanded his system of symbols to include the umbrella, the drum, and water, and he adopted the cosmic symbolism of the colors red for the sun and blue for the moon.

Biggers's other major painting of the period forms a dramatic contrast to *Jubilee.* In *Kumasi Market* (Fig. 38), an elegant young woman wearing a huge straw hat is seated on a table amid the energetic confusion and dynamic interaction of the marketplace. The market is Biggers's metaphor for humanity at its crossroads, and the woman—beautiful in her serenity, solitude, and poise—symbolizes the purity of the human spirit within a tumultuous universe.

Fishing Village (Fig. 15) embodies the energy and order of African life. The village, with

Fig. 15.
Fishing Village, 1962
(Cat. no. 70)

Opposite: Fig. 16.
Ashanti Architecture, 1962
(Cat. no. 71)

48

49

its arching palms and subtly curved mud houses, communicates a sense of calm and grace. With this drawing, Biggers creates a new vision of Africa, challenging the stereotypical images prevalent at the time. His village is an autonomous community, in harmony with nature.

When Biggers visited Ghana, many of the people still lived in self-contained villages in the countryside. Their houses, richly ornamented with traditional Akan motifs, were in effect large-scale sculptures. Biggers's fascination with these raised relief patterns is evident in his drawing *Ashanti Architecture* (Fig. 16).

Every African community expressed a variety of skills. Throughout the country, women were outstanding potters. Several of Biggers's drawings for *Ananse* celebrate these women and the vessels that they made to carry water, store foodstuffs, and transport goods to market. Along the coast of both Nigeria and Ghana, fishermen defined the culture. The carved and painted boats that lined the shore, adorned with symbols to protect against the dangers of the sea, became another important subject for the artist. Biggers also discovered that, similarly, shrines were built in the yam fields as a precaution against drought, pestilence, and other threats. Having grown up in a community where families cultivated crops and raised livestock in their own backyards, Biggers was especially sensitive to the visual rituals that surrounded the growing and harvesting of food.

In West Africa, musicians are highly regarded because they carry on the traditions of oral history through music. Drummers and vocalists are central to ceremonies incorporating art, costume, music, and dance, and throughout his travels, Biggers was deeply affected by the strong polyrhythmic drummers. His tribute to African drumming traditions, *Drummers of Ede* (Fig. 17), a drawing in conté crayon, depicts men of intelligence, energy, and artistry reveling in their skills.

Traditional African society emphasizes the authority of the elders, especially the women, within a family clan. The older women are responsible for training young girls in the traditions of their culture. In her book *Radiance from the Waters,* Sylvia Boone describes the qualities that a young girl must attain before she can enter adulthood as a productive woman in her village.[36] The nobility of the elders is eloquently depicted by Biggers in his archetypal portrait, *Before the Shrine* (Fig. 18; also known as *Queen Mother*). In it, an older woman, her erect posture emphasizing her personal strength and dignity, is shown standing with a young child. One senses immediately that the child will be trained properly and thoroughly, and that she, too, will grow into a woman of character and substance.

When Biggers returned from Africa he experienced another culture shock. Much of what he and Hazel had seen and learned was totally unknown, and almost inexplicable, at home. Most of Biggers's colleagues had no appreciation of African culture, nor could they understand the diversity of the continent's newly independent countries. Africa, for the most part, was still covered by its colonialist shroud of mystery. To communicate his overwhelmingly positive and life-changing experience, Biggers turned to his drawings, notes, and diaries. *Ananse: The Web of Life in Africa* became his voice amid the confusion and the refusal among American blacks to look to Africa for a sense of their identity. By sharing his own experiences, Biggers enabled many curious African Americans to gain new insights into their motherland.

Biggers was initially overwhelmed by the task. Working in a still-segregated city, the artist was challenged to create works that would slowly, quietly, and steadily draw in the viewer. The large scale of Biggers's drawings allowed them to be seen by several people simultaneously, and thus encouraged public discussion. Biggers's style at this time, as evident in the *Ananse* drawings, was still naturalistic. In a fundamental way, however, these works differ from the artist's earlier representations of people working the land, where the figures often convey a sense of burden or ordeal. In the African drawings, there is a new feeling of spiritual connection with the earth. Above all in these drawings, Biggers's lyrical use of line, combined with veils of crosshatching or richly constructed areas of darkness, imparts an elegance and importance to even the most humble object. By adopting this poetic but naturalistic style, Biggers made his scenes of African life almost universally accessible.

One of Biggers's wisest decisions was to integrate the narrative text for *Ananse* with the drawings. The text is an intimate journal of exploration and discovery, combining exciting public events with deeply personal experiences, revelations, and newly discovered connections to the past. Biggers apparently made few changes to the notes he composed in West Africa.

Ananse introduced Biggers to Frank Wardlaw, the dynamic editor of the University of Texas Press, who served as editor for the book. A southern intellectual who was quick to recognize Biggers's contributions to Texas life, Wardlaw had written the biographical essay for Alwyn Barr's book *Texans Then and Now,* and had also edited *Black Leaders: Texans for Their Times,* published in 1978. Through Wardlaw, Biggers received a commission from *Reader's Digest* in 1966 to illustrate Pearl Buck's *The Good Earth.* With the release of *Ananse* in 1962, Biggers became, after Elton Fax, the second African-American artist in history to publish his impressions of his motherland. The book propelled Texas Southern University and the University of Texas to the forefront of documenting the African diaspora.

Ananse helped to replace Hollywood's concoctions of the "Dark Continent" in American thinking with realistic images of African life. Because the book was printed by a university press, however, it did not benefit from a major commercial distribution. Instead, it became known by word of mouth, its images and narratives moving gradually through the consciousness of black America. Since the publication of the book coincided with the advent of the civil rights movement, *Ananse* became a means by which African Americans learned about, and took pride in, their heritage and armed themselves for cultural battle. For young black intellectuals, *Ananse* represented the promise of a homeland.

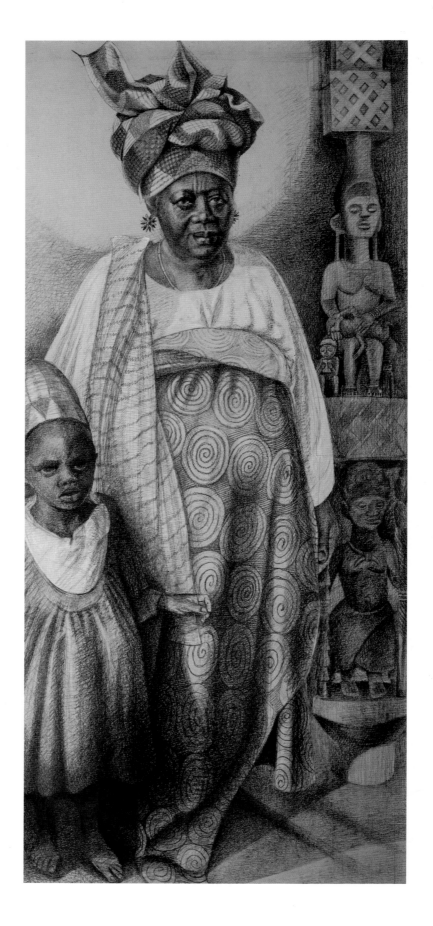

Fig. 18.
Before the Shrine
(Queen Mother), 1962
(Cat. no. 65)

For a new generation of black artists—including Tom Feelings, Paul Goodnight, and Jeff Donaldson—Biggers's work signified a new direction in black creativity.

Arriving like a magnificent and unexpected gift, *Ananse* helped elevate the collective black consciousness to a new and higher level of self-awareness.

VI. METAMORPHOSIS

After his journey to West Africa, John Biggers returned to Houston with a heightened awareness of his cultural origins. In this, he bore the burden of a man ahead of his time, very often in solitude. The civil rights movement was changing the thinking of the black community, and art sometimes seemed peripheral to the daily struggle. Students at Texas Southern, who regarded Biggers as an enlightened spokesperson, sometimes coopted his prestige for political causes that he had not always actually endorsed. At the same time, Biggers's emphasis on Africa was not resting well with the more conservative faculty members.

In the spring of 1967 a major eruption occurred on the campus of Texas Southern University. White male students from the University of Houston had developed the habit of speeding down Wheeler Street, the main thoroughfare that bisected TSU's campus, shouting insults at black female students. Hoping to put an end to the abuse, TSU students had unsuccessfully petitioned for the street to be closed to public traffic. Frustrated by the unresponsiveness of the city government, and inspired by the activism of groups such as the Student Nonviolent Coordinating Committee (SNCC), a number of students were determined to address the situation through some sort of demonstration. Eventually they decided to retaliate. On the evening of May 16, when the UH students began their regular invasion, hurling unseemly remarks at TSU's women students, male TSU students responded by throwing rocks, bottles, and virtually anything else at hand. In response, the Houston Police Department, under the direction of Chief Herman Short, stormed the campus. The result was havoc. Later that night, male students were indiscriminately forced from their dormitory beds and made to lie outside on the cold ground while police ransacked their rooms. Claiming to be searching for weapons, HPD offices destroyed personal property and dumped clothing out of windows. Even the house-mother of the upperclassmen's dormitory was forced to lie outside on the ground. Many students were arrested and taken to the police station. This outrageous mistreatment of the TSU students led to a congressional hearing, at which Biggers and other members of the TSU faculty testified.[37]

The police department's destruction of student property was carefully documented at the hearing. One student testified that his grandfather's pocket watch, his only remembrance, had been deliberately smashed by a sadistic police officer. Other students displayed wounds that they had received from an attack by police dogs. Chief Short claimed that the officers were simply responding to the report of a riot on the campus. The students and faculty replied that the actions of the officers violated the civil rights of all students. Although the police were not disciplined for the attack, soon after the hearings Wheeler Avenue was permanently closed to through traffic on campus.

As the civil rights movement developed, Biggers continued to teach the fundamentals of drawing, printmaking, and painting, especially mural painting, and the murals created by his students increasingly reflected the movement's struggles. The growth of this new black sensibility is chronicled in Hannah Hall, TSU's main administration building. On the second floor, the earliest murals embody the philosophy of engendering change through education. There are images of black students paying their college tuition with livestock or produce, young black scientists working toward discoveries that would make positive social changes, and black families saying grace at the dinner table. On the third floor, however, the mood shifts, revealing a dramatic change in consciousness. With the

advent of the 1960s—riots, marches, and the leadership of Martin Luther King, Malcolm X, and others —the struggle of the average black person became the premier subject for the murals.

Biggers encouraged his students to express the serious issues that were on their minds. As a result, talented students such as Bennie Settles, Edward Mills, and Bert Samples created murals dealing with a broad range of issues, from the universal to the political to the personal. Some faculty began to complain that Biggers was allowing his students too much liberty in their work. To some, the subject matter of the murals was too raw, too violent, too political, and too black. Some thought that the kind of painting that Biggers taught was too depressing. Why couldn't the students paint pleasant and colorful subjects for the hallways of the administration building? Who wanted to see a child being eaten by rats or a man being lynched and beaten? Biggers, however, recalled his own cathartic experience when as a student he had painted *Dying Soldier*. He was convinced that freedom of expression was crucial for his students, who were living through tumultuous social changes.

At Texas Southern, as on any campus, there were many student factions. In the art department, some wanted to learn more than the Afrocentric curriculum that Biggers taught. They felt that they were missing instruction in the mainstream of modern art that they might have received at a major art school. Others, believing that art should be derived from personal experiences, fully endorsed Biggers's philosophy. Despite his detractors, Biggers continued to gain accolades for the university. Many of his students had become practicing artists themselves. Others were highly respected art teachers, who had begun to send their own students to Texas Southern.

Susan McAshan saw that the Texas Southern art department was making a huge impact not only on campus, but also on the larger Houston community. She began compiling a photo-archive of art produced at the school, including murals by Biggers's students. In 1974 she commissioned John Biggers, Carroll Simms, and John Edward Weems to write *Black Art in Houston,* a book that would chronicle the history of the department, and would preserve both in image and in print the contributions of the TSU art faculty and students.

During the spring of 1971, however, a catastrophe occurred. To make way for a new computer system, one of the walls on the second floor of Hannah Hall, on which there were murals by Oliver Parsons and several other former students, was ordered torn down. Word of this reached Biggers only when one of his students, Earlie Hudnall, raced across campus to report that the wall was crashing down. By the time Biggers arrived on the scene, Parsons's mural had been totally destroyed, and the others were badly damaged. Biggers rushed to the office of the president of the university to protest what had happened.

The destruction of the murals led to a major uproar on and off campus. The incident was discussed in the newspapers, and prominent local artists such as Jean Lacy expressed their outrage at the loss. For Biggers, seeing black people destroy the creations of their own artists was shocking, especially when these works were valued and supported by whites like Susan McAshan. The fact that students had been ordered to help destroy art created by their colleagues seemed a particularly grotesque twist. Fortunately, however, the destroyed murals were documented, for Mrs. McAshan had already commissioned photographs of them. The following summer, Oliver Parsons, who was then teaching in Phoenix, returned to Houston to reconstruct his mural from its documentary photograph.

The destruction of the Hannah Hall murals was particularly painful to Biggers because it reminded him that his vision was not universally shared. Emotional regrouping was no simple matter; years of alcohol abuse, coupled with depression over what had happened at TSU, led to a two-year illness. During this time Biggers was unable to create art; instead he focused his energies on preserving his department.

In 1974, the Museum of Fine Arts, Houston presented the traveling exhibition *African Art of the Dogon: The Lester Wunderman Collection.* The show awakened Biggers once again

to the richness of West African culture. In the presence of the figures of the Hommos and Tellem, the primordial ancestral couple, and surrounded by the magnificence of Dogon architecture and philosophy, Biggers felt revived. He began to study the art and culture of Africa in earnest again.

Shortly after the Dogon exhibition, Biggers was asked by students to create a mural for TSU's newly built Sterling Student Life Center. This invitation meant a great deal to the artist. He began his work on *Family Unity* (1974–1977) with a series of preparatory drawings, the most powerful of which is the monumental *Metamorphosis—Birth and Rebirth* (p. 121), an explosive conté crayon drawing of a couple united in their own creative energy. In this drawing, Biggers redefined his approach to the human form. Inspired by his recent study of Dogon art, he adopted an abstract sculptural style that contrasted strongly with the narrative linearity of his earlier work.

In *Family Unity*, and also in *Quilting Party* (1981; pp. 122-125), a mural commissioned by the McAshan Foundation for the City of Houston Music Hall, Biggers began to develop a new visual vocabulary. *Family Unity* brings together many of the elements that Biggers had explored throughout his career, but the work also reveals the forceful impact of African art. The couple in the center of the composition is an extension of the Dogon-inspired drawing *Metamorphosis—Birth and Rebirth*. Old symbols take on new meanings as the shotgun house is transformed into a temple. At the base of the mural, a two-headed crocodile moves the entire spectrum of black culture across primordial waters. In this work, Biggers begins to distill the essence of his experiences in Gastonia, in Virginia, in Pennsylvania, in Texas and in Africa.

In *Quilting Party*, the great ceremonial events of African culture, as depicted in *Jubilee: Ghana Harvest Festival,* here become a point of departure. The emblems of pageantry employed in this work represent the continuity of an ancient and majestic culture. In each generation, there is a new expression of the essence of the old, a new permutation of the original configuration, a new ascension from the foundation into the upper arena of the unknown, the pure. The xylophone in the center of the composition, which recalls an African balaphon, becomes a heaven-borne vessel, energized by the force of tradition and the power of a communal energy.

In 1986 Biggers was approached by Sally Sprout, corporate curator at Transco Art Gallery in Houston, who wanted to organize a major exhibition of his paintings and drawings. This exhibition gave Biggers an opportunity to express his regained energy in new works. It was his first major solo exhibition since his retirement from teaching in 1983, and it signified a turning point in his career. For it, he created a series of startlingly complex paintings and drawings, including *Wheel in Wheel* (Fig. 19), *Climbing Higher Mountains* (Fig. 20), and *Starry Crown* (p.144). In these works, Biggers seems to have rediscovered the sheer joy of painting. Although he invoked the Renaissance-like jewel tones of *Jubilee: Ghana Harvest Festival* and *Kumasi Market*, in his treatment of the human figure Biggers now sought to paint as African sculptors carve, reducing every three-dimensional form to its essence and eliminating all incidental detail.

While working on these paintings, Biggers also embarked upon a vast program of study, immersing himself in the writings of Schwaller de Lubicz, Ivan Van Sertima, Cheikh Anta Diop, and other scholars of African culture and the African diaspora. With ample time to paint and draw, he was able to reach deeply into his own consciousness to create new imagery. Patricia Johnson, the art critic for the *Houston Chronicle,* who had reviewed Biggers's accomplishments over the years, recognized this new body of work as a breakthrough, noting particularly the artist's immense reservoir of images. These majestic paintings were not part of any movement in American art during the 1980s. Their vision was entirely Biggers's own.

In the painting *Starry Crown,* as in the mural *Family Unity,* Biggers continued to explore the meaning of cultural symbols. The three women in the painting, reminiscent of the figures in Biggers's monumental work *Three Quilters* of 1952 (Fig.21), now repre-

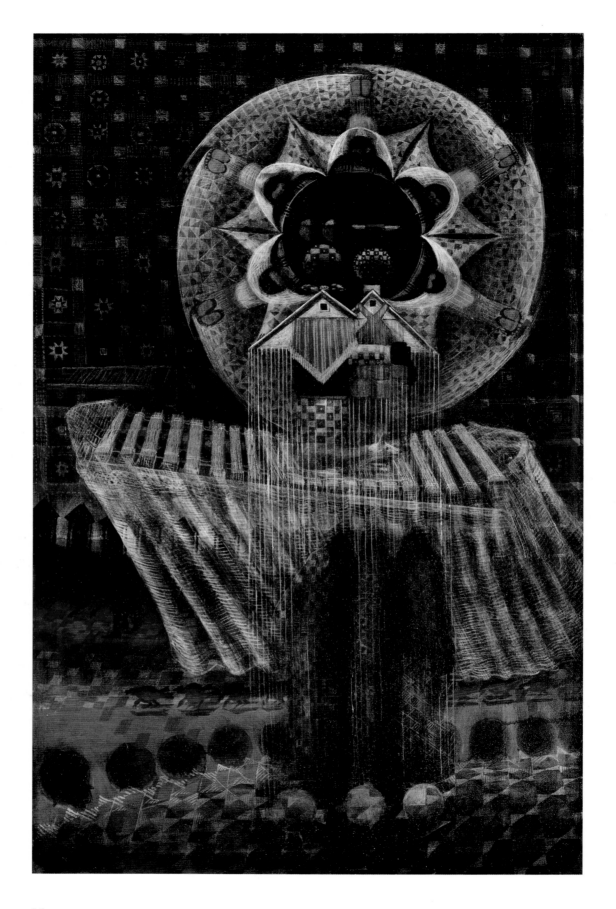

56

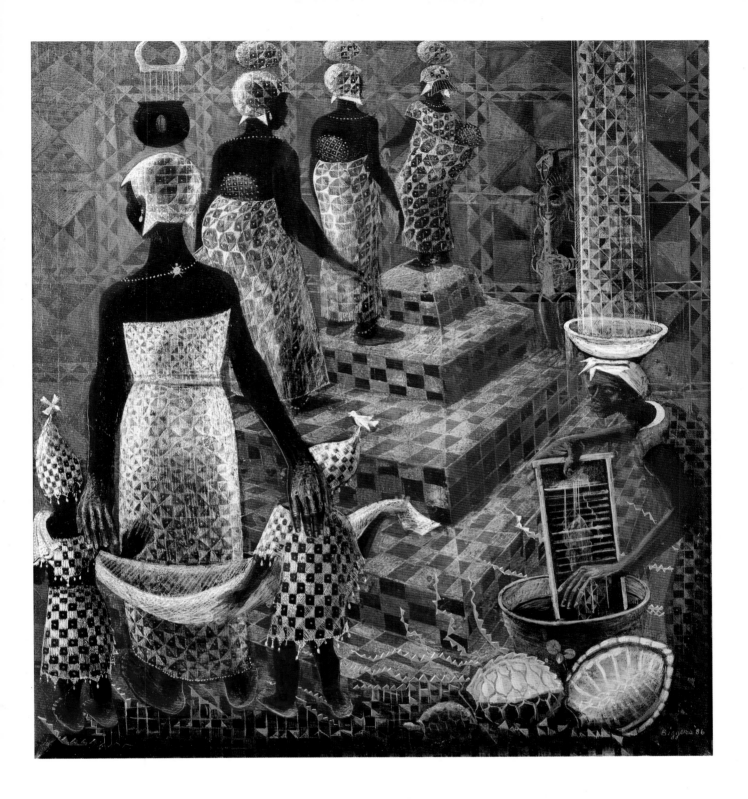

Opposite: Fig. 19.
Wheel in Wheel, 1986
(Cat. no. 115)

Above: Fig. 20.
Climbing Higher Mountains,
1986 (Cat. no. 112)

sent the African civilizations of Egypt, Benin, and the Dogon. The women wear crowns symbolizing these civilizations, and together they create a cloth based upon the sacred geometry that has brought order to each culture. The white forms on their laps represent cotton and light, both symbols of cultural development. Their regal bearing expresses a unity of purpose: these women are not simply making a quilt, they are creating a culture. In the work *Wheel in Wheel*, a similar larger-than-life energy is expressed. The wheel, in its mobility and its pure geometric form, denotes eternal movement and spiritual progress. This symbolism is emphasized by the allusion to the heavens in the setting of the wheel against the indigo night sky.

During this period, Biggers expanded his repertory of symbolic imagery and also reinvestigated the symbols that he had explored throughout his long career. In particular, he returned to the shotgun house, an everyday image that Biggers now elevated to the status of the sacred and eternal. His rediscovery of this symbol was inspired by a commission that he received in 1980. He was asked by the Harris County Commissioners to create a mural based on the life of Christia V. Adair, the first executive secretary of the NAACP and a longtime civil rights activist.[38] Biggers visited her at her home in the Third Ward and made some preliminary sketches of houses in the neighborhood. He wanted to convey the heroism of her life and the magnitude of the responsibilities that had rested upon her shoulders.

The shotgun house, as documented by John Vlach, has a long history in the South. The origins of these structures can be traced to the Caribbean and West Africa. Now rapidly disappearing from black communities, the shotgun house has been used by many black artists—including Jacob Lawrence—as a symbol of black culture. The traditional assumption is that the house was designed to allow the circulation of air from front to back. In fact, shotgun houses in Houston, New Orleans, Montgomery, Augusta, and Savannah also fostered black communal life and culture. Their porches were an ideal meeting ground for the exchange of neighborhood news.

In Biggers's painting *Shotguns, Third Ward* (Fig. 22), the figures on the porches serve as symbols of this culture. Moreover, Biggers transforms the houses themselves into an abstract interconnected pattern that moves across the picture plane, and seemingly, into infinity. This transformation is first seen in the Christia V. Adair mural, completed in 1983, where the movement of the composition ascends through pyramidal patterns formed by the shotguns' peaked roofs upward from the horizon.

The theme of ascension reappears in *Song of the Drinking Gourd* (completed in 1987), a mural on an exterior wall of the Tom Bass Park Multi-Service Center in Houston. Biggers worked closely with James Marshall, the architect of the building, to achieve complete harmony between the painting and its setting. The mural embodies Biggers's study of the creative systems of the universe, with plant and animal forms set against an abstracted cosmos. Rabbits, turtles, fish, and other animals at the base of the mural represent earth and water. Above them rise male and female forms representing the opposing and yet complementary forces of nature. Over the male figure rises the sun, or fire, and above the female figure rises the moon, or water, while giant African combs fill the background. In the center a constellation of gourds represents the Big Dipper, a reference to the spiritual "Follow the Drinking Gourd," in which African Americans escape to freedom by following that constellation. Thus, freedom is dependent upon an awareness of the larger universe.

Biggers also painted murals in other parts of Texas and the South. In Paris, Texas, he was commissioned by the local library to create a work for its new building. *East Texas Patchwork, Paris, Texas* (also completed in 1987; pp. 70-72), is a celebration of the incredible patterns and color permutations possible in quilts. Another important commission came from Winston-Salem Delta Fine Arts, Inc., in the artist's home state of North Carolina. He was asked to create *Origins* (p. 153) and *Ascension* (p. 152), two murals for the library at Winston-Salem State University. President William Harvey of Hampton

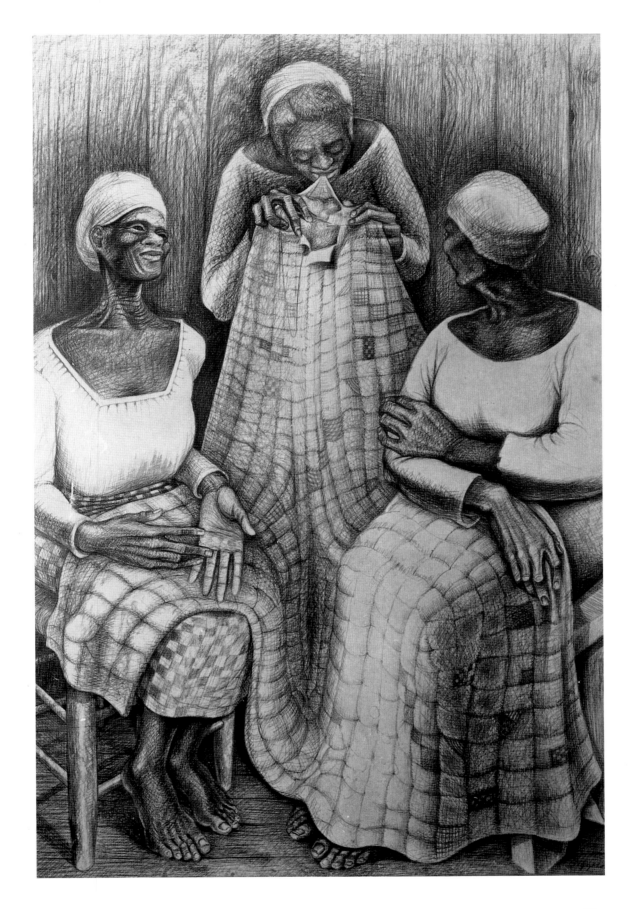

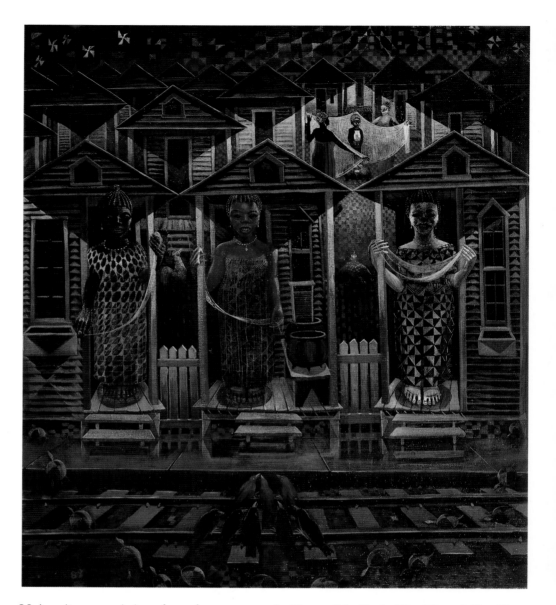

Fig. 22.
Shotguns, Third Ward, 1987
(Cat. no. 105)

University commissioned another two murals, *House of the Turtle* (Fig. 25) and *Tree House* (Fig. 23), for the school's library. Biggers worked on the Hampton murals simultaneously, and he and Hazel moved back to the campus for a year so that he could complete the works. Both of these major projects were completed in 1991.

The Winston-Salem murals depict the story of African culture, from its beginnings in ancient Egypt to its passage through the diaspora into the New World. The railroad track and shotgun houses symbolize the transportation and transformation that allowed African culture to survive in the New World. In developing this work, Biggers had the wonderful opportunity to work professionally for the first time with his nephew James Biggers, the son of his brother James, an artist and administrator in the public schools of Gastonia. At first the two artists worked in separate locations and on different areas of the mural; John Biggers developed the lower section in Houston, while James Biggers developed the upper portion in Gastonia.

At Hampton, the challenge was to create murals for the new university library that reflected the history of the university and at the same time projected the importance of African and world mythology. These murals represent the revitalization of the arts that occurred on this historically black campus. That this was where Biggers began his artis-

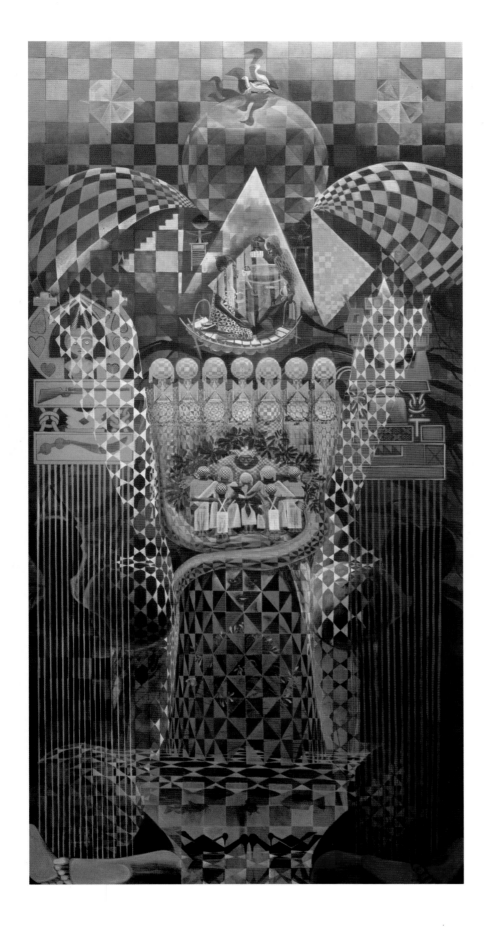

Fig. 23.
Sketch for the mural
Tree House, 1989
(Cat. no. 101)

tic career made the commission all the more meaningful.

As the 1980s progressed, Biggers began to receive widespread public acknowledgment of his many contributions to the arts. He was named Texas Artist of the Year by the Art League of Houston in 1988. In 1989 he was featured in the major traveling exhibition *Black Art—Ancestral Legacy: The African Impulse in African-American Art,* which was presented in Dallas, Atlanta, Milwaukee, and Richmond. Such wide exposure also led to substantial nationwide media attention. In developing a segment for the CBS program "Sunday Morning," the producers decided to focus on Biggers as he was completing the Winston-Salem murals. Independent documentary filmmakers Barbara Forst and Sherri Fisher Staples recorded the entire evolution of the Hampton murals from conception to installation.[39]

Blessed with a broad spectrum of challenging activities to interest him, Biggers continued to develop new themes for his art. He reconsidered the African-American male in light of the positive social changes that had occurred over the years. He began a new series on animals and their attributes, and another on holidays with ancient origins. In these works, as in all his art, Biggers endowed the common components of our everyday existence with new layers of meaning.

VII. Ascension: Weaving the Seventh Word

Through the course of his career as an artist, John Biggers has created what is in effect a visual belief system. Because of the completeness of this system, works created fifty years ago are still rich in meaning today. The artist continually strives to express in his art the spiritual values, cultural traditions, and social structures that historically have defined the African-American community.

The transformation of Biggers's style from the naturalistic to the monumental, first seen in the 1974 drawing *Metamorphosis—Birth and Rebirth* (p. 121), allowed him to explore a deeper level of meaning in his art. The artist's new vocabulary, greatly indebted to his study of African sculpture, rendered his images more elemental and more universal. Thus, while earlier works such as the 1946 painting and 1947 drawing *Old Couple* (Fig. 5 and p. 134) represent a certain moment in one couple's life, in the 1974 drawing *Metamorphosis—Birth and Rebirth* the couple is shown as ageless and timeless.

In his later drawings and paintings, Biggers has continued to reduce forms to their essence and to explore new kinds of symbolism. The monumental naturalism of portraits such as *Man* (p. 139) and *Man Throttled* (p. 161) conveys an overwhelming emotional power. In *King Sarah* (Fig. 26) and *Brother Man,* the geometrized masklike shape of the faces lends a formal structure to the works, but also adds a new layer of meaning. These two works evoke the Yoruba belief that the head is the temple of the body, a concept well documented by Professor Robert Farris Thompson of Yale University. Similarly, the poet Maya Angelou has written about the African ability to speak in "deep talk," a symbolic language with layers of meaning far beneath the surface of the conversation.[40] The new phase of geometrized monumentality in Biggers's art is like a visual "deep talk," suggesting the transcendent truths beyond appearances.

Biggers's trip to Africa in 1957 changed his life and his art in fundamental ways. Because of it, he embarked on a lifelong study of the continent's cultures, integrating into his work many of the concepts of African tradition and philosophy. Today, Biggers continues to pay homage to African art while exploring the human themes that have always concerned him.

The black woman, and the mother and child in particular, has always been central to Biggers's art. He originally explored this theme by documenting the women of Gastonia in such early works as *Mother and Child* (Fig. 12) and *The Cradle* (Fig. 9), which depict

Fig. 24.
Study for the mural
Christia Adair, 1983
(Cat. no. 96)

the immense responsibility of motherhood. Later, the African woman came to represent the continuation of tradition in society. Biggers ultimately found in the black woman/mother a symbol of cosmic energy, traditional knowledge, and creative power.

Biggers has collected numerous maternity figures from throughout Africa. His fascination with these works is both analytical and emotional. The placement of a child or children in proximity to the mother, the direction in which they look, and the way they are connected through touch and gesture to the mother all reveal a coded language to the artist. Equally important are the seating of the maternal figure on a chair or stool, the placement of her legs and arms, her adornment, and the geometrization of her hairstyle. To Biggers, the woman's body is a temple, and her child or children are the offspring of her energy and wisdom. Biggers traces this sacred maternal figure to ancient Egypt, where the lap of Isis served as a throne for the young pharaohs. Thus, his mother figures represent the passing on of cultural knowledge through maternal wisdom.

Biggers has also developed symbols from the animal kingdom to represent the fundamental order of the universe. He associates the turtle, the crocodile, and the serpent with the antiquity of the earth, and he uses these creatures to embody the primeval and mysterious beginnings of life. In works such as *Family Unity*, where the composition rests on a two-headed crocodile, the underlying message is that despite all of our technological advances, we have not altered the inherent structure of the natural world, and we must still respect the ancient animal powers. The industrious spider of *Ananse* symbolizes the development of universal order, while other animals, including the cow, the horse, the chicken, the rooster, and the pig, represent domestication.

Biggers adopted symbols of endurance and order in the African-American community early in his career. Ordinary objects, such as the anvil, the iron pot, the washboard, the railroad, and the shotgun house, all express deeper meanings. For example, the anvil, which is used by the blacksmith—a man with mystical powers in African culture—to transform metal into tools and weapons, is, for Biggers, a male symbol of power and effective change. The iron pot, used for cooking and washing, became for Biggers a symbol for the womb. Rhythmic movement was represented by the washboard. The railroad, which transported black families and black culture from the South to the North, was a symbol of migration and escape. Although it remained a lifeline that connected the old with the new, the railroad was also a symbol of isolation and segregation, dividing the white and the black sections of southern towns. Above all, Biggers continued to use the shotgun house as a symbol of the endurance of traditional black culture. Within its modest confines, generations of black families learned to prevail and to create order.

Over the years, Biggers has become increasingly absorbed in his study of African culture. He began by reading books on African art, which introduced him to the various ethnic groups, such as the Yoruba, the Ife, the Akan, and the Fang, and to their traditional forms of sculpture. His readings ranged from the nineteenth-century examination of ancient cultures in Godfrey Higgins's *Anacalypsis* to the 1981 work by William Erwin

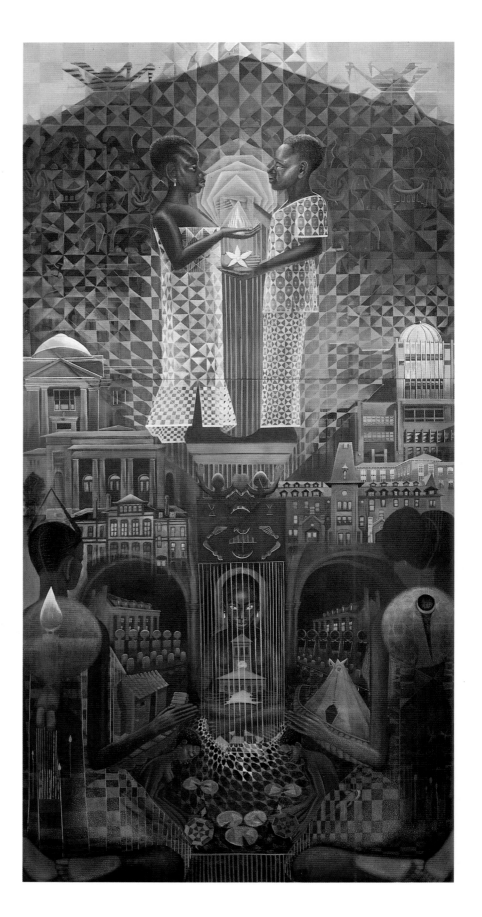

Fig. 25.
Sketch for the mural
House of the Turtle, 1989
(Cat. no. 102)

64

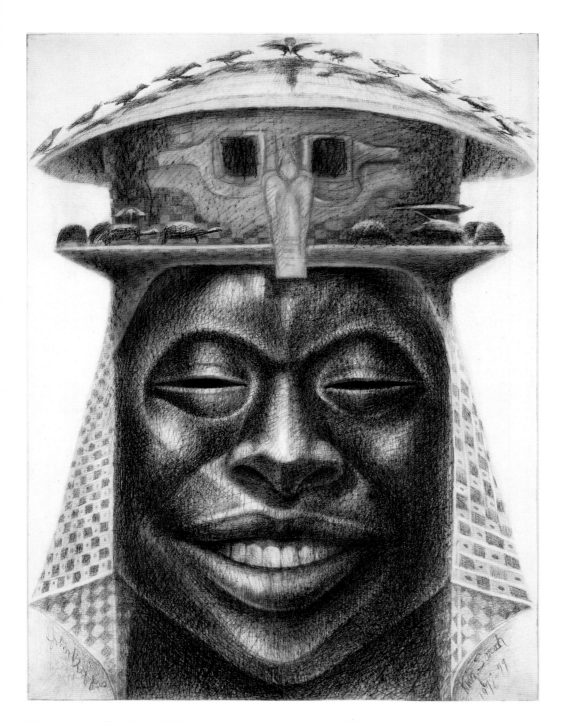

Fig. 26.
King Sarah, 1978–79
(Cat. no. 88)

Thompson, *The Time Falling Bodies Take to Light: Mythology, Sexuality and the Origins of Culture.* In order to understand the deeper meaning and visual symbolism of African art, he has also delved into the writings of a number of scholars of African civilization, particularly Dr. Yosef Ben-Jochannan and Charles Finch, who have examined the cultural and scientific contributions of the Nile valley people to the rest of ancient Africa and the African diaspora.

Much of what Biggers looked for was to be found in the structure of the ancient Egyptian mystery system, a program of education in which the student reached a higher level of enlightenment as he mastered each of four "sciences," mathematics, astrology, medicine, and architecture. Biggers shared his exploration of these ideas with an infor-

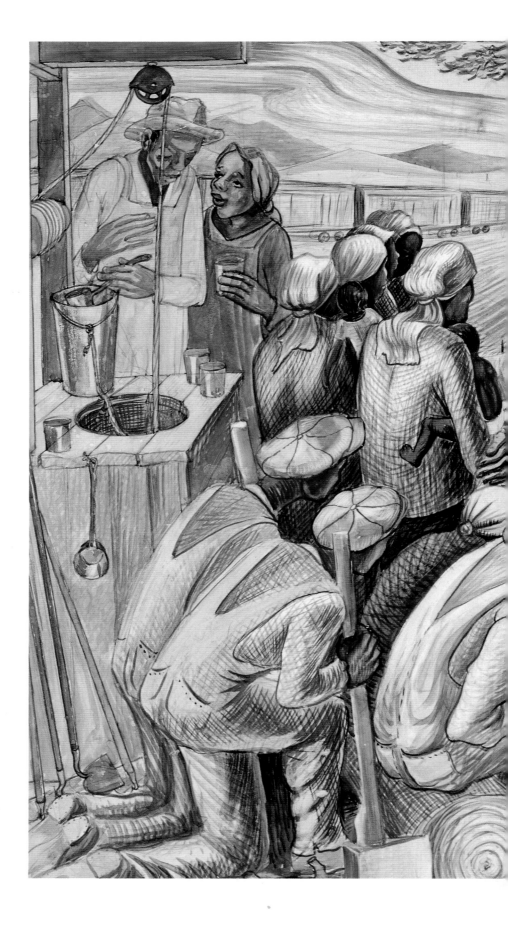

The Contribution of
Negro Women to American Life
and Education, 1952
(Cat. no. 55)

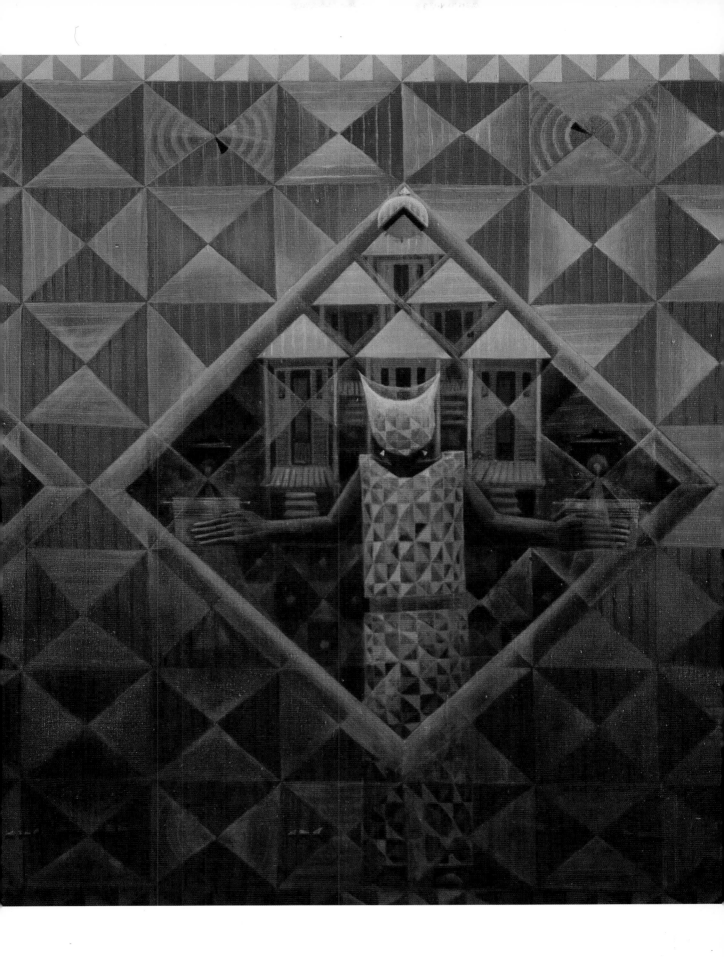

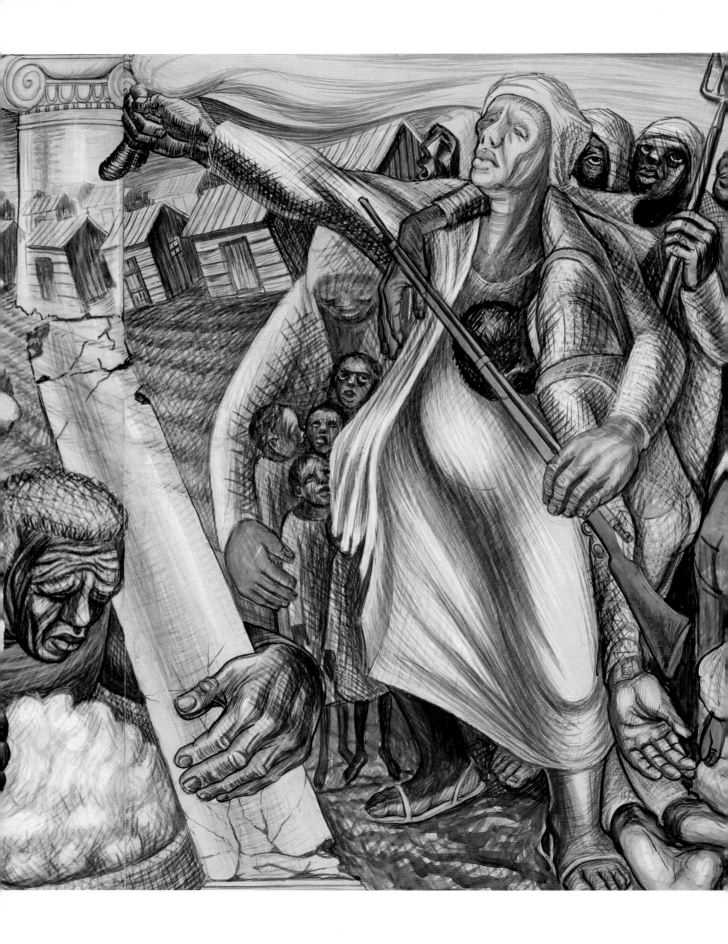

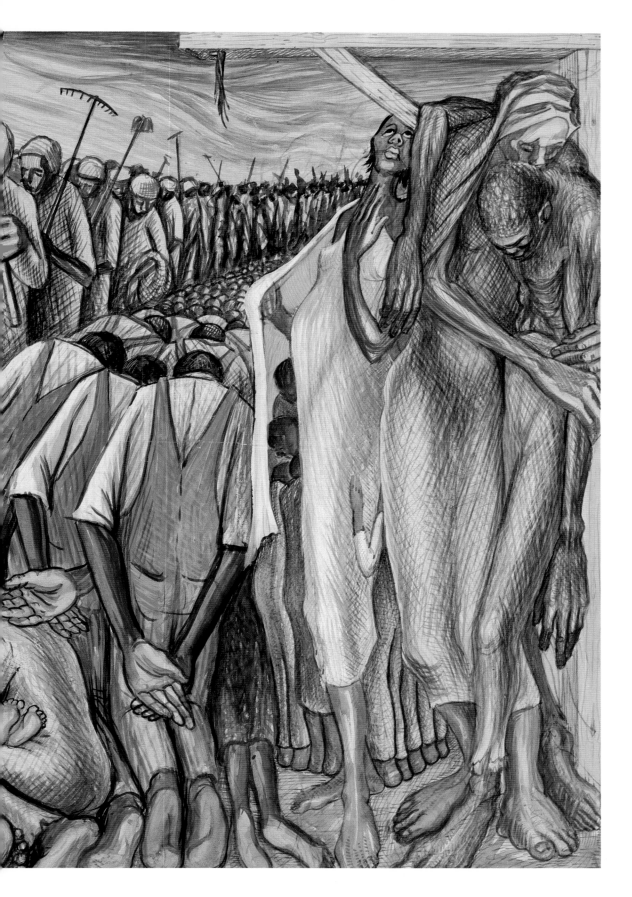

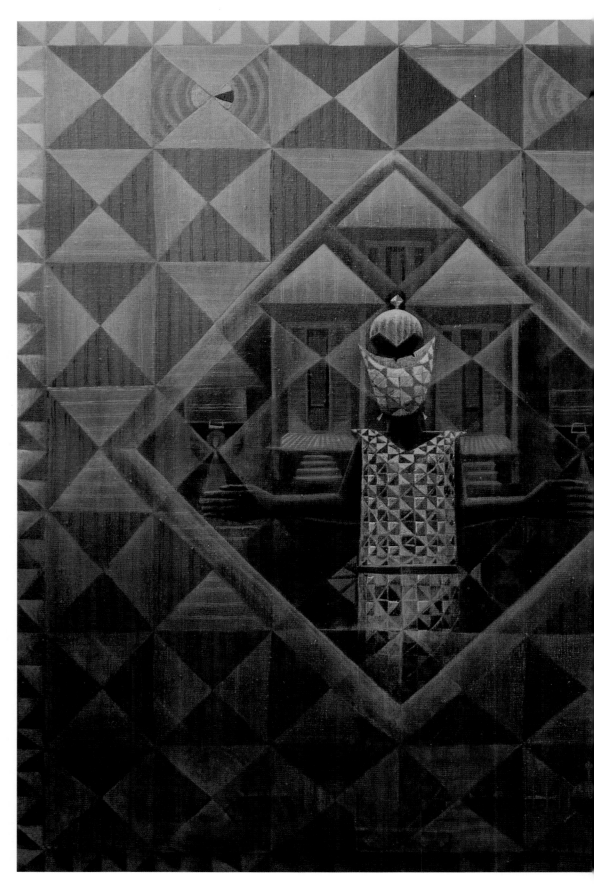

70

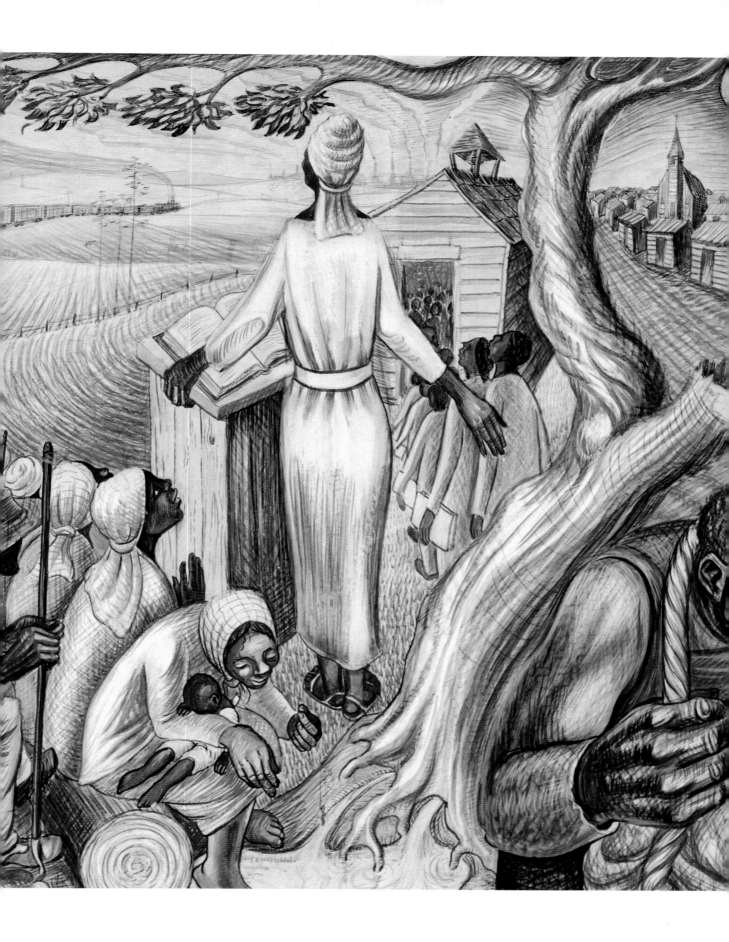

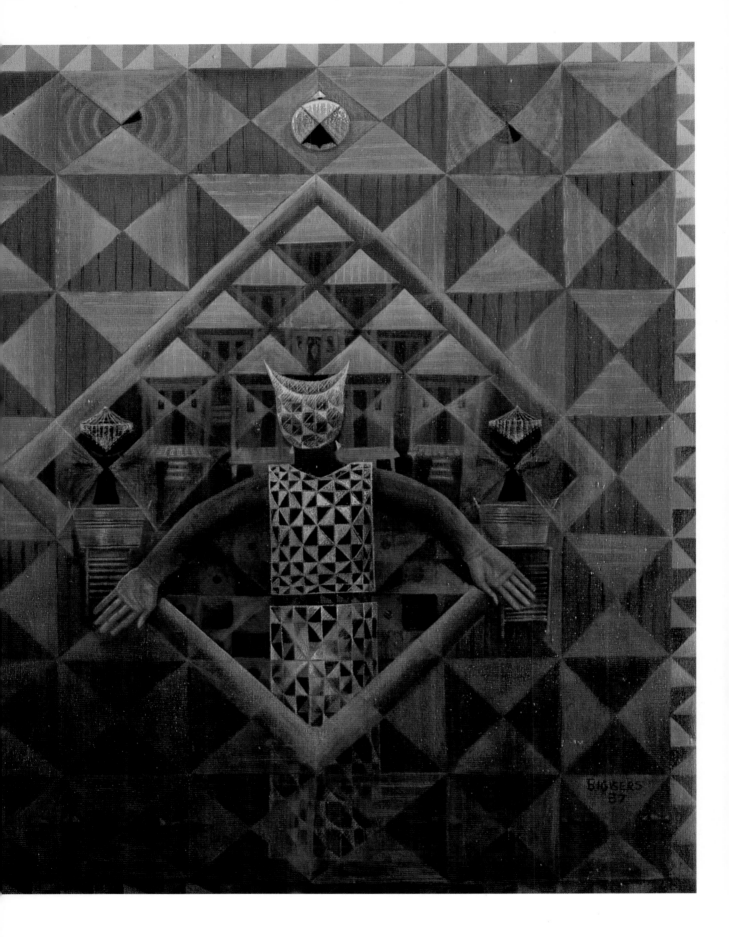

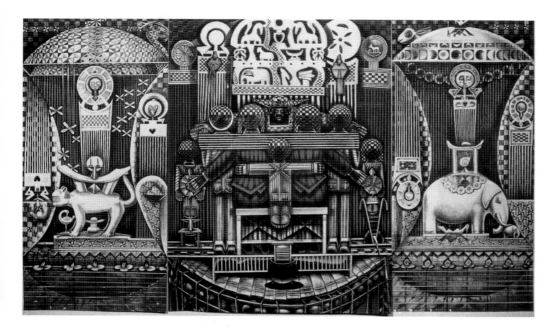

Fig. 27.
Lithograph
Family Arc, 1992
(Cat. no. 120)

*Gatefold, Opposite:
East Texas Patchwork,
Paris Texas, 1986
(Cat. no. 98)*

mal circle of friends, including the artists Harvey Johnson and Jean Lacy, the physicist Robert Powell, the physician Robert Galloway, and others. Conferences such as those sponsored by the Third Eye, a group in Dallas devoted to African studies, provided opportunities to discuss these ideas and to learn more. Ivan Van Sertima, Dr. Naim Akbar, Dr. Yosef Ben-Jochannan, and Biggers himself were often featured as speakers, and African-American art as a source of enlightenment was a lively topic of discussion for all participants. For Biggers, it was an affirmation that his work was valued not simply for its beauty and decorative power, but foremost for its content.

The notion of ascension as a means of enlightenment is essential to Biggers's art. This concept is not yet developed in his earliest work, which expresses the anger and inner turmoil that Biggers felt as a young black man in a racist society. Only after the artist had been to Africa and studied African art and culture was he able to understand and articulate the meaning of spiritual ascension, a concept that receives its first clear expression in the paintings created for the Transco gallery exhibition and in the Winston-Salem State University murals *Origins* and *Ascension*. In the paintings *Wheel in Wheel, Climbing Higher Mountains*, and *Midnite Hour*, men and women transcend their solitary spheres of existence and move toward a recognition of their place within the universe. That recognition is in itself an act of ascension.

Attaining enlightenment is similarly expressed in Dogon cosmic thought. To the Dogon, seven—representing the union of male (three) and female (four)—is the perfect number. The Dogon consider the act of weaving an act of creating language, thus, "weaving the seventh word" signifies the creation of the most perfect language.

Rebirth, another act of transformation, is most clearly represented in the ritual of baptism in water, which occurs in Christian and in ancient African traditions. In African cultures, as in other civilizations, water is associated with power and life. In the *House of the Turtle* mural at Hampton (Fig. 25), and in Biggers's later works, knowledge and institutions literally rise up from the water of life. In *Song of the Drinking Gourd*, waters of renewal pour down upon a civilization. The green water is the source of life, the home of the crocodile and the turtle, a place where humans can no longer dwell but to which they must return for nourishment. Just as the waters of the womb serve as the first home in each human life, this reconnection with water signifies a return to one's pure beginnings.

John Biggers returned to his own beginnings by moving back to Gastonia in 1989. In this small community he sees echoes of the great traditions of African society. For

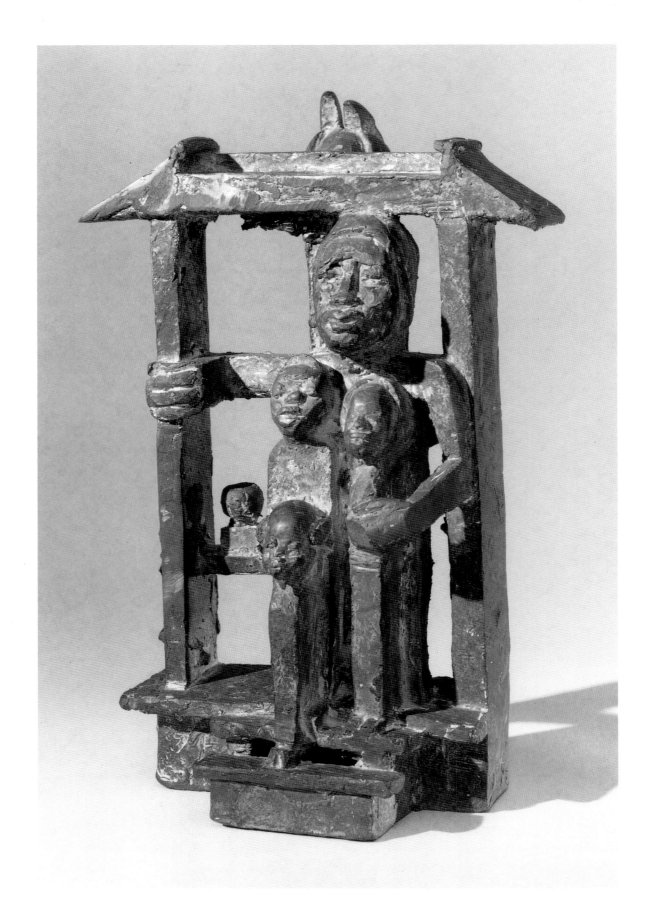

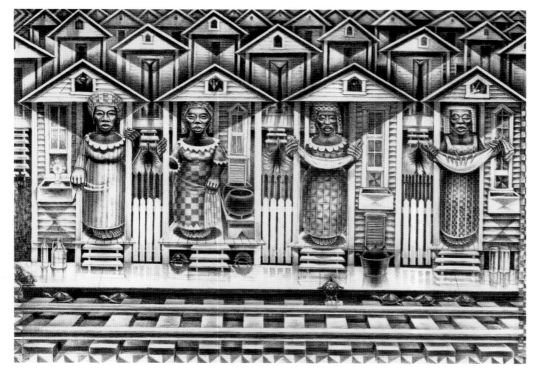

example, he finds in the builder Jethro Mann, a childhood friend, the same understanding of man's humanistic relationship to science as Schwaller de Lubicz's work, *The Temple of Man,* describes in African craftsmen. Similarly, the organizations of African-American men in Gastonia—the Elks, the Woodsmen, and the Masons—serve the same functions as the men's organizations of Africa, providing support and assistance to their communities in times of need. In both cultures, the women, too, belong to groups, such as the Eastern Star in Gastonia and the Sande Society of the Mende in Africa, that concern themselves with the special responsibilities of being female.

The move back to Gastonia, where he has established a new studio, has made Biggers even more aware of the impact of geography on creativity. In Gastonia the land is rolling and variegated and the changes of the seasons emphatic. Biggers's lithograph *Four Seasons* (1984; Fig. 29) is a reminder of the passage of time in his own life. He has also returned to sculpture, creating in the sculptor John Scott's studio in New Orleans a wonderful bronze of a shotgun house, *Family of Five* (Fig. 28). He also has plans to construct a foundry on the grounds of his Gastonia home. Recently he created for the Brandywine Graphic Workshop in Philadelphia a new print, *Family Arc* (Fig. 27), and was honored by that organization in 1992 for his contribution to the arts.

While he works, Biggers listens to spirituals, to the majestic and plaintive voices of Nina Simone and Aretha Franklin, and to speeches and lectures by great black thinkers. He continues to collaborate with other artists, and in 1994 completed a suite of drawings for the poem "Our Grandmothers," by Maya Angelou.[41] In fact, drawing has become central to Biggers's creative life. When asked about his work, he will quickly say: "It is the drawings that I love to do most."

Like many artists whose careers span several decades, Biggers follows an orderly regime. There is little time for frivolous projects, and everything that he does must relate to his central philosophy of life and creativity. Working in a style that has become increasingly direct, Biggers is ready to explore more levels of meaning in all that he sees around him.

John Biggers: A Perspective
by Edmund Barry Gaither
Director and Curator,
The Museum of the National Center of Afro-American Artists

I n the early decades of this century, as some American artists were struggling to come to grips with the meaning of modernism as promoted by the Armory Show of 1913, and others were casting off the decorum of the nineteenth century by focusing on new immigrants, the city's working poor, and their urban environment, African-American artists were giving a face to black humanity. They were committed to launching a figurative tradition that could accept black physiognomy and celebrate its features. This was a change of immense consequence, one that was to dominate the character of much of the art by African Americans throughout the duration of the century. John Biggers's work is a significant contribution to this distinctive tradition.[1]

Before the "Negro Renaissance" (c. 1920–35), African-American artists produced few works depicting the black physiognomy. Major nineteenth-century figures such as Joshua Johnston (active 1789–1825), Robert Scott Duncanson (1823–1872), Edward Mitchell Bannister (1828–1901), Edmonia Lewis (1845–1909), and Henry Ossawa Tanner (1859–1937) seldom ventured into this arena except under quite specific circumstances. A principle of inverse response to racism seems to have been at play[2] whereby, in order to maximize the possibility of their art being viewed on its own terms, the artists avoided subjects that might invoke race. Thus, when compared to the broad range of themes embraced by nineteenth-century American artists in general, black artists concentrated on more neutral subjects, such as landscape and still life, leaving genre, history, and portraiture relatively unexplored.

Opposite:
Fig. 30.
The Harvesters, 1947
(Cat. no. 47)

Among the many known portraits by Joshua Johnston, there are fewer than four black sitters.[3] Robert Duncanson's *Uncle Tom and Little Eva* (1853), one of his few paintings in which a clearly black figure appears, was produced at the request of James Francis Conover, the abolitionist publisher of the *Detroit Tribune.*[4] The figures in Edmonia Lewis's *Forever Free* (1867–68; Howard University Gallery of Art), a marble sculpture celebrating black emancipation, are at best ambiguous, resembling classicizing stereotypes more than American slaves. And in the case of Henry Ossawa Tanner, the towering giant of nineteenth-century African-American art, a mere handful of black themes are found, beyond the portraits of his parents and of Booker T. Washington (Fig. 31).[5] It is clear that a cardinal difference between nineteenth-century and twentieth-century African-American art is the latter's acceptance of black figure types as appropriate subject matter.

The Negro Renaissance, a manifestation of the creative energy released as blacks forged a new identity, had its catalyst in the collective shedding of a rural, parochial self-image and its replacement by an expanded progressive, urban one. As the rapid and dramatic movements of the black population during World War I led to the development of densely inhabited black cities-within-cities throughout the industrial North and Midwest, the modern, urban black community, with its problems and assets, was born. This newly formed society experienced a strong sense of empowerment as blacks congregated in complex, yet racially monolithic, neighborhoods. Intellectuals, Alain Leroy Locke (1886–1954) foremost among them, regarded this rebirth of the spirit as an opportunity to vanquish certain earlier propositions that dehumanized blacks. Recalling assertions that blacks were subhuman, infantile, overly sensual, and incapable of producing creative work of serious intellectual merit, Locke and other Negro Renaissance proponents saw black artistic production as convincing proof of black humanity, on the principle that art-making is a quintessentially human accomplishment.[6] By bringing black art to the cultural marketplace, Locke and his associates hoped to persuade critics of the black race to see its members as cocreators of a world heritage. In this construct, African

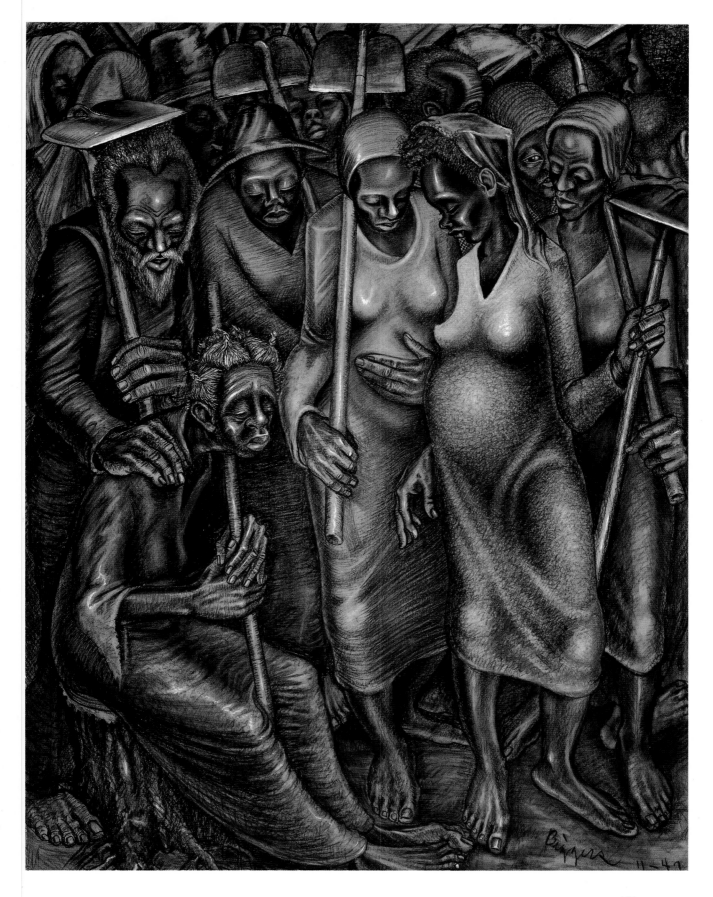

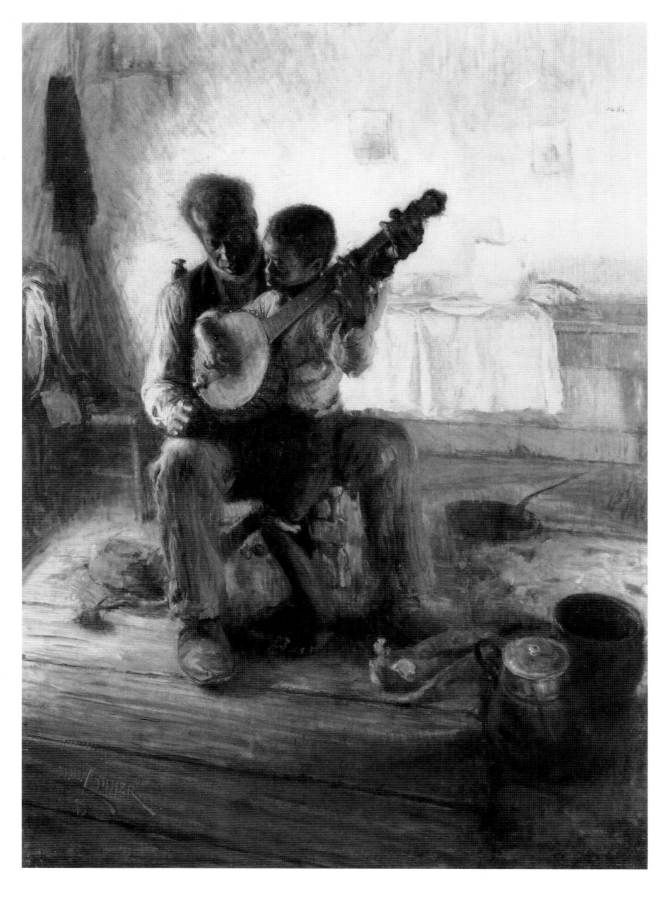

art or old Negro art was the black world's grand tradition. This assertion seemed obvious, given the crucial place of African art in Cubism and, by extension, in the transformation of modern European painting and sculpture. Art thus became a pillar of an essentially ideological argument.

While this argument was advanced on all fronts, including music, dance, theater, and literature, the visual arts had a special role to play. Painters, sculptors, and printmakers were positioned to visualize the "new Negro," to form an image of this new personality with all its complexities and diversities. Locke declared that "the Negro physiognomy must be freshly and objectively conceived on its own patterns if this is ever to be seriously and importantly interpreted."[7] He further insisted that "art must discover and reveal the beauty which prejudice and caricature have overlaid."[8] African-American artists were admonished to create their own iconography, integrating into one system African, Caribbean, southern rural, and northern urban experiences, types, and characterizations. Under this injunction, three distinct imperatives surfaced in the visual arts: reclamation of the African theme as an aspect of racial heritage; sympathetic portrayal of black life using black physiognomy; and integration of Caribbean subject matter as an aspect of global black identity.[9] Decades later, the first two of these directions became vital influences in the work of John Biggers.

If putting a face on the black identity was a pressing mandate, much of its force came from black intellectuals' deep-rooted concern for what was until recently called "racial uplift." This motivation, born of a sense of collective struggle against overwhelming racism, permeated all sectors of the black community, enforcing a sense of inescapable obligation on talented and successful African Americans. Of course, racial uplift, given its strength in and centrality to black life, mediated the form and substance of the new face being created by visual artists. It tended to suppress images suggesting subservient or slavish behavior, as well as the stereotypes of the American media. At the same time, racial uplift encouraged heroic, purposeful representations suggesting enhanced social, cultural, and spiritual wholeness. Many artists regarded giving visualization to these high ideals as their contribution to the restoration of black human personality. Their art, infused with a sense of mission, laid the foundation of modern, positivistic, black figuration. Because the destructive socioeconomic forces impinging on black communities have only slightly lessened over the decades, many socially conscious artists, working explicitly to promote positive racial and cultural values, have continued to play a defining role in African-American art. John Biggers is such an artist.

Locke, whose influence Biggers acknowledges,[10] called for the creation of a "racial" art in 1925.[11] He saw such a manifestation as providing authentic validation of the black creative heritage, while adding a new dimension to American art.[12] Not viewing his call as separatist, Locke felt that black artists could command respect only if they used their own unique heritage as a foundation. Thus grounded, they could bring something new and different to the mix of what Locke regarded as an evolving cultural democracy.

Locke's point of view was directly challenged by his fellow faculty member at Howard University, James Amos Porter. The first art historian to study black art systematically, Porter believed that black artists were simply American artists who had been overlooked and underdiscussed. Locke and Porter came to represent polar opposites in the discussion of African-American art taking place within historically black colleges and universities.[13]

Hampton Institute, whose art program began in 1939, only two years before Biggers's arrival, was drawn into this controversy. Viktor Lowenfeld, who had founded the art department at Hampton and who was himself a displaced Austrian Jew, was sympathetic to the Lockean view of art as a potent force for positive growth and change.[14] This perspective he imparted to the young Biggers, encouraging him to see the potential of art for communication. Lowenfeld also encouraged Biggers to value African art as both his personal legacy and as a world heritage.

During the Works Progress Administration or WPA (1933–1943), the mural became

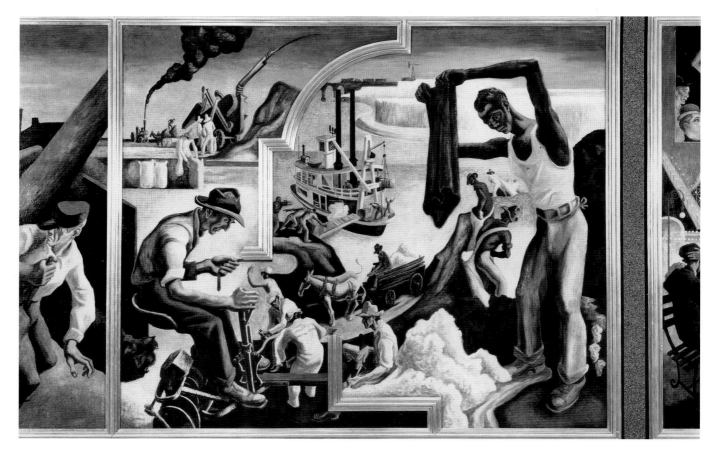

a particularly important form for painters. The mural division of the WPA, charged with commissioning work for public buildings, fostered large-scale art projects across the nation, many of which were less than successful endeavors. Nevertheless, when one thinks of American murals, this decade corresponding with the Depression and the beginning of World War II still quickly comes to mind.

American mural making, of course, had been stimulated by the provocative example of Mexican artists, especially José Clemente Orozco, whose murals at the New School of Social Research had been completed in 1930. Commenting on the impact of Orozco's work, the critic E.P. Richardson noted that their "effect was electric, for here was an art of meaning which at the same time embodied the stylistic discoveries of twentieth-century painting. . . . No one can understand the thirties without remembering the influence of Mexico both on painters of social protest and upon the mural paintings done under the Federal government projects."[15]

Murals of the period generally took one of two directions. Many depicted the American scene, especially the Midwest. These works are associated with Regionalists such as John Steuart Curry, Grant Wood, and Thomas Hart Benton (Fig. 32).

Of these three, Benton was the most prominent. The art historian John McCoubry observed that he "painted on canvases and public walls a heroic pageant of American life. The only style he could find for this undertaking was a supercharged neo-baroque, with tortuous contours and extravagant gestures."[16] Another art historian, Milton Brown, also referring to Benton's approach to murals, said, "It presages the nature of this later ruralism also that in treating these areas his critical irony turns to quaint humor and native mythology, for what he describes of them is not their contemporary life, but their tradition."[17] It is clear that Regionalist artists were creating an American saga that embodied generalized attitudes of patriotism and occasional hints of antiurban sentiment.

The second direction—occurring in but not limited to murals—evidenced a strong

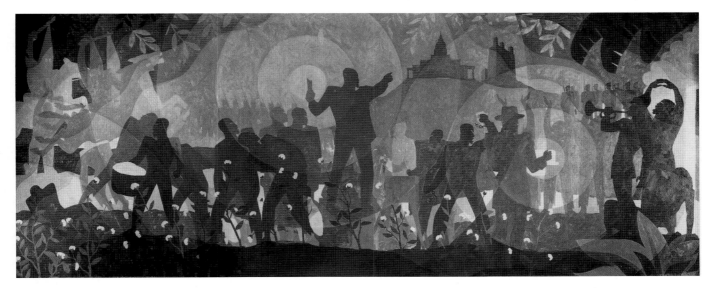

quality of social protest reminiscent of Orozco. Works capturing the perspective of protest artists sought to "reexamine rural and small-town America as well as her urban and industrial life, [and] sharpen its comments on social injustice."[18] This direction was taken by painters such as William Gropper, Ben Shahn, and Robert Gwathmey, who "found in poverty no redeeming poetry but only a condition which debased humanity."[19]

By the early 1940s, interest in murals, whether of the American scene or of social protest, was on the wane, and their painters fell victim to a sharply critical assessment that "if they could have escaped the extreme artistic isolationism which seems now, in retrospect, an unnecessary if understandable part of their philosophy, they might have prolonged the freshness of discovery and escaped the limiting dogma of a regionalism proclaimed for its own sake."[20]

Although the American Regionalist mural movement had declined as an important and defining thrust in American art by the end of World War II, the African-American mural tradition was at that time still in its ascent. For black artists, the mural remained a relevant and lively form, which thrived throughout the 1940s and 1950s in historically black colleges. A decade later, murals regained attention with the creation of Chicago's *Wall of Respect* (1967), a collaborative work depicting African-American heroes, which transformed visual explosions of energy to express inner-city cultural and political feelings.[21]

The African-American mural tradition begins with the work of Aaron Douglas (1899-1979), whose *Aspects of Negro Life* (Fig. 33; Schomburg Center for Research in Black Culture, The New York Public Library) was completed in 1934. These early works, painted in Harlem, use a muted palette and highly stylized figures to narrate black contributions to American life and culture. Strongly influenced by African flat patterns, Douglas's murals have a decidedly decorative quality. Using carefully composed silhouetted shapes to suggest the monumentality and permanence of Egyptian art, Douglas shows evidence of having assimilated ideas associated with Art Deco, as well as the simplified decorative motifs promoted by his mentor Winold Reiss. Over the course of the 1930s, Douglas painted several other murals in New York, and in the library of Fisk University, a well-known liberal arts institution in Nashville, Tennessee, whose faculty he subsequently joined.[22]

In 1937, Charles Alston (1907–1977) executed *Primitive and Modern Medicine* for the Harlem Hospital. Commissioned by the WPA, this work drew heavily on African stylizations to represent the intersection of modern science with the traditional healing of African and African-American experiences.

The two figures most strongly associated with murals prior to the 1950s were Hale

Fig. 33.
Aaron Douglas,
Aspects of Negro Life: From Slavery Through Reconstruction,
1934. Oil on canvas,
5' x 11' 67".
Photo: Manu Sassoonian.
Schomburg Center for Research in Black Culture, Art and Artifacts Division, The New York Public Library, Astor, Lenox and Tilden Foundations

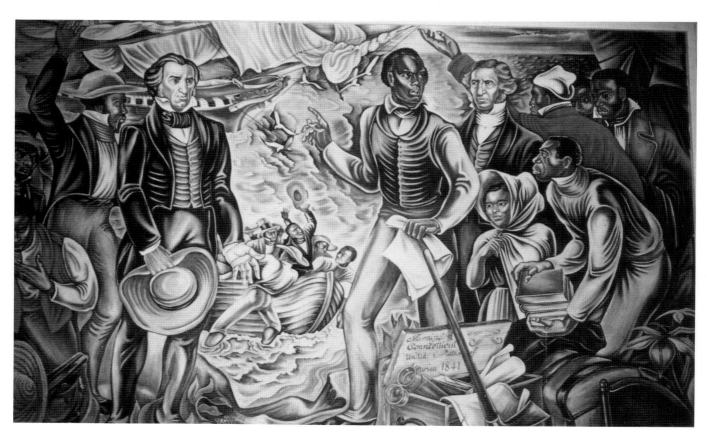

Fig. 34.
Hale Woodruff,
The Mutineers Return to Africa,
from the *Amistad* mural,
1938–39.
Savery Library, Talladega
College, Talladega, Alabama.
Courtesy, Talladega
College

Woodruff (1900–1980) and Charles White (1918–1979). Woodruff began the *Amistad* murals, a group of four panels in the Savery Library at Talladega College in Talladega, Alabama, in 1938 (Fig.34). The *Amistad* murals set a new standard for black muralists through their compositional complexity and narrative power. Unlike Douglas's paintings, Woodruff's murals emphasized dramatic, figurative groupings devoid of decorative impulses or Africanized forms. Though stylistically indebted to Regionalists such as Benton for his rhetorical gestures and grand staging, and to the Mexican muralists for their passion and pathos, Woodruff brought to his series an original and sincere vision of how he wanted the viewer to interpret the episodes. Woodruff continued painting murals for historically black colleges until his departure from the South, although his later works, such as *The Art of the Negro* in the rotunda of Trevor Arnett Library at Atlanta University, which was completed in 1951, increasingly evidenced a growing interest in Abstract Expressionism.

Charles White, more than any other black artist, reflected the direct influence of Mexican social art on mid-century black painters. His mural studies completed in 1939–40 use sculptural, rounded masses crowded into the picture frame to describe human form. These features are commonly used in Mexican social art to create a deep sense of pathos, anxiety, and peril. White, demonstrating early mastery of these compositional devices, paints his figures with strongly etched faces, rippling muscles, and bold rhetorical gestures. They seem to burst out and invade the viewer's space with an overwhelmingly raw, naked emotion. By 1940, White's mural studies (e.g., *Five Great Negroes;* present location unknown) left no doubt of his affection for David Alfaro Siqueiros, Diego Rivera, and José Clemente Orozco.

A few years later, White and his wife, artist Elizabeth Catlett, arrived at Hampton Institute in Hampton, Virginia, to begin work on the mural *The Contribution of the Negro to American Democracy,* which was completed in 1943 (Fig.3). John Biggers, then a student at Hampton, met White and worked as his aide on the massive project.[23] The two men

become lifelong friends, and White included a likeness of his helper in the mural.[24]

Biggers's encounter with White had multiple effects: it introduced him to mural making and gave him firsthand experience in the technical demands of this art; it underscored the power of the mural to communicate knowledge and inspire the development of a people; and it dramatically demonstrated the use of black figure types to address universal concerns. Biggers could easily appreciate White's remark that he used "Negro subject matter because Negroes are closest to me. But [also] to express a universal feeling through them, a meaning for all men."[25] In short, Charles White initiated Biggers into the tradition of black mural masters.

John Biggers, born into a poor working family in Gastonia, North Carolina, has an extraordinary love for the people who made up the intimate network of family and community that defined his childhood years. Well acquainted with their gnarled hands and toothless mouths, their bent bodies and plaited tufts of hair, their averted eyes that belie the inner strength and resourcefulness enabling them to weather life's storms, he intuitively understood their inner beauty, and their caring love for their forebears. Biggers paints black elders, like Miss Emma[26] in Ernest J. Gaines's *Lesson for Dying,* who prevail by guileful indirection and humility in the fashion of the fictional characters from *Ananse* tales, the traditional folk tales of West Africa. His art began with his effort to give visual expression and form to those elders' inner qualities, which coexist with the humming of hymns and the recitation of folk wisdom.

Several very early works reveal Biggers's concern for capturing the wisdom of these matriarchal and patriarchal figures whom he first knew imperfectly in his youth. Travel in Africa as an adult, and especially encounters with elder villagers, would in time help him to more fully realize the implications of acknowledging one's ancestors. Appreciation of his community and of the validating experiences of his neighbors and ancestors gave him the compassion so evident in his early figurative works.

Pietà (Fig. 35), a small terra-cotta sculpture completed in 1952, recasts the traditional representation of the dead Christ in the arms of the Virgin Mary, with a black mother gently but mournfully holding the body of her dead son. The mother's unadorned head droops forward sadly, exposing her plaits, while her enormous hands and feet pull to her the limp form of her son. Like a plaintive solo voice singing "Sometimes I feel like a Motherless Child," the two figures are weighed down by grief. Implied in *Pietà* is the bitter recollection of hundreds of lynchings etched into the consciousness of black people across the South. *Pietà* is a portrait of perseverance, of resignation, and of biding time.

Aunt Dicy, another terra cotta finished almost a decade later in 1951 (p. 148), has a primordial quality. In this sculpture, the ancient woman, who resembles a Benin mudfish in her compactness and proportions, cups her hand as if to listen to the whispered teachings of the universe. Aunt Dicy's narrow shoulders support enormous hands that, along with her tremendous feet, testify to a lifetime of hard work. Yet her face is strangely attentive, suggesting a hidden mystery of the sort that only the very old comprehend. Aunt Dicy, in her simple checked bandanna, is a sculptural equivalent of Käthe Kollwitz's famous self-portrait (Fig. 36).

A more communal comment on these spiritual ancestors of Miss Jane Pittman[27] can be seen in the 1947 drawing titled *The Harvesters* (Fig. 30). Five workers carrying cotton sacks completely fill the picture plane, crowding and pushing at the margins of the drawing. These cotton pickers, men and women, young and old, are icons of rough field labor. With hands and feet cracked and calloused, and faces weary, they share a communion of hardship. One senses a similar bond between the man and wife depicted in the *Old Couple* (p. 134), a conté drawing of 1947. In both *The Harvesters* and *Old Couple,* Biggers was still learning how to reveal the inner self that one later encounters in *Three Kings* (Fig. 43) and *Man* (p. 139), both of which rely more heavily on psychological interpretation than on literal representation.

In Biggers's early works, one can observe his struggle to realize meaning to the notion

84

of a racial art through an exaggerated, figurative approach not yet fully tempered by time and experience. Nevertheless, his art illustrates Locke's sentiment that for the poor, "even ordinary living has epic depth and lyric intensity, and this, their material handicap, is their spiritual advantage."[28] Within these early experiments are the passion and conviction that continue to inform and energize Biggers's current work.

In 1949, John Biggers accepted a teaching position at Texas Southern University in Houston, where he founded the art department and made mural painting a key aspect of its offerings. The post at TSU made Biggers acutely aware of the role of education in black life, perhaps even reminding him of how highly valued it was even in the most rural outposts. It is worth recalling how crucial education was for blacks across the South in the decades following Reconstruction: "Blacks emerged from slavery with a strong belief in the desirability of learning to read and write. This belief was expressed in the pride with which they talked of other ex-slaves who learned to read and write in slavery and in the esteem in which they held literate blacks."[29] In the Gastonia of Biggers's childhood, echoes of black youngsters' eagerness to learn still reverberated, mimicking W. E. B. DuBois's description of Fisk University's outreach teaching in 1886. Of the children partaking of that experience, DuBois said: "They remind us of their ancestors who sat in the woods in secret places with spelling books. They . . . illuminate the cumulative Afro-American beliefs in learning and self-improvement that were transmitted from slaves to the freedpeople."[30]

Against this background, Biggers undertook several murals with education as their subject, including *The History of Negro Education in Morris County, Texas* (1954–55; Paul Pewitt Elementary School, formerly George Washington Carver High School, Naples, Texas; Fig. 47) and *The Contribution of Negro Women to American Life and Education* (1952–53; Blue Triangle YWCA, Houston, Texas; pp.66-69).

The second of these narrates the important role of women and education in the South.[31] Its panoramic picture-space is divided into two halves, representing different and opposing themes. On the right, a huge white column symbolizing the antebellum South breaks before the advance of liberty, represented by Harriet Tubman, carrying the torch of freedom and leading a phalanx of slaves. Immediately to the left of the falling column, and above a heavily burdened field laborer, rises the tree of life, which shades and nurtures the community of freedmen to its left. Beneath its branches are an old man reading by lamplight, and Sojourner Truth, teaching an assembly of attentive students of all ages. Several babies are there with their parents, including a quilting woman, and one is in the arms of

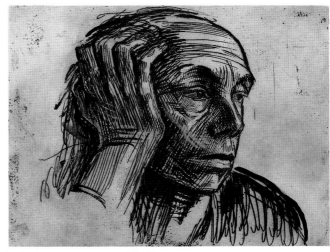

*Above: Fig. 36.
Käthe Kollwitz,
Self-Portrait, 1921. Etching,
8 ½" x 10 ½". Courtesy,
Museum of Fine Arts,
Boston. Frederick Brown
Fund*

another woman reading a text by the eighteenth-century black American poet Phyllis Wheatley. At the upper left are two scientists conducting agricultural research and nurses attending to the sick and elderly. There are churches on both sides of the divide, indicating the primary role they have played in African-American life, both before and after emancipation. The more clearly delineated church on the right may also serve as the community meeting hall and school. Next to the church is a railroad track, symbolizing industrialization and mobility. *The Contribution of Negro Women to American Life and Education,* Biggers's third major mural, is a prime example of his early mural style, and it clearly establishes several of the motifs that would later become constant in his art, including the tree of life and the matriarchal heroine.

Simple, multiepisodic narratives treated in a fundamentally descriptive—even illustrative—manner characterized Biggers's murals before his travels in Africa in 1957. Other works rendered in a similar style include *The Harvesters* (Fig. 30), *The Gleaners* (Fig. 37),

Night of the Poor (p. 119), *Day of the Harvest* (also known as *Harvest Song*; Fig. 8), and his mural for the Longshoremen's Local 872 (Fig. 48).

Beginning in mid-1957, John Biggers and his wife enjoyed an extended stay in Africa, visiting Ghana, Togo, Dahomey (presently the Republic of Benin), and Nigeria. The experience propelled him closer toward his longing to, "as an American Negro, . . . bridge the gap between African and American culture."[32] Africa gave Biggers a richer appreciation for the kinship between the community he had always known and that of his African cousins. He asserted that "these old women reminded me of the washerwomen back home who made soap by boiling hog fat, lye, and ashes in big, black, metal washpots."[33] He reported, "While I was in Africa I became convinced that the 'promised land' American Negroes had sung about and prayed for during centuries of slavery was only a historical memory handed down from the golden past of Africa."[34] This sense of ancestral memory, more than a quarter of a century later, would transform his art, filling it with balaphons (West African xylophones) and Ashanti combs, royal stools, fabric patterns and designs.

Especially striking to Biggers were the relationships he saw that revolved around women. African women accrued a new and extraordinarily metaphoric dimension for him. They became "daughters of the moon, queens of the fertile earth, mothers of toil and sorrow, descendants of Eve trampling through life's Garden of Eden, as countless generations before them had trampled and were trampled on, bearing their burdens and gifts with pride."[35] Their magnificence was not limited to Africa, but extended to the America that was his home. After all, were not these same women who were the cradle of African life also the "cradle of American life . . . for both white and black people"?[36] And was not the role of African women as leaders "personified not only in thousands of 'mammies' who reared white children as well as their own, but also in such women as Harriet Tubman, Sojourner Truth, and Mary M. Bethune"?[37] Women, long a leading motif in his art, now became the primary icons in virtually all of his paintings and prints, appearing as mystical African maidens or matrons.

After digesting his African experiences, Biggers returned to his work, planning to capture "something universal in the many Kojos, Kwasis, Kwames—the many Abenas, Amas, Afus—the washerwomen, farming women, fishermen, lumber workers, market women, mothers, fathers, and children"[38] he had internalized on the mother continent.

Before resuming mural making, however, Biggers produced an important body of easel paintings and drawings that helped him come to grips with all the new ideas and images Africa had given to him. Eighty-three of his drawings were published as *Ananse: The Web of Life in Africa* in 1962. The artist also produced a number of related paintings in 1959 and 1960.

Jubilee: Ghana Harvest Festival (1959–63; pp. 126-128) is an excellent example of such Africa-inspired canvases. It offers a casual but panoramic snapshot of this traditional celebration, emphasizing neither the presence of the paramount chief nor the spectacle of his orchestra carrying their drums aloft, but rather the eager gathering of women and children heading toward and joining the festival procession. Some onlookers gaze out at the viewer while others chat among themselves. In the distance, approaching the horizon, are the parasols of the royal parties. Somewhat reminiscent of Italian Renaissance paintings of spectacles such as Paolo Uccello's *Battle of San Romano*, *Jubilee: Ghana Harvest Festival* is painted with clear light, carefully modeled forms, and a predominantly blue palette. The painting has a gaiety, a lightness, and a busy energy suggestive of some Renaissance and Baroque paintings. Similar qualities, as well as the artist's obvious enjoyment of African subjects, can be seen in related paintings such as *Laughing Women* and *Kumasi Market* (Fig. 38).

Jubilee: Ghana Harvest Festival captures a wonderfully playful spirit of pageantry, with its panoramic throng of women, men, and children swept up in celebration. The subject is the whole event, rather than the individual participants. By contrast, *Three Kings*

(Fig. 43), a drawing of three distinguished elders from the Kano area of Nigeria, is a study in characterization. Unlike the artist's earlier works, in which figures may represent types or embody virtues such as heroism or compassion, *Three Kings* reveals the inner lives of these community leaders. To the right, one king, wearing a *fele* on his head, peers out cautiously, revealing a personality of great circumspection and wariness. His skin is stretched tautly over his well-formed skull, and his jaw bones and furrowed brow catch the light. He moves deliberately, holding with both sinewy hands his staff, a symbol of authority. The central king, wearing a white turban and a modern wristwatch, strolls under his parasol, intently gazing ahead. His face is stern and unyielding and his presence is one of solemnity and composure. Largest and youngest of the three, the king on the right is wrapped in layers of billowing drapery. A spiraling, conical brass ring adorns one hand, while the other holds a staff surmounted by curvilinear designs and openwork. His broad features—visible through the opening of his turban—suggest that he is at once a physical embodiment of his people and a caretaker of their interests. This ensemble illustrates Biggers's mastery of drawing as well as his ability to achieve convincing psychological characterization with a relatively economical use of crosshatching. Thoughtfully balancing the darker tones of the first king's face and the third king's robes, Biggers examines the smallest details, such as the shadow of the parasol handle and the openwork against the third king's *bubba*, or robe.

By the early 1960s, Biggers had fully absorbed his African experiences, and their images were slowly retreating from the forefront of his consciousness, replaced by a more metaphorical emphasis on mystery, veiled meaning, and parabolic teaching. His abiding interest in fables, tales, and stories[39] increasingly shifted his approach to art away from simple description toward allegory. Nowhere is this evolution clearer than in his movement from descriptive murals such as *The Contribution of Negro Women to American Life and Education* toward metaphorical examples such as *Birth from the Sea*. These new murals embrace the ambiguity and complication inherent in seeing the world through spiritual truth rather than dogmatic literalism.

Birth from the Sea (1964–66; Fig. 39) presents a transformed vision of Africa's western shores as the cradle of birth and the site of origins. Rising in a rhetorical twist of energy, a muscular but graceful figure representing the maternal sea uniting water, earth, and sky bisects the composition. Unlike the passive and delicate goddess in Botticelli's *Birth of Venus* (Fig. 40), a nearly inescapable comparison, Biggers's maternal sea dances in the tide, her motion seeming to raise the wind. Of the mural's iconographic program, Biggers says:

In the center is depicted the womb of the sea. From it emerges a vessel, a Fanti fishing boat carrying a sphere: an egg—a new world. Dancing beside the boat is the maternal sea, whose wisp of garment is like an umbilical cord binding boat and figure as twins.

In the middle ground a group of women . . . discuss the great miracle that unfolds. On the right is another group, bearing gifts in anticipation of the miraculous birth. Emerging from this group, a fisherman casts forth his nets. Above the fisherman a leviathan sends forth waves and currents. At extreme top right, drummers beat an eternal rhythm as they ride into the womb of the sea. In the foreground, left, a serving mother, the matriarchal symbol, bends over her work, like God bending over the clay while making the first man.[40]

Biggers uses this theme to explore further his heightened interest in the African woman as a symbol of creative force. To a small extent, such a usage was anticipated in the composition, gestures, and attitudes displayed in *Jubilee: Ghana Harvest Festival, Kumasi Market,* and related works finished more than half a decade before. In addition, Biggers's translucent drapery in the earlier works anticipates his use of light and reflection in *Birth from the Sea* to heighten its visionary qualities.

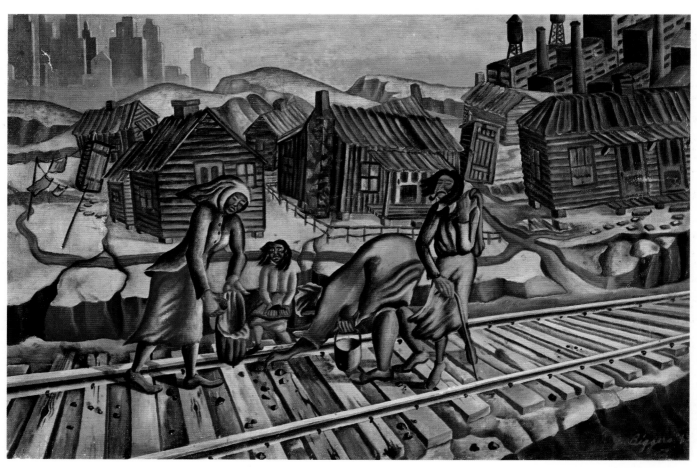

Over the course of the 1970s and 1980s, the artist's work became more abstract, more preoccupied with architecture and architectonic complications, and more symbolic. Especially after a serious illness in the mid-1970s, he began to synthesize, merge, and combine southern and African symbols into a new language of visual poetry and mystery. His paintings became like quilts, unified by their geometric patterns. Biggers's murals, prints, and paintings derived similar unity from the thin, linear elements that described a geometry superimposed over—yet born out of—his imagery.

Before turning to the works of the past two decades that demonstrate his affection for abstraction, geometry, and symbolism, it is worthwhile to analyze briefly some of the major symbols that form the vocabulary of Biggers's mature works. These symbols were like a fresh language, offering him endless possibilities for uncharted syntactical relationships.

Throughout his long career, Biggers has viewed women as bearers of multiple levels of meaning. As he wrote in *Ananse: The Web of Life in Africa,* "for many years I had been occupied with a desire to produce an image of the black matriarchal concept: maternity and motherhood."[41] In time, woman came to symbolize the moon, the queen of creation, the source of regeneration, the bearer of all futures, and the primordial ancestor. When Nana Peazant, a character in Julie Dash's remarkable *Daughters of the Dust,* a 1992 film about Gullah women of the sea islands off the Carolinas (p. 91), said that "ancestors and the womb—they're one, they're the same,"[42] she expresses exactly Biggers's conviction that woman is both womb and ancestor, and also the very universe itself.

The woman symbol in Biggers's art is often located at the center of constellations of related icons. These may include washpots, rubbing boards, beaded headdresses, quilts, fabrics, parasols, combs, and birds, especially chickens. Moreover, the woman symbol may also appear as part of a couple, associated with houses, or as part of the cosmic order of sun, moon, and stars.

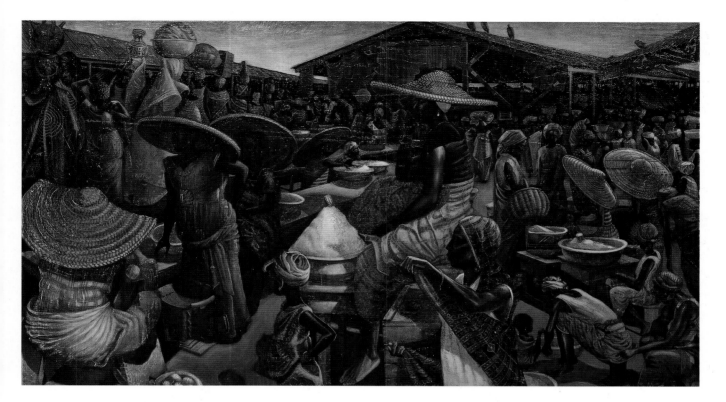

Fig. 38.
Kumasi Market, 1957–60
(Cat. no. 63).

Rooted in memories of the South, washpots, the old cast-iron three-legged kind, refer to washerwomen. Sometimes accompanied by tin tubs or wood-and-tin washboards, the cast-iron pots recall Biggers's personal memories of his mother, who was a launderer. Southern washpots, in their roundness and proportions, conjure images of African *yabbas,* or round-bottomed clay vessels used for cooking. In his paintings and prints, Biggers used washpots and related paraphernalia to suggest rejuvenation and restoration, cleansing, perhaps even purification in the Biblical sense. Thus, as clothes are renewed by the act of being washed, so is humankind restored for fit living.

Typically, Biggers's women are African, whether actually in Africa or in the American South. In either setting, they may be observed wearing a beaded or jeweled crown or veiled headdress. Inspired by traditions such as that of the Benin rulers, whose faces were shielded from viewers by a veil of beads, Biggers uses this device to imply what he calls the transformation of "meaning passing into mystery."[43] Vessels of mystical knowledge, veiled or bejeweled women express the idea of the unknown future while also shedding their light—hope—on those in their presence.

Such mystical women are often dressed in layers of African patterned, translucent fabric. Their frilled wraps sparkle with both the light they reflect and the light they emit. Sometimes the association is developed further, and textiles appear as if quilted into a new unity with their environment, with threads connecting one to the other. In other cases, where the ground of the picture has been described as African fabric, the bejeweled women practically disappear amid the field of zigzags, circles, and triangles. Relating women to quilts is important for Bigger, who, in discussing a recent mural at Hampton University, expressed admiration for the beautiful bedding that poor women he knew in his youth made from bits and pieces of recycled cloth to cover and warm their children.

The motif of the parasol or umbrella began to appear in Biggers's art after he witnessed the grand pageants of the traditional Ashanti chiefs in Ghana. We can find parasols in settings ranging from *Three Kings* to *Jubilee: Ghana Harvest Festival.* Like the beaded veils and headgear, they are articles of prestige in Africa; and thus, when they are carried by women in the artist's paintings of southern subjects, they suggest the royal kinship and

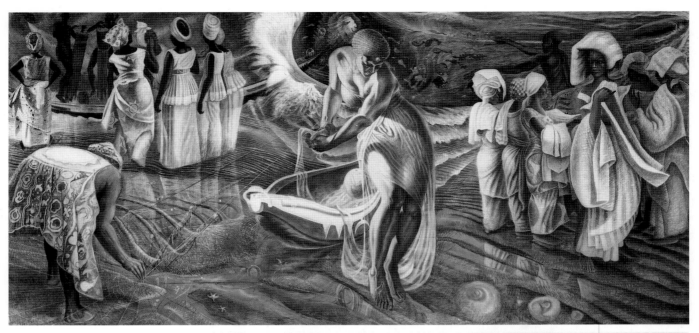

mystical divinity of these American queens of heaven. Combs, too, may invoke Africa, especially with their characteristically carved openwork or flat relief passages, but they more often suggest the physical self.

Many paintings depict mystical villages of shotgun houses with chickens or other birds, as well as women, nearby. The fowl seem to have several functions: they imply a domestic setting and available sustenance; hens generally restate the idea of female fertility as the precondition for a future.

Where couples appear, they immediately bring to mind the ancient Egyptian images of the pharaoh and his queen presiding over the affairs of life. They also evoke Dogon sculptures depicting the ancestral couple locked in formal embrace. Emphatically present in these African figures is the idea of procreation, of family and clan unity, and of the proper relationship between man and woman, whose generative forces yield children. In Biggers's symbolism such ancestral couples become the sun and moon, and their children, the stars.

A scene from
Daughters of the Dust,
a film by Julie Dash.
Released by
Kino International
Corporation. © 1992
Kino International
Corporation

Speaking of the dwellings and granaries he saw while traveling in Africa, Biggers said: "To me these did not look like the houses and barns that they were, but like gigantic ceramic sculptures and exquisite earthen vessels produced by a master sculptor who used delicate, abstract patterns to enhance the beauty of his product."[44] The same attitude is brought to bear in Biggers's treatment of the shotgun house as an icon of southern black housing. Exploiting their narrow fronts and peaked gables, he stacks shotgun houses in rows, emphasizing their architectural rhythms through repetition. Like the figures on a Dogon granary door, his shotguns take on visual energy through their modulated, repetitive forms. And, as Dogon granary door figures express the concept of generations descending from primordial ancestors, so the shotguns express the idea of community characterized by closeness, interdependence, and continuity.

Two additional African symbols appear with frequency in recent works by Biggers. They are the balaphon and the turtle. The former, a West African xylophone consisting of hardwood keys suspended over gourd or calabash resonators and played with batons,

Fig. 41.
Upper Room, 1984
(Cat. no. 108)

is associated in Biggers's imagery with all-permeating, spiritualized music through which we are lifted closer to our ancestors and by which we bridge life's difficult passages. Turtles symbolize endurance. Occurring frequently in the art and oral tales of West African peoples, turtles are also associated with water and life, sometimes being regarded as an ancestral totem. In some traditions, the turtle is an emblem for the sun, that universal source of all energy on earth.

Although not of African origin, railroad tracks are also an important symbol for Biggers. Simultaneously, they represent the ability to come and go as well as an obstacle in the

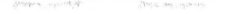

Fig. 42.
How I Got Over, 1987
(Cat. no. 126)

way. In the case of the second meaning, tracks are not only physical barriers that may trip one's step; they suggest barriers of race and class, as noted in such expressions as "the other side of the tracks."

Trees appear in a considerable number of works, sometimes playing a crucial syntactical role. Always, the tree represents the Tree of Life, the living connection of the four elements of earth, air, water, and fire. By its physical form, with roots in the ground, from which it draws water, and with branches reaching into the air, and by its process of photosynthesis, which converts light, or radiated fire, into food, the tree unites the four cardinal elements that sustain life.

By 1980, Biggers, often using titles taken from traditional songs widely known in the South, began to create a body of work absorbed with the notion of transformation. Over the next decade, he virtually abandoned scientifically constructed pictorial space, replacing it with a highly patterned ground where flattened figures inhabit very shallow spa-

tial windows. Thus Biggers superseded phenomenal with metaphysical space, denying the apparently real in favor of the truly mystical.

Upper Room (1984; Fig. 41), represents an early stage of this development. The lithograph depicts two southern women carrying on their wrapped heads a building—indeed, a shrine. Beside them is a third woman carrying a ladderlike structure that supports a growing vine. Above the vine, a boy and girl—a protocouple—climb toward the future. Their outstretched hands high above their heads transform them into images reminiscent of the Tellem figures, which the Dogon of Mali regard as ancestral.

The women, carrying the "weight of creation,"[45] stride confidently along the furrows of a plowed field. In front of them are several round pots and a row of chickens marching—like the women—into the future. In the middle ground, two turtles slowly make their way. From the area where the pots sit rises a tree, whose branches provide a perch for a bird as well as supports for two upside-down round-bottomed pots.

The building supported by the women's heads simultaneously represents a house, a church, and a school. As a house, it offers a bed as an altar for procreation, a table, a porch, and chairs. The two chairs await the installation of an ancestral couple. Over the door is a horseshoe, which, like the upside-down pots, suggests African taboos and spiritualist ideas. As a church, the building is surmounted by a steeple and bell. The bell, of course, is a means of summoning the community, of calling kin and friends for the rituals of life. Because black communities were frequently forced to provide education for their children from their own resources, churches commonly doubled as schools, just as ministers sometimes doubled as teachers or principals.

The title, *Upper Room,* was inspired by a widely sung spiritual bearing the same name. The song, a call to the community to come together and welcome the spirit of redemption, freely interpreted the New Testament story of the disciples awaiting the gift of the Holy Ghost in the upper room on the day of Pentecost. As was their custom, blacks reworked its meaning to fit their needs.

How I Got Over (1987; Fig. 42) exhibits a considerable shift toward dematerialization of space in Biggers's work. A couple stands beneath a parasol between the rails of a train track, facing away from the viewer and toward the future. The husband leans on a cane. In front of them, a girl washes clothes, and another girl, bearing a bucket on her head, holds a panel of nearly transparent clean cloth, as if to fold it or hang it to dry. At her feet are two rinse tubs, with hints of bluing in the water. Over an expanse of shotgun houses, their pediments forming crisp architectural patterns, is a rooster on a rooftop. An African comb is silhouetted against the distant sun. As in *Upper Room,* the picture title is derived from a spiritual. The song calls for reflection on the journey of the soul, especially its triumph over obstacles.

By 1987, when *Three Washer Women* was finished, Biggers's evolution toward the dematerialization of space was complete. Here, he has obliterated even shallow space. Along the flat surface of the painting, three women are depicted. Two are pausing from washing cloth, as is evident from their washpots, rinse tubs, and rubbing boards. A bird sits on the rim of the bucket in which the rinse water has been fetched. Dominating the picture is the large woman who, like a figure of Christ in benediction, extends her hands, her back turned to the viewer. On her back is a child whose face cannot be seen. The woman's veiled headdress disappears alternately into the patterns of the shotgun houses and the firmament in the uppermost register of the picture. The washerwomen flanking her and the baby also wear beaded headgear.

Starry Crown (p. 144), painted at approximately the same time, reveals similar formal devices; its pictorial space, however, is more completely dominated by what Biggers called "sacred geometry." As a result, it communicates an almost ethereal feeling.

Several of Biggers's late works are highly symmetrical in their visual organization. This is certainly true of *Shotguns, Third Ward* (1987; Fig. 22), in which three women, like cathedral pillars, stand as sentinels before their houses. Their complexions range from black to

Fig. 43.
Three Kings, 1962
(Cat. no. 83)

red to brown, and their hair is coiffed in the African style. Each holds a strip of fabric. Adjacent to the red woman are her washpot and rubbing board. The railroad tracks that lie before her are crossed by thirteen turtles traveling along an arc that partially encircles several black birds (perhaps crows) and red birds (perhaps cardinals). Amid the parade of rooftops in the upper third of the painting is a strange scene of two women holding a cloth, upon which a male figure stands on an upside-down pot, or perhaps a turtle's back. The iconographic message of *Shotguns* is challenging.

The quintessential expression of Biggers's complicated symbolic language, as well as his preference for abstraction and geometrical integration, is visible in such murals as *Ascension* (p. 152) and *Origins* (p. 153). These large-scale works reveal the further development of the artist's preferred iconographic themes. They are masterfully woven together through a series of overlapping geometric forms such as circles, pyramids, and triangles. Like medieval stained-glass windows, these murals demand committed and careful study. Thus approached, they hold treasures that both delight the eye and guide the spirit toward metaphysical meditation.

To this day, John Biggers seeks transformation through his art, hoping to convey his understanding of how all forms of life are interrelated and continually intermingled. Through the use of what he calls "sacred geometry," the knowledge of the ancient meaning of mathematical measures, he infuses into his paintings a timeless message of the generative energy of the universe and its inseparability from all creative and imaginative endeavors. Using the quilt as a comprehensive model, he has sought and achieved the translation of southern black and African perspectives on the meaning of life into visually exciting and intellectually provocative images. His contribution to contemporary art will endure for its quality of thought, brilliance of expression, and discipline of presentation.

John Biggers: American Muralist
by Alison de Lima Greene
Curator of Twentieth-Century Art, The Museum of Fine Arts, Houston

Too often mural painting has been assigned a secondary role in the history of twentieth-century American art. The flowering of mural projects promoted by private enterprise and New Deal agencies in the 1930s has been dismissed as "post-office and hospital decorations"[1] and as a necessary but ungainly overture to the "triumph" of the Abstract Expressionist painting of the 1940s.[2] Great murals have been lost to political expedience, as demonstrated by the obliteration of Diego Rivera's 1933 *Man at the Crossroads* from the walls of Radio City Music Hall, New York, while others had a brief life as they were created for temporary structures, such as Philip Guston's *Maintaining America's Skills,* painted on the facade of the Works Progress Administration Building at the 1939 World's Fair. Landmark masterpieces, including Aaron Douglas's *Evolution of the Negro Dance,* created in 1935 for New York's 135th Street YMCA, are on the brink of total decay, and urban renewal has caused the wholesale destruction of countless monuments. Further, many of the murals that have been saved have survived only at the cost of being transposed from their original sites.[3]

John Biggers, born in 1924, came of age in the wake of the achievements of the Depression-era artists, and throughout his career he has shared many of the vicissitudes faced by American muralists. However, his uniquely strong ties with the Houston community, with Hampton University in Virginia, and with his native North Carolina have enabled him to complete a remarkable oeuvre of mural paintings. Biggers created his first such composition in 1942 while still a student at Hampton; over the past five decades he has painted close to twenty major murals unparalleled in scope and remarkable in evolution. His early paintings demonstrate a fresh synthesis of sources, and as his work matured Biggers drew increasingly upon personal experience to chart a world vision.

When John Biggers entered Hampton Institute (now Hampton University) in 1941, there were few examples of African-American murals for him to draw upon. Even with the initiatives of the WPA's Federal Art Project, opportunities for black artists to receive mural commissions remained limited. Typically only sites in Harlem or at regional black educational institutions were available to African Americans, and racial prejudice plagued many commissions. For example, Vertis Hayes's and Charles Alston's 1936–37 murals for the nurses' residence at the Harlem Hospital met with initial resistance from the hospital's administration. Hayes's *Pursuit of Happiness* depicted stages of "life among the Negro People," in Africa and America and Alston's *Primitive and Modern Medicine* murals similarly contrasted African ritual with Western science.[4] Correctly reading these compositions as dealing "with various phases of Negro endeavor and community life," Lou Block, project supervisor at the hospital, formally complained to Charles Alston that the subject was inappropriate for a city institution.[5] Nevertheless, these and other outstanding murals by African-American artists only a few years older than Biggers established a critically important precedent. Furthermore, the extraordinary arts program founded by Viktor Lowenfeld at Hampton in 1939 offered an ideal environment for Biggers's first explorations in mural design.

Biggers's 1942 studies for *Dying Soldier* (Fig. 2; p. 130) demonstrate Lowenfeld's formative influence on the young artist. Biggers recalls Lowenfeld as one of this country's greatest art educators, a man who inspired him to "see art not primarily as an individual expression of talent, but as a responsibility to reflect the spirit and style of Negro people."[6] Lowenfeld, who had studied both art and psychology in his native Austria, actively encouraged students at Hampton to study African art. As a recent émigré from war-torn Europe, he was also able to speak eloquently on Expressionist art to his classes. The *Dying Soldier* drawings show Biggers's assimilation of such German masters as George Grosz and

Opposite:
Fig. 44.
Diego Rivera,
Detroit Industry: East Wall,
1932–33. Fresco. ©
The Detroit Institute of Arts,
Founders Society Purchase,
Edsel B. Ford Fund
and Gift of
Edsel B. Ford

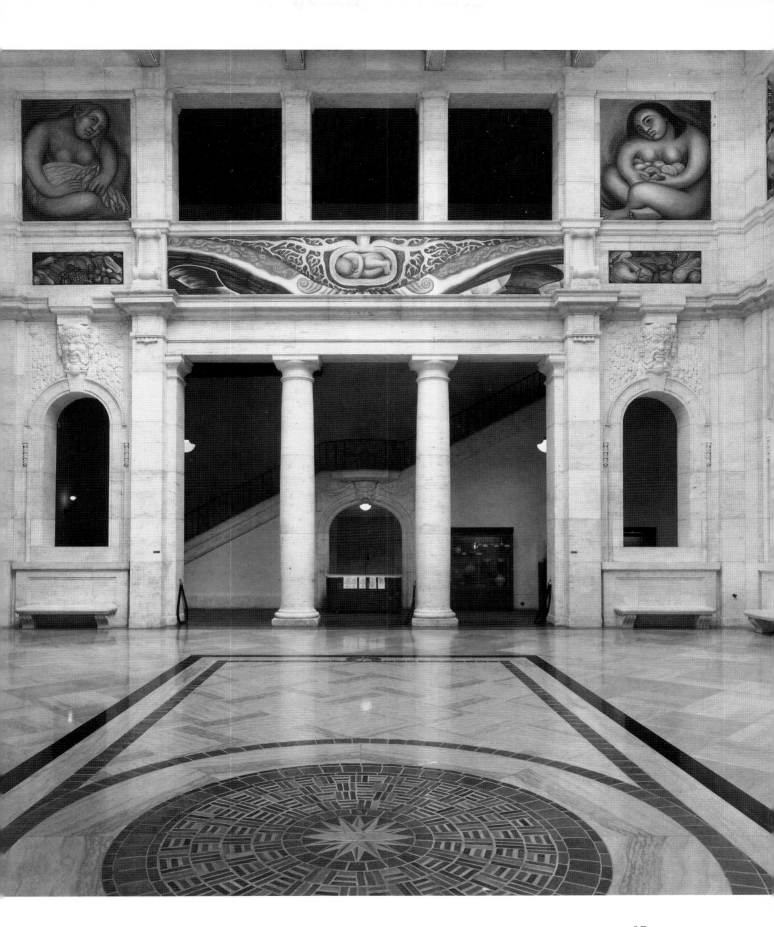

Otto Dix, as well as the great Mexican muralist José Clemente Orozco. The black soldier caught on the battlefield is a secularized Christ figure, crucified against a barbed-wire fence. The timeless tragedy of the image echoes the horror of Grosz's battlefield sketches, while its unblinking realism and physical terror find closer parallels in Dix's *War* triptych of 1932 (Staatliche Kunstsammlungen Dresden, Gemäldegalerie Neue Meister). Finally, Biggers's fractured compositional structures and use of Christian iconography reflect such works as Orozco's *Modern Migration of the Spirit* (1932-34; Hanover, Dartmouth College).

Shortly after Biggers entered Hampton, Charles White joined the faculty as an artist-in-residence at the invitation of Lowenfeld. His Hampton mural, *The Contribution of the Negro to American Democracy,* 1943 (Fig. 3), gave Biggers an opportunity to study first-hand the techniques and effects of mural painting. White became Biggers's second great mentor during his years at Hampton, and Biggers's *Country Preacher* mural study of 1943 (p. 118) shows both White's influence and Biggers's independence. The foreground of the composition is occupied by a preacher and his congregation; the rear wall of the chapel—which appears to be decorated with images of African dancers—offers a dramatic counterpoint to the Christian ceremony. The vividly delineated features of Biggers's protagonists can be related to the historical physiognomies that animate White's mural, and both artists employ gesture and densely packed space to heighten the emotional tenor of their compositions. However, where White addressed the spectrum of history, Biggers mined a much more personalized past, recalling the rural ministries of his childhood.

Country Preacher also reveals the influence of another key figure in Biggers's evolution, Diego Rivera. The Mexican Mural Renaissance of the 1920s and 1930s, with its commitment to education and social equality, had profoundly shaped the progress of American mural painting in the 1930s. Rivera's celebration of Mexico's native heritage and his ability to conflate precolonial history with the postrevolutionary present had a particularly striking significance for African-American artists. Such murals as the *Detroit Industry* cycle, 1932–33 (Fig. 44; The Detroit Institute of Arts), can be cited as specific sources for both White and Biggers. However, where White was fascinated primarily by the structural complexity of Rivera's example, Biggers responded more immediately to the spiritual presence of the harvest figures that preside over Rivera's scenes of industry. In *Country Preacher* Biggers achieves a similar duality by conjuring up an exotic African past through the ghostly dancing figures on the wall, thus bringing together the present reality and the ancestral legacy of African Americans.

The year 1946 was pivotal for Biggers. He moved to Pennsylvania to continue his studies with Lowenfeld, who had recently joined the faculty of Pennsylvania State University. This move resulted in his first large-scale mural project, a complementary pair of harvest scenes created for the Burrowes Education Building on the university campus: *Day of the Harvest* (Fig. 8; also known as *Harvest Song*) and *Night of the Poor* (p. 119). At the same time he created his first panorama, *Sharecropper Mural* (Fig. 45), which is now installed in the Paul Robeson Cultural Center at Penn State. That same year, both the *Dying Soldier* and *Country Preacher* murals were installed in the United Transport Service Employees center in Chicago. As Biggers witnessed his murals entering the public sphere, he confronted the example of America's most famous muralist, Thomas Hart Benton.

Benton's murals of the early 1930s had given recognition to black Americans, albeit in stereotypical roles, and had established the Negro as a protagonist on the American scene. From the Herculean cotton picker and chain-gang laborers of the *Deep South* panel of the 1930 *America Today* mural (Fig. 32; commissioned by the New School for Social Research, now in The Equitable Collection), to the gospel singer and his audience in the *Arts of the South* panel of *The Arts of Life in America* (created in 1932 for the reading room of the newly opened Whitney Museum of American Art, now in the New Britain Museum of American Art), Benton both celebrated black Americans as heroic figures integrated into the panorama of American life and segregated them as personifi-

cations of rural southern labor and culture. Benton's easel paintings of this era illustrated even more negative stereotypes; *Cotton Town* was captioned in a 1934 *Time* article: "The result of Benton's trip through Georgia in 1932. In spite of his personal gaiety, Artist Benton excels in imbuing his Negro characters with an indolent melancholy."[7]

Benton's harshest contemporary critic on the issue of race was Stuart Davis. Motivated by leftist politics, as well as by essential differences of artistic conviction, Davis denounced Benton in a 1935 article published in *Art Front*:

His opinion of radical and liberal thought is clearly symbolized. . . . For Huey Long he can point to his Puck *and* Judge *caricatures of crap shooting and barefoot shuffling negroes. No danger of these negroes demanding a right to vote even if the poll tax has been taken off.*[8]

As Romare Bearden and Harry Henderson have recently noted, Davis's challenge and subsequent articles in *Art Front* provided a new forum of discussion. "African-American artists . . . followed this controversy with interest [and] *Art Front* became the means through which many American artists learned for the first time of African-American artists and their special problems."[9]

Hale Woodruff provided the first important revision of Benton's subject and approach. His *Amistad* murals, 1938–39 (Fig. 34; Alabama, Talladega College,), took Benton's stereotypes and gave them new historic dignity. James A. Porter, writing in 1943, contrasted Benton's work with that of Woodruff:

Benton's delineation of Negro physique runs to heavy, awkward, and even grotesque bodies with long, gesticulating arms and flexible aspect. All this over-emphatic drawing, however, cannot kill the sense of drama that he unfailingly achieves. . . . Woodruff, for all his stunts and linear ecstasies, is more concise in expression. . . . His picturizations of Negro life and milieu have a more authentic setting.[10]

Biggers took Woodruff's revision of Benton a step further. Where Woodruff had used Benton's narrative clarity to illustrate a momentous event in the history of African-American emancipation, Biggers concentrated on an anonymous and impoverished present. In painting rural laborers Biggers was addressing directly Benton's favorite subject matter. Where Benton typically celebrated the rural abundance of the harvest, Biggers took an uncompromising view, contrasting the bounty of *Day of the Harvest* with dearth and starvation in *Night of the Poor*.[11]

In formal terms the artists shared more common ground. Both Benton and Biggers held El Greco in high regard and both artists adopted the sweeping arabesques of the Mannerist master. The serpentine layering of space, the pictorial clarity, the flow of energy from one figure to another, and the unity of labor and laborer in Benton's murals are reinterpreted and condensed in *Day of the Harvest* and *Night of the Poor*. Benton's emphasis on community and church, reiterated throughout the panels of the *Social History of the State of Indiana* murals, 1933 (Bloomington, Indiana University Auditorium), is also the focus of Biggers's *Sharecropper Mural*. Ultimately, however, Biggers rejects Benton's relentless social optimism. While Biggers's protagonists are able to raise their voices in song, they also face a yawning poverty rarely portrayed in contemporary American murals.[12]

In part motivated by his studies in art education, Biggers's Penn State murals have a specific didactic program. In the text panels installed next to the murals the artist stated:

In this mural [Day of the Harvest], as contrasted to the opposite painting, it is shown how people of all lands have learned to cooperate and share in a spirit of creativeness. Their rich life is symbolized by fruit and harvest which have been the historical symbols of fertility and wealth. The singing is indicative of the well-being of people whose happiness has been founded on the education

and care they received during childhood as depicted by the group of children of different origin and their teacher.

In [Night of the Poor] the effect which lack of education has on people is depicted. It is shown by their inability to get along, their lack of cooperation and knowledge which results in "empty bags" as symbols of poverty, lack of knowledge and starvation. Through such contrasting experiences as seen in the two murals, the artist sought to emphasize that the ultimate goal of education is life.[13]

Biggers's understanding of mural art as a vehicle for education was rooted both in Lowenfeld's teaching and the examples set by American muralists of the WPA era. In 1948 he received his B.S. and M.S. in Art Education at Penn State. After remaining one year as a teaching fellow, Biggers moved to Texas, where the didactic mission of his mural work found expression in a broader and more complex urban context.

When Biggers came to Houston in 1949 to establish the art department of the newly expanded Texas State University for Negroes (now Texas Southern University), he came as a mature artist. While he gained statewide recognition through prizes awarded at the annual exhibitions at the Houston and Dallas museums in 1950, 1951, and 1952, he faced a monumental task in educating young African Americans living in the segregated South.[14] Like his colleague Carroll Simms, a sculptor with whom he shared a number of public commissions, Biggers was committed first and foremost to promoting the art program at TSU and in its immediate community. While his murals and paintings continued to be enriched in execution and ambition, his development over the next eight years was primarily motivated by the need to provide instructive and positive images of southern African-American culture.

Biggers's first major project in Texas was the sixty-foot-long *Negro Folkways* mural created for the communal meeting room at the newly constructed Eliza Johnson Home for the Aged, 1950–51 (Fig. 11). Exploiting the architectural divisions created by a series of windows, the artist broke the composition into four major units, each one containing a series of narrative vignettes. Biggers later recalled:

I intended to express some of the eternal values of folkways upon the land. . . . I decided to depict in the mural, from left to right, season and harvest. A youth fishing against a background of baptism, which would be an expression of religious ecstasy, symbolic of man's rebirth and soaring spirit. Woodsmen felling trees and gathering timber. Indoor life during winter months and a warm atmosphere of quilting, cooking, children sleeping, men sharing conversation and warmth provided by womenfolk and by the home. A huckster supplying farm produce to town neighborhoods from his market on wheels. Finally, elders and children going picnicking and fishing in a horse-drawn wagon.[15]

Many of the vignettes that make up the *Negro Folkways* mural recast images found in Biggers's earlier easel paintings and drawings, for example: *Coming Home from Work* (p. 117), *The Harvesters* (Fig. 30), and *Baptism* (Fig. 46). However, as befitted an environment that was supposed to bring comfort to the elderly, Biggers emphasized "the golden autumn and winter" of life.[16] While lacking the compositional and emotional tension that animated Biggers's earlier work, the narrative sweep and cyclical unity of theme and symbol found in this work were to be of critical importance in his later murals.

Biggers's next major project was *The Contribution of Negro Women to American Life and Education,* 1952-53 (pp. 66-69), commissioned by Reverend Fred T. Lee for the Blue Triangle YWCA, a new building close to the TSU campus. Although more contained than the Eliza Johnson mural—the overall dimensions are 8' x 248'—*The Contribution of Negro Women* was programmatically far more complex. Biggers's preliminary studies for the mural were executed during a summer term spent at the lithographic studio of Jules Heller at the University of Southern California. While there he was able to renew his

Fig. 45.
Sharecropper Mural, 1946
(Cat. no. 3)

friendship with Lowenfeld, and through discussions with his former mentor he arrived at a mural program that represented his first comprehensive essay into historical subject matter.[17]

Biggers's initial premise for the project was to present a panorama of Negro women's achievement, much in the manner of White's *Contribution of the Negro to American Democracy* of 1943 (Fig. 3). Encouraged by Lowenfeld to focus on the complementary figures of Sojourner Truth and Harriet Tubman, Biggers wove together a brilliantly nuanced vista of the African-American march toward freedom and education. Abandoning the linear narratives of his earlier work, Biggers achieved a remarkable synthesis of temporal events which finds its closest parallels in Rivera's late mural masterpieces.[18]

The History of Negro Education in Morris County, Texas (Fig. 47; also known as *The Evolution of Carver High School*), created in 1954–55 for the Carver High School (now the Paul Pewitt Elementary School, Naples, Texas), offers a masculine mirror to the great matriarchy summoned up in the Blue Triangle mural. However, Biggers has shifted back into the present tense. The varying roles of educators, from spiritual leaders to schoolroom assistants, are rendered to reflect the scope of a community devoted to both agriculture and industry. Similarly, the 1956–57 *Longshoreman's Mural* (Fig. 48; created for the International Longshoremen's Association Local 872, Houston) is firmly set in the modern realities of Houston's Ship Channel. The most urban of Biggers's murals, the dense activity of the dockside longshoreman is captured with a compressed realism comparable to the Precisionist Regionalism championed by Dallas artists Jerry Bywaters and Alexandre Hogue.[19]

Although Biggers's early Houston murals depicted his protagonists in a southern environment of shotgun shacks and bayou thickets familiar to the residents of East Texas, the Texas landscape plays a minor role in Biggers's work. *Red Barn Farm,* 1960 (Fig. 13; commissioned by Dr. Ford B. McWilliams for the Dowling Veterinary Clinic, Houston), is an exception. As was appropriate for a veterinary clinic, Biggers created an idyllic vista in which science and nature coexist in peaceful harmony. The domesticated and wild fauna of Texas—from thoroughbred horses and Siamese cats to hogs and bluejays—find sanctuary under Dr. McWilliams's care. Where the church offered an image of social unity in earlier works, a vast barn offers similar shelter.

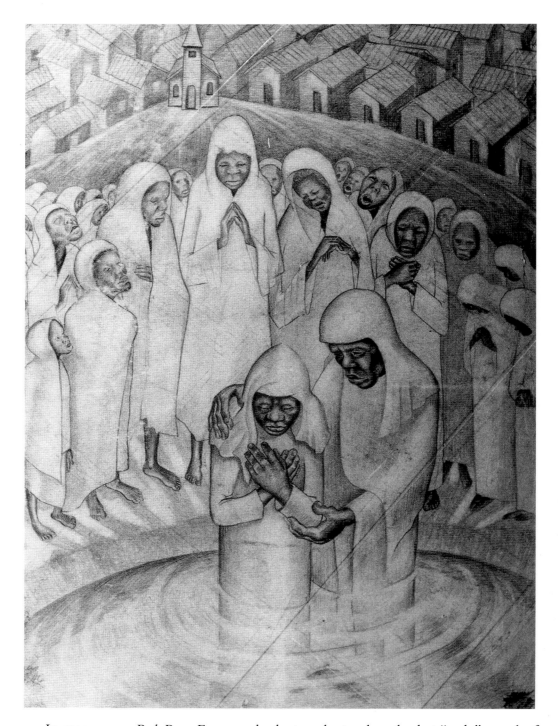

In many ways *Red Barn Farm* can be best understood as the last "early" mural of Biggers's career. Although painted after Biggers's 1957 journey to Africa, it is more closely tied to his murals of the 1940s and 1950s than the monumental *Web of Life,* 1956–62 (Figs. 49-52; Houston, TSU, Nabrit Science Hall), Biggers's first mural to reflect upon his African experience.[20]

Biggers's elementary studies for the *Web of Life* mural began in late 1956. In a statement prepared by Biggers, Simms, and Joseph Mack in March 1957 for the art program of TSU's new science building, Biggers projected that the challenge of the mural was:

to portray graphically certain basic events on the meaning of protoplasm, the interdependence of liv-

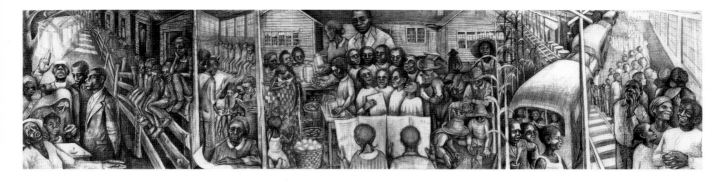

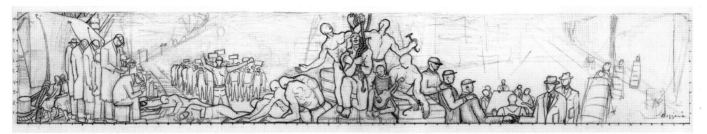

ing organisms in the balance of nature, and the relationship of all organisms to one another through the long line of evolutionary descent.[21]

Progress on *Web of Life* was interrupted, however, by Biggers's encounter with West Africa, a journey of six months, which he later described as "the most significant of my life's experiences."[22] As Biggers developed a new body of work from his African sketches and notes, *Web of Life* gained in both iconographic and compositional complexity. The mural was completed concurrently with the publication of Biggers's book *Ananse: The Web of Life in Africa,* and much of the mural's imagery evolved from the artist's contemplation and assimilation of African culture.

The final composition is consistent with Biggers's initial program of 1957, emphasizing the cyclical nature of creation: decay feeds new life, winter gives way to spring. The central figure of the mural is a nursing mother surrounded by root forms that engender, nurture, shelter, and feed upon an array of organic life. Much as Diego Rivera had employed an embryonic infant cradled by plant forms on the east wall of the *Detroit Industry* mural (Fig. 44) to represent the seed of culture and industry, Biggers established the nursing mother as the source of all creation.[23] Writing in *Ananse,* Biggers stated: "The African woman, in her divine creative capacity, motivated within me a desire to paint murals on creation from a matriarchal point of view; whereas European artists had been motivated to paint creation from a patriarchal point of view."[24]

Web of Life is not without reference to Western art, however; crowning the central portion of the mural, two nude figures clasp hands, echoing in pose and iconography the heroic sculptures of Michelangelo's *Night* and *Day* from the tomb of Giuliano de' Medici (1519–34; Florence, Medici Chapel).[25] The left side of the mural can be read as the realm of the feminine night, which includes a parade of African women water bearers lit by moonlight; the daylit masculine realm on the right reveals a vista of men sowing seed across a tilled field. Unlike most twentieth-century figurative painters—from Benton to Paul Cadmus—who used references to Michelangelo to give authority to scenes of everyday life, Biggers's intent is more specifically revisionist. Much as he adapted Benton's mural designs during the 1940s to reflect more accurately African-American rural experience, he now addressed Michelangelo, whose Sistine Ceiling is the greatest Western expression of the miracle of genesis. In *Web of Life* creation does not spring down from the sky; rather, it rises up from and returns to the earth. Where Michelangelo's program

Top: Fig. 47.
The History of Negro Education
in Morris County, Texas
(The Evolution of Carver High
School), 1955 (Cat. no. 56)

Above: Fig. 48.
Longshoreman's Mural, 1956
(Cat. no. 57)

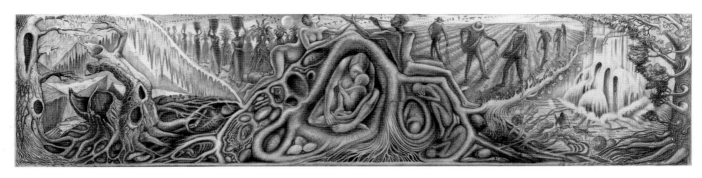

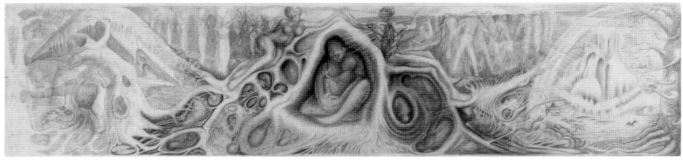

reveals the glory of God the Father, Biggers's celebrates the *maamé,* the woman who is the cradle of African life.[25]

Birth from the Sea, 1964–66 (Fig. 39; Houston Public Library, W. L. D. Johnson branch) offers a marine counterpart to *Web of Life.* Biggers recasts Botticelli's *Birth of Venus* (Fig. 40; 1482, Florence, Uffizi Gallery) with images drawn from his African sketches. The central figure rising from the waves is a classical archetype, her pose echoing the majesty of the antique *Capitoline Venus* (Rome, Capitoline Museum) and the fluid grace of Jacopo Sansovino's *Venus Anadyomene* (c. 1527; Washington, D.C., National Gallery of Art). However, a West African Fanti boat replaces Venus's shell, Venus herself is converted into a great African maternity figure, and her court is garbed in the traditional dress of Ghana.[27]

The reconciliation of Western archetypes with his direct experience of Africa characterizes Biggers's mural work of the 1960s. While the UNESCO trip to West Africa rightly has been recognized as key to the artist's evolution, the fact that he traveled through Rome, Paris, and London on his return should not be overlooked.[28] Furthermore, in 1956 Houston's Bank of the Southwest had installed a mural by Rufino Tamayo, and in 1962 Biggers made his first trip to Mexico City, where Elizabeth Catlett introduced him to Pablo Higgins, Diego Rivera's mural assistant. Thus, Biggers's growing knowledge of African culture was balanced and enriched by his firsthand study of Renaissance and Mexican masterpieces.

Social forces had their influence on Biggers's evolution as well. *Web of Life* and *Birth from the Sea* were created during the years that the civil rights movement was gaining momentum in the South. While Houston was spared the violence of other cities, issues of desegregation, voter registration, and civic autonomy were changing the fabric of Biggers's community. By addressing timeless myths of genesis and renewal from Africa and the West, Biggers offered a harmonic and affirmative vision extolling the riches of both cultures.

Birth from the Sea has a celebratory grace that finds its first expression in the artist's *Day of the Harvest* mural of 1946 (Fig. 8), and both compositions share an essential musicality. As Biggers moved into the next stage of his career, he abandoned linear narrative and specific references to Western archetypes, adopting instead a synthetic compositional approach that finds its closest equivalent in musical harmony.

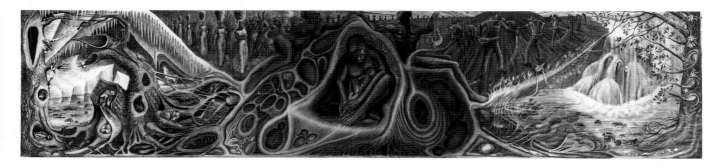

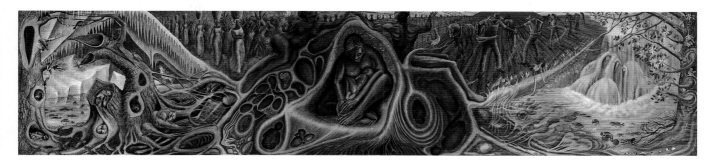

Top: Fig. 51.
Tempera study for
Web of Life, 1958
(Cat. no. 80)

Above: Fig. 52.
Web of Life, 1958
(Cat. no. 81)

Following the completion of *Birth from the Sea,* Biggers withdrew from mural commissions for close to a decade. *Family Unity,* 1976–77 (Houston, TSU, Sterling Student Life Center), establishes the pictorial leap he had begun in his easel paintings of the mid 1970s, a shift in part inspired by an exhibition of Dogon art hosted by the Museum of Fine Arts, Houston, in the spring of 1974.[29] Although Biggers had begun to move away from narrative conventions as early as 1952 with the Blue Triangle YWCA mural, *Family Unity* is imbued with a new dynamic kineticism and abstract freedom. Composition and content are balanced with absolute authority—measure, repetition, and pattern are exploited to emphasize the images of physical and spiritual harmony.

The evolution of the *Family Unity, Quilting Party,* 1980–81 (pp. 122-125; Houston, Music Hall), *Christia Adair,* 1983 (Fig. 53; Houston, Christia V. Adair County Park), *Song of the Drinking Gourd,* 1987 (Harris County, Texas, Tom Bass Regional Park), and *East Texas Patchwork,* 1987 (pp. 70-72; Paris, Texas) murals demonstrates Biggers's growing independence from precedents in the canonical history of Western art. Dogon art offered one source of inspiration; another, closer to the artist's personal memory, was quilt making. Beginning with *Family Unity,* the interlocked compositions and symmetrical patterns of quilt design are combined with images of music making and celebration. Biggers has recently commented: "Quilts are pure poetry."[30] In an earlier statement he explained in detail:

It has really been there from the beginning. In the very first mural in the Eliza Johnson Home of the Aged, the quilt is there. That's one of the major themes. The women are doing quilts. . . . For a long time it was almost unconscious. I didn't think about it as a subject. It was just something that happened. Now it has truly become the structure of the mural . . . If you bring all the little pieces and put them together, it's like putting life together again. That is really the symbolism to me.[31]

Feminist artists and writers have also reclaimed the quilt as a part of their heritage. Beginning in the late 1960s Faith Ringgold's narrative quilts and Miriam Schapiro's more abstract compositions challenged assumptions about fine arts and crafts, art history, biography, and women's work. Gloria Naylor has written eloquently in *Mama Day* of how the making of quilts is a gesture of love and ancestral memory passed from one generation to the next, how each fragment of fabric carries meaning as it is saved and reused.[32]

For Bigger's the assimilation of parts into a whole offered an ideal analogue for the process of mural painting, while the shared labor of quilting could represent communal unity.

At the same time, the later Houston murals look back on the multiple vignettes of the 1950–51 *Negro Folkways*. Family groupings, anecdotal details, and images of community animate these compositions. Features from Biggers's earliest works—railroads, shotgun houses, churches—become transcendent symbols of travel, identity, and spiritual rebirth.

Biggers's most recent murals, *Ascension* and *Origins*, 1990–91 (pp. 152-153; North Carolina, Winston-Salem State University) and *Tree House* and *House of the Turtle*, 1991 (Figs. 23,25; Virginia, Hampton University) can be read as summations of the artist's life, brilliantly fulfilling his goal of expressing "the triumph of the human spirit over the mundane and the material."[32] Both pairs of murals offer complementary vistas of past and future, African sources and American culture, retrospection and aspiration. In particular, the Hampton murals echo with personal resonance as the artist synthesizes the architecture of the campus of his youth and images drawn from a life of travel and intellectual exploration. Surface pattern weaves in and out, creating a complex fabric of space and time. In these most recent works, the artist demonstrates a synchroneity of memory and experience. For Biggers, the African *maamé* has become one with the southern mammy.

Taken as a whole, Biggers's career is without equal in our time. The murals can be seen as charting a young artist's assimilation of contemporary sources and his emergence as an independent creative force with a mission to give voice to his community. No other artist of his generation has left us so vivid a record of African-American community life in the rural and urban South. Biggers's lifelong career as an educator is eloquently recorded in his paintings; they not only reflect the changing self-identity of African Americans, but invite all viewers to share in their transcendental passion.

John Biggers's achievement is all the more astonishing when contrasted to the activities of his contemporaries. The 1940s, 1950s, and 1960s saw few great mural commissions created for the public sphere in the United States; although several major mural projects were offered to artists, few works ultimately were realized *in situ*.[34] With the rise of corporate patronage of the arts in the 1970s and 1980s, PaineWebber, Equitable, and Chase Manhattan Bank, among others, have commissioned outstanding murals by artists as diverse as Roy Lichtenstein, Sol LeWitt, Nam June Paik, and Susan Rothenberg. However, with only rare exceptions have corporate sponsors undertaken the humanistic and educational mission that is at the heart of Biggers's work. While the Liz Claiborne 1992 campaign against domestic violence engendered a series of compassionate and politically engaged work by such artists as Carrie Mae Weems and Barbara Kruger, their photographic murals offer no parallel to the complexity and historical sweep of the TSU, Hampton, and Winston-Salem cycles.[35]

Biggers's closest peers have come from communities that have supported grass-roots mural and public art movements. William Walker's Chicago murals of the late 1960s offer a vital parallel to Biggers's work; for example, the *Wall of Respect*, 1967–69 (destroyed 1970), created by Walker and his colleagues in the group Africobra, offered a communal sounding board for the emerging Black Pride movement. Similarly, the West Coast Chicano mural movement of the past three decades has produced such artists as Jesús Campusano, Carlos Almaraz, Frank Romero, Gilbert Luján, and Beto de la Rocha, among others, who have celebrated their Hispanic heritage. In Texas Luis Jimenez and César Martínez have captured both the mundane and the mythic aspects of Hispanic life much as Biggers has charted the African-American experience. Closer to home are artists who have shared their lives with Biggers, from senior colleagues such as Carroll Simms and Jean Lacy to students such as Harvey L. Johnson and Bert Samples, who have emerged as important artists in their own right.

The walls of Houston have in large part preserved the brilliant range of Biggers's mural oeuvre. This is not a heritage to be taken for granted, and indeed, important

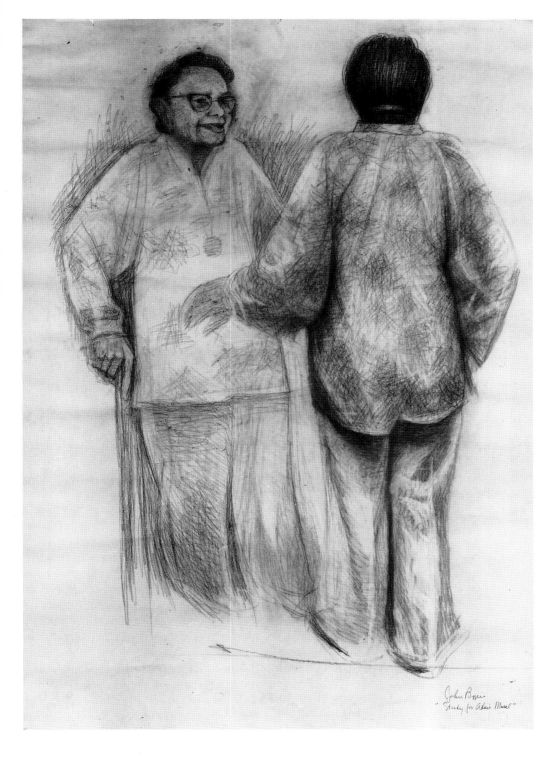

Houston murals by Biggers's contemporaries have been lost already: Leo Tanguma's 1973 *Rebirth of Our Nationality* has faded almost completely from the walls of the Continental Can Company, and Tamayo's epic *América* was removed from the Bank of the Southwest and sold at auction in 1993.[36] Major conservation work is currently in process to preserve the great *Web of Life* and *Quilting Party* compositions; other paintings will require attention in time. Biggers's mural legacy demands to be protected, for, as the artist has stated, "Everyone in the community becomes a part of that mural."[37]

John Biggers's *Shotguns* of 1987:
An American Classic
by Robert Farris Thompson
Professor of Art History, Yale University

"Painting [is] a machine to convey philosophy." —Jean Dubuffet, quoted in Yves-Alain Bois,
Painting as Model, *1993.*

Fig. 54.
Grant Wood,
American Gothic, 1930.
Oil on board,
29 ¹⁵⁄₁₆" x 24 ¹⁵⁄₁₆".
The Art Institute of Chicago,
Friends of American
Art Collection.
Photograph © 1994,
The Art Institute of Chicago.
All rights reserved.

Opposite: Fig. 55.
Shotguns, 1987
(Cat. no. 103)

In the history of American art certain paintings achieve the canon. One of these is certainly Grant Wood's *American Gothic* of 1930 (Fig.54). Stern and sober, a white couple, small-town citizens, pose before their house.[1] A gothicizing window speaks of a European heritage. The pitchfork in the man's hand emblemizes personal determination and domestic skill. But it also declares, clearly, that he will fight, if necessary, to defend his property, his family, and his way of life.

Severely outlined against the habitat, this husband and wife clearly embody American individualism in the decade of the Great Depression. Their resilience, their stoicism, their church-going faith spiritually reassure those shaken by the bank failures and other dislocations of those years.

At the same time that Grant Wood was engaged in capturing in paint "the hard-edge Middle West civilization," multiple migrations were bringing the life and movement of African Americans from farms to the city—to Detroit, Chicago, Seattle, Houston, and New York. As Grant Wood combined the gothic with the pitchfork, confirming habitat and effort with a spare but telling choice of elements, so John Biggers's *Shotguns* of 1987 (Fig. 55) is a richly nuanced masterpiece of American painting.

Once again, a painter declares a heritage, translating into paint individuals and their architecture. But it is not only the "shotgun," perhaps the premier form of African-influenced architecture in the West Indies (Haiti) and the United States that Biggers here declares.[2] On the front porch of each of the five closest shotgun houses appears a key feature of traditional African-American yard art: vessels by the door. They stand for black culture in practical, domestic acts: preparing soap, cooking pork, bathing infants.[3] But they also signify covert spiritual protection, Grant Wood's pitchfork taken underground. The pot before the door "cooks" or contains more than meets the eye. It metaphysically caparisons the traditional black yard and house, as do African-American bottle trees and bottle shelves and bottle-lined walks and garden beds. I have seen such a pot lashed with iron chains to the front porch of a black grandmother in Austin, Texas, as a reliquary of her mother's mother, on the one hand, and as a mystic filter for evil on the other. For it is believed, in Kongo and in black America, that a basket or a pot by the door is a catch for evil at a critical space.[4]

During a recent interview, John Biggers pointed to an illustration in John Vlach's *Back of the Big House: The Architecture of Plantation Slavery,* which showed a black yard at the Seward home in Washington County, Texas, in 1936. Biggers traced with his finger the area in the center, where three iron kettles appeared, suspended from an elevated horizontal log. Then he quietly remarked: "these three great pots were for cleaning hogs and making soap. My life is based on such reality."[5] *Shotguns* illustrates, therefore, more than a single aspect of black culture, traditional domestic architecture. Illuminating space and elevation with philosophy, the painting becomes a model of belief and practice. It illustrates numinous qualities in complex interaction; it carries us into process, where black Creole vision takes the poetic measure of three worlds—Europe, Africa, and America—and combines them. It does this in order to make a medicine, an *nkisi,* as artistic images and charms for healing and protection are called in Kongo.[6]

Biggers's *Shotguns* is a veritable *nkisi*-painting: it embeds black spirit in textile-

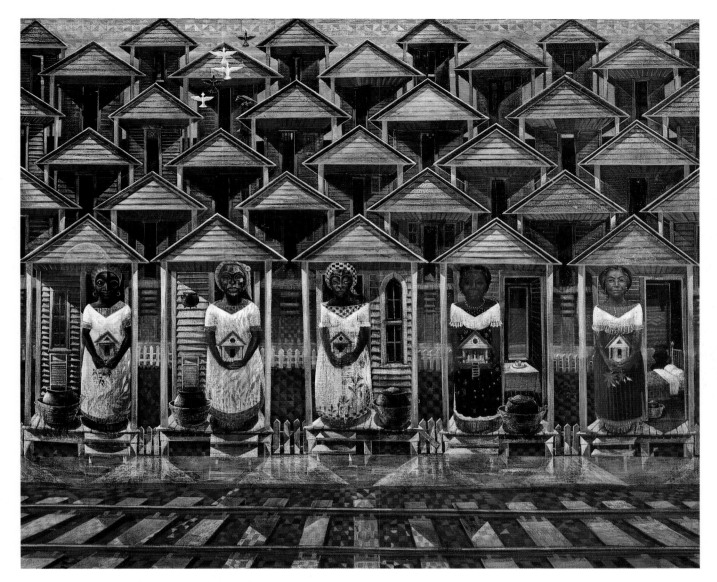

patterned earth so that you feel the ghost of grandma beneath the quilt that echoes beneath the railroad tracks. You see, in addition, spirit taking flight to report to God, portrayed as birds with spread wings near the top of the painting. This painting-medicine tells the spirit to build for the people and their future, like the miniature houses held like lanterns in the hands of the five black women on their porches; to guard the purity of the people, in the repetition of the motif of the washboard; and to prepare for ascent, with the washboards set like ladders within the pots.

As cultural preparation for this masterpiece, Biggers benefited from the spiritual support of his parents in North Carolina. There he was carefully instructed in the making of the *nkisi*-like *nkobera* charm, to which we shall return later. Today, handsomely present and all around him, the spiritual support of his adoptive city, Houston, also has a bearing on the fluency of his vision. Or, rather, the city within the city, Third Ward and Sunnyside.

Sunnyside is where the fabled yard-artist Cortor Black worked in the 1970s, one block off Cullen Boulevard. He "prepared" his lawn with multiple whirring, kinetic things, fans and fan-blades. Decoding this, a woman in black Austin told me in 1992 that fan-blades guard a house from "birds" and signify, in their flash, a house protected. Very likely for similar reasons Cortor Black wallpapered his house with tinfoil, as Biggers's

biographer Alvia Wardlaw personally attests. Mirrors and flash throw back envy. Cortor Black carried this spiritualized architecture, the flash of the soul in brilliant motion, into new realms when he transformed his Pontiac into a "light chariot" by affixing shining clusters of chrome and red glass "bullet lights" to its hood and sides. A famous photograph, taken about 1972, shows him standing, in the "Kongo pose" (left hand on hip, right hand extended), touching the top of his remarkable vehicle. All of which seems an imaginative Africanizing of the sense of mobility built into Sunnyside, where to this day there are numerous black auto parts stores.

Cortor Black inspired the contemporary yard-artists of black Houston, Cleveland Turner, who lives at the corner of Sampson and Francis, and Robert Harper, who lives nearby. Turner works with mirrors, chrome pieces, and figuration, Harper with essential signs of the cosmos and the progress of the soul—diamonds, arches, fanwheels, and wheels (Fig. 56)—deepening the themes of the now-vanished Cortor Black's car and yard-show. Harper's yard-emblems are frequently chosen for the color blue, perhaps because in the African-American tradition "evil is said not to be able to cross the color of the sky."[7] In the process, Harper finds, in industrial detritus, the release of the soul's own voice and idiom. Biggers is aware of Harper. He admires his yard-art: "dressed in blue light." "This," Biggers says, "is an art of transformation; this brother slipped through the mirror."[8]

So John Biggers, when he walked the streets of the Third Ward and drove the streets of Sunnyside, found his Western studio training complicated by another social aesthetic system. It was black visual memory: shotgun houses and yard-shows. The art and architecture of the black streets of Houston taught him to inscribe Western realism with sub-Saharan themes of "dressed" (spiritually protected) habitats, and other textile-like narrations. Earth became a quilt, checked black and scarlet.

Note that in *Shotguns* one cannot see the sky. The clay red coloration of the pediments interplays with shadowed porches, light against dark, in a spatial quilting governed by the law of opposites. The red is Africa: "laterite red, the foundation color." It is also warmth, a day in summer.

Biggers recalls that when he walked through the shotgun house areas of Third Ward Houston on hot summer days, the heat gave a shimmering quality to space and figuration:

As I came upon this special potency I told myself, hey, I've got to show this whole community as it is, with women on the porches, and show their meaning, that what they see and do truly is dynamic. Put women on the porches, Third Ward women, organized women, women who, when they voted, took the whole block with them. As I passed the churches and the juke-joints it come to me: you ain't painting perspective, you're painting shotgun blocks, *their own spatial concept, all the houses of the past, all the houses of the future, just let it roll."*

And so pediments and porches blur heroically into a textile pattern, like repeating motifs on a rug from Iran. Then five shotguns come forward to frame, like miniature stages, five women, themselves holding miniature shotguns in their hands, guardians of the culture.

He sets the scene immediately after rain, when the sidewalk is a mirror. Certain Houston streets, with railroads in the middle, inspired the tracks that set time and space in motion, as if viewed from the window of a Pullman car. As Biggers remembers, "There was such a street in Third Ward where I worked. The tracks are still down there." And of course, as for many African-American families, the railroad was awesome, hooting blues with its whistle and escape with its motion. When Biggers lived in North Carolina his house was near the tracks. Every day he heard the Bob train (so called because the engineer's name was Bob) "come down from the mountains, pass Hickory, then us, then roll on into South Carolina."

The optical perturbations of light and dark stop where the women stand. This empha-

Fig. 56.
"Flower Man's" House
(Robert Harper),
Houston, Texas, 1992.
Photo by
Diane Sibbison.
Courtesy, The Orange Show,
Houston

sizes their importance, their inner illumination. They spark the energy in the geometry, the rhythmic repeats of porch and column, that make the whole block move before the railroad tracks.

The corrugated walls behind the women are cryptic ladders. As the artist says, "This extends their backbone, essence of support." In another work, *Wheel in Wheel* of 1986 (Fig. 19), Biggers dressed a shotgun with a shawl, to represent a woman, and a matching shotgun with overalls to represent a man. The crowd of "dressed" buildings here prevents perspectival vanishing lines from vanishing, backgrounds from being backgrounds. In sum, the accent given is not on isolated objects but on multiples of forms in rhythmic relations. In the process, he is spelling out a powerful parallel classical tradition: the architectures of Kongo and Dahomey as creolized together with European patterns on the soil of Haiti and then transmitted to this nation via Haitians in New Orleans, and, perhaps, another current direct from Kongo via captives landed on the Carolina coast. The gothicizing current that Grant Wood loved traveled east to west, from France to America to Eldon, Iowa, where the artist sketched them in carpentered translation. But the shotgun traveled from south to north, up from Haiti through the Delta to the South at large, a pattern in the minds of blacks who wandered as far as Tacoma, Washington, in the 1860s, where nineteenth-century documents suggest the reemergence of such plans.[9]

Biggers knows the shotgun literally from the ground up through the center; he was born in one, in Gastonia, North Carolina. He knows how to "medicate" a house, too, in the African manner: "Tie string onto a nail then put it into an old mayonnaise glass jar, half full of water under the doorstep. The belief was that if someone came to do you in, the string turned into a serpent, bit and destroyed them." This was *nkisi nkobera,* a tradition received from his parents and their own parents.

And Biggers knows the yard-show universe, the recurring themes: "I've seen hundreds of back and front yards with tires and hubcaps and bottles and dolls and whitewashed stones, arranged for beauty and protection. This is what I come from, this vocabulary, this source to be drawn on." Putting all these influences together in a single painting, Biggers reveals their incantatory quality, a chanting of solids against the void. In the process, *Shotguns,* "American Kongo," becomes a perfect pendant to *American Gothic.* A new America pushes up, from the depths of its architectures, plural and rich, at the dawn of a universal nation.

Catalogue of the Exhibition

I. THE BLACK FAMILY

1. Crossing the Bridge
1942
Oil on board
30 ½ x 45 ½"
(77.5 x 115.6 cm)
Hampton University Museum,
Hampton, Virginia

2. Old Couple
1946
Oil on board
40 ⅛ x 32" (101.7 x 81.3 cm)
Collection Mr. and Mrs. James
Arnold

3. Sharecropper Mural
1946
Tempera
48 x 96" (121.9 x 243.8 cm)
The Paul Robeson Cultural Center,
Pennsylvania State University,
University Park

4. Old Couple
1947
Conté crayon and gouache
29 ⅞ x 22" (75.9 x 55.9 cm)
Collection the artist

5. Coming Home from Work
1944
Oil on board
40 x 32" (101.6 x 81.3 cm)
Collection the artist

6. Going to Church
1944
Graphite
13 ⅛ x 11" (33.5 x 27.9 cm)
Hampton University Museum,
Hampton, Virginia

7. Sleeping Children
1950
Terra cotta
4 x 19 ½ x 12"
(10.2 x 49.5 x 30.5 cm)
Collection the artist

8. Pietà
1952
Terra cotta
29 x 13 x 14 ⅝"
(73.7 x 33 x 37.2 cm)
Hampton University Museum,
Hampton, Virginia

9. Mother and Three Children
1960s
Conté crayon
24 x 36" (61 x 91.4 cm)
Collection Clarice Pierson Lowe

10. Mother, Father, Child
1944
Graphite
10 ¹⁵⁄₁₆ x 8 ⅞"
(27.8 x 22.5 cm)
Hampton University Museum,
Hampton, Virginia

11. Mother and Children
1947
Conté crayon and gouache
30 x 22" (76.2 x 55.9 cm)
Collection the artist

12. Family
1953
Terra cotta
7 ¼ x 3 ¼ x 2"
(18.4 x 9.5 x 5.1 cm)
The African American Museum,
Dallas, Texas. Gift of the artist

II. THE AFRICAN-AMERICAN MALE — GOING THROUGH THE STORM

13. Middle Passage
1947
Crayon on corrugated board
9 ⅛ x 12 ¼"
(23.2 x 31.1 cm)
Ed Anderson Collection

14. Dying Soldier
(mural sketch – soldier in barbed wire)
1942
Graphite
22 x 28" (55.9 x 71.1 cm)
Hampton University Museum,
Hampton, Virginia

15. Dying Soldier
(mural sketch – girl and boy)
1942
Graphite
20 ½ x 20 ½"
(52.1 x 52.1 cm)
Hampton University Museum,
Hampton, Virginia

16. Dying Soldier
(mural sketch–rape)

1942
Graphite
22 x 28" (55.9 x 71.1 cm)
Hampton University Museum,
Hampton, Virginia

17. Dying Soldier
(mural sketch – mother scrubbing)
1942
Graphite
28 x 22" (71.1 x 55.9 cm)
Hampton University Museum,
Hampton, Virginia

18. Going Through the Storm
1942
Linocut
14 x 9 ½" (35.6 x 24.1 cm)
Collection the artist

19. Crucifixion
1942
Oil on Masonite
50 ½ x 34 ½"
(128.3 x 87.6 cm)
Hampton University Museum,
Hampton, Virginia

20. The Garbage Man
1944
Oil on board
39 ⅞ x 33"
(101.3 x 83.8 cm)
Collection the artist

21. Sleeping Boy
1950
Conté crayon
18 ¼ x 23 ¼"
(46.4 x 59.1 cm)
Dallas Museum of Art; Neiman
Marcus Company Prize for
Drawing, Fifth Southwestern
Exhibition of Prints and Drawings,
1952

22. Despair
1952
Lithograph
16 ⅟₁₆ x 11 ¹³⁄₁₆"
(40.8 x 30 cm)
Hampton University Museum,
Hampton, Virginia

23. Blind Boy and Monkey
1948
Conté crayon and gouache
34 ¼ x 30" (87 x 76.2 cm)
Collection the artist

24. Kneeling Man
1953
Plaster
13 x 9" (33 x 22.9 cm)
Atlanta University Collection of
Afro-American Art at Clark Atlanta
University

25. Momolou Speaks
1964
Conté crayon
23 ¹⁵⁄₁₆ x 18 ⅟₁₆" (60.8 x 45.8 cm)
Collection the artist

26. Man
1950s
Conté crayon
38 x 32" (96.5 x 81.3 cm)
Golden State Mutual Life Insurance
Company, Los Angeles

III. BLACK WOMEN AS SPIRITUAL CENTER

27. Mother and Child
1944
Oil on board
55 ¼ x 43 ¼"
(140.3 x 109.9 cm)
Hampton University Museum,
Hampton, Virginia

28. First Shotgun
1949–50
Tempera on board
48 x 36" (121.9 x 91.4 cm)
Hampton University Museum,
Hampton, Virginia

29. Aunt Dicy
1950s
Terra cotta
20 x 11 ½ x 8 ½"
(50.8 x 29.2 x 21.6 cm)
Hampton University Museum,
Hampton, Virginia

30. Woman Listening
1950
Plaster
14 ½ x 6 x 5 ½"
(36.8 x 15.2 x 14 cm)
Collection Mr. and Mrs. James
Biggers

31. Three Quilters
(Quilting Party)
1952
Conté crayon

58 x 48" (147.3 x 121.9 cm)
The ADEPT NEW AMERICAN Museum, Mt. Vernon, New York

32. According to Where the Drop Falls (Aunt Dicy Making Biscuits)
1954
Conté crayon
19 ⅛ x 26 ⅜" (48.6 x 67 cm)
Harry Ransom Humanities Research Center, The University of Texas at Austin

33. Waiting for the Bus
1954
Lithograph
18 x 12" (45.7 x 30.5 cm)
Collection Richard A. Long

34. Hazel
1963
Conté crayon
19 ½ x 15" (49.5 x 38.1 cm)
Collection the artist

35. Ma Biggers Quilting
1964
Conté crayon
39 x 29" (99.1 x 73.7 cm)
Collection the artist

36. The Visitation
1970s
Lithographic pencil
39 x 24 ½" (99.1 x 62.2 cm)
Collection Mr. and Mrs. Gerald B. Smith

37. Mother and Child
ca. 1951
Terra cotta
12 x 11 x 13"
(30.5 x 28 x 33 cm)
Mr. and Mrs. Herbert Mears

38. Nude Study – Tougalou
1966
Conté crayon
38 x 28" (96.5 x 71.1 cm)
Collection Dr. Edith Irby Jones

39. Pregnant Prostitute
1943
Painted plaster
47 x 13 ½ x 27"
(119.4 x 34.3 x 68.6 cm)
Hampton University Museum, Hampton, Virginia

40. Victim of the City Streets #2

1946
Oil on canvas
40 ⅛ x 20" (101.9 x 50.8 cm)
Collection the artist

41. The Cradle
1950
Conté crayon
32 ¼ x 29 ¼"
(83.2 x 74.3 cm)
The Museum of Fine Arts, Houston, 25th Annual Houston Artists Exhibition, Museum Purchase Prize, 1950

42. Laundry Woman
1940s
Graphite
18 x 12" (45.7 x 30.5 cm)
Collection Samella Lewis

43. Broken Stone
1966
Lithograph
20 ⅞ x 25 ⅞" (53 x 65.7 cm)
Collection the artist

IV. THE ROLE OF THE LAND

44. Cotton Pickers
1950s
Etching
22 ⁷⁄₁₆ x 18 ⁷⁄₁₆"
(57.1 x 46.8 cm)
Hampton University Museum, Hampton, Virginia

45. Cotton Pickers
Early 1940s
Plaster
20 ½ x 8 x 9"
(52.1 x 20.3 x 22.9 cm)
Collection Mr. and Mrs. Michael Archey

46. The Gleaners
1943
Oil on canvas
27 1/8 x 40" (68.9 x 101.6 cm)
Collection the artist

47. The Harvesters
1947
Conté crayon
40 x 29 ⅞" (101.6 x 75.9 cm)
Collection the artist

48. Night of the Poor
(mural study)
1948
Graphite

30 x 34 ¹⁵⁄₁₆" (76.2 x 88.7 cm)
Collection the artist

49. Day of the Harvest (Harvest Song)
(mural study)
1946
Graphite and conté crayon paper mounted on board
29 ⅞ x 34 ⅞"
(75.9 x 88.6 cm)
Collection the artist

50. *Study for Negro Folkways mural for Eliza Johnson Home for the Aged (mural sketches: a, b, c)*
1950
Tempera
a. 20 ⅞ x 35 ⅛"
(53 x 89.3 cm)
b. 20 x 45 ⅝"
(50.8 x 115.9 cm)
c. 19 ½ x 40 ¹⁄₁₆"
(49.5 x 101.7 cm)
Department of Fine Arts, Texas Southern University, Houston

51. Red Barn Farm
1960
Oil
75 ⅝ x 75 ⅝"
(192.1 x 192.1 cm)
Collection Dr. F. B. McWilliams, Dowling Animal Clinic

V. BLACK INSTITUTIONS

52. Country Preacher
1943
Pencil
12 x 9 ¹⁄₁₆" (30.5 x 23 cm)
Hampton University Museum, Hampton, Virginia

53. Baptism
1956
Pencil
24 ⅝ x 31 ⅛"
(62.6 x 79.1 cm)
Collection Rev. Douglas Moore

54. Freedom March
1952
Terra cotta
19 x 31" (48.3 x 78.7 cm)
Collection the artist

55. The Contribution of Negro Women to American Life and Education (mural sketches: a, b, c)
1952
Tempera

a. 25 ¹⁵⁄₁₆ x 31 ⅞"
(65.9 x 81 cm)
b. 26 x 28 ⅛"
(66 x 71.4 cm)
c. 19 ½ x 40 ¹⁄₁₆"
(49.5 x 101.7 cm)
Department of Fine Arts, Texas Southern University, Houston

56. The History of Negro Education in Morris County, Texas (The Evolution of Carver High School)
Conté crayon
35 ¼ x 134 ¼"
(90.8 x 342.3 cm)
Collection the artist

57. Longshoreman's Mural
(mural sketch)
1956
Graphite
5 ¾ x 16" (14.6 x 40.6 cm)
Department of Fine Arts, Texas Southern University, Houston

58. Hampton Centennial Seal
1966
Pencil on paper
22 ¹⁄₁₆ x 22 ¹⁄₁₆"
(56 x 56 cm)
Hampton University Museum, Hampton, Virginia

59. Going to Church
1964
Conté crayon
17 ⅜ x 16 ¼"
(44.1 x 41.3 cm)
Collection the artist

VI. FINDING MAAMÉ — THE ANCIENT BLACK WOMAN

60. Dancers of the Ghana Harvest Festival
1957
Conté crayon
39 ¼ x 29 ⅝"
(99.7 x 75.3 cm)
Collection the artist

61. Laundry Women (Washerwomen in Volta Region)
1959
Oil on canvas
43 ½ x 55 ½" (110.5 x 141 cm)
Collection Diggs Gallery, Winston-Salem State University, North Carolina. Gift of Winston-Salem Delta Fine Arts, Inc.

62. Women Walking to Market
1957
Conté crayon
37 ⅛ x 28 ⅜"
(94.9 x 72.1 cm)
Collection the artist

63. Kumasi Market
1957–60
Mixed media
34 x 60" (86.3 x 152.4 cm)
Private collection of Ms. Maya
Angelou

64. Jubilee: Ghana Harvest
Festival
1959–63
Tempera and acrylic on canvas
38 ⅜ x 98" (97.5 x 248.9 cm)
The Museum of Fine Arts,
Houston. Museum purchase with
funds provided by Panhandle
Eastern Corporation

65. Before the Shrine (Queen
Mother)
1962
Conté crayon
26 x 59" (66 x 149.9 cm)
Collection Dr. and Mrs. Warren
Brooks

66. Daughter of the Moon
1957
Conté crayon
29 ⅞ x 22 ⅛"
(75.9 x 56.2 cm)
Collection Jan Campbell Rothrock

67. Waiting Patiently
1957
Conté crayon
29 ½ x 33 ⅜"
(74.9 x 84.8 cm)
Lowell Collins Gallery, Houston

68. Gondor Market: Ethiopian
Mother
1970
Conté crayon
41 ¼ x 29 ¾"
(104.8 x 75.6 cm)
Collection Dr. and Mrs. Joseph A.
Pierce, Jr.

VII. LIFE ON THE LAND

69. Shepherd
1958–61
Conté crayon
27 ⅝ x 40" (70.2 x 101.6 cm)
McAshan Foundation, Houston

70. Fishing Village
1962
Conté crayon
37 x 40" (94 x 101.6 cm)
Hampton University Museum,
Hampton, Virginia

71. Ashanti Architecture
1962
Conté crayon
40 x 37" (101.6 x 94 cm)
Collection Mani Jasiri Short and
Ryan Adrian Fitzgerald

72. Woman and Twins with Boat
mid-1970s
Oil and acrylic
47 ½ x 47 ⅝"
(120.7 x 121 cm)
Collection Dr. and Mrs. Robert
Galloway

73. It is Life #2 (Roots)
1970s
Conté crayon
35 ¼ x 26 ¼" (90.8 x 68 cm)
Columbia Museum of Art, South
Carolina

74. Harvest from the Sea
1957
Conté crayon
38 ⅝ x 36 ¼"
(98.1 x 93.4 cm)
McAshan Foundation, Houston

75. Returning Home
1957
Conté crayon
23 x 56 ⅜" (58.4 x 143.2 cm)
Collection Dr. and Mrs. Joseph A.
Pierce, Jr.

76. Oarsmen
1962
Conté crayon
41 ⅛ x 63 ¼"
(104.5 x 160.7 cm)
The Museum of Fine Arts,
Houston. Gift of the McAshan
Educational and Charitable Trust

77. Cocoa Farm
1957
Conté crayon
29 x 29" (73.7 x 73.7 cm)
McAshan Foundation, Houston

78. Web of Life
(1" scale study)
1958
Graphite

10 ⁷⁄₁₆ x 40 ⅛"
(25.6 x 104.5 cm)
Collection the artist

79. Web of Life
(3 ½" scale study)
1958
Graphite
24 ¼ x 91 ⅜"
(61.6 x 232.1 cm)
Ed Anderson Collection

80. Web of Life
(3 ½" scale study)
1958
Tempera on wood
22 x 92 ⅛" (55.9 x 234 cm)
Collection the artist

81. Web of Life
1958
Casein on canvas
72 x 312" (182.9 x 792.5 cm)
Department of Fine Arts, Texas
Southern University, Houston

VIII. OBAS AND ELDERS

82. Yoruba Shrine
1957
Conté crayon
39 ¼ x 22 ½"
(99.7 x 57.2 cm)
Collection the artist

83. Three Kings
1962
Conté crayon
38 ½ x 59 ½"
(97.8 x 151.1 cm)
Collection Sarah Blaffer Hrdy

84. His Highness the Timi of
Ede
1962
Conté crayon
33 ½ x 58 ⅜"
(85.1 x 148.3 cm)
Collection Jackie Kimbrough Ryan

85. Drummers of Ede
1959
Conté crayon on paper mounted on
board
40 x 56 ½" (101.6 x 143.5 cm)
McAshan Foundation, Houston

86. Prempe II (Ashanti Royalty)
1957
Conté crayon
38 ⅝ x 29 ½"
(98.1 x 74.9 cm)

Ed Anderson Collection

87. Brother Man
1978
Conté crayon
48 x 36" (121.9 x 91.4 cm)
Collection Samella Lewis

88. King Sarah
1978–79
Conté crayon
39 ¼ x 29 ⅛" (101 x 74 cm)
Collection Dr. and Mrs. Joseph A.
Pierce, Jr.

89. James Baldwin
1970s
Conté crayon
22 x 32 ⅛" (55.9 x 81.6 cm)
Collection the artist

90. Man Throttled
1968
Conté crayon
36 ⅛ x 24 ⅛"
(91.8 x 61.3 cm)
Collection Ida Baird

IX. THE ARTIST AS GRIOT

91. Metamorphosis — Birth and
Rebirth
1974
Conté crayon
84 ¼ x 42" (214 x 106.7 cm)
Collection the artist

92. Three Generations
1979
Conté crayon
29 ½ x 36 ¾"
(74.9 x 93.4 cm)
Collection Mani Jasiri Short

93. Birmingham — Children of
the Morning
1964, printed 1989
Linocut
11 ¹⁵⁄₁₆ x 16 ¹⁄₁₆"
(30.3 x 40.8 cm)
Collection Mani Jasiri Short

94. Shotgun, Third Ward #1
1966
Oil on canvas
30 x 48" (76.2 x 121.9 cm)
National Museum of American Art,
Smithsonian Institution,
Washington, D.C.

95. Quilting Party (mural)
1980–81

Oil and acrylic
83 x 252" (210.8 x 640.1 cm)
*The Collection of the City of
Houston, Texas*

96. *Study for* Christia Adair
(mural)
1983
Graphite, pen, and colored pencil
10 ⅝ x 41 ¾"
(27 x 106.1 cm)
*Department of Fine Arts, Texas
Southern University, Houston*

97. Double Portrait of Christia
Adair
1983
Conté crayon
41 ⅝ x 29" (105.7 x 73.7 cm)
*Department of Fine Arts, Texas
Southern University, Houston*

98. East Texas Patchwork, Paris,
Texas *(mural)*
1986
Oil and acrylic
42 x 96" (106.7 x 243.8 cm)
*Paris Public Library, City of Paris,
Texas*

99. Ascension *(mural sketch)*
1988
Graphite and colored pencil
19 ½ x 40 ¹⁄₁₆"
(49.5 x 101.8 cm)
*Collection Winston-Salem Delta
Fine Arts, Inc.*

100. Origins *(mural sketch)*
1988
Graphite and colored pencil
22 ⅝ x 45 ¼"
(57.5 x 114.9 cm)
*Collection Winston-Salem Delta
Fine Arts, Inc.*

101. Tree House *(mural sketch)*
1989
*Graphite and colored pencil on
Mylar*
28 ⅛ x 13 ⅛"
(71.4 x 33.3 cm)
*Hampton University Museum,
Hampton, Virginia*

102. House of the Turtle
(mural sketch)
1989
*Graphite and colored pencil on
Mylar*
50 ¾ x 26 ¾"
(128.9 x 68 cm)

*Hampton University Museum,
Hampton, Virginia*

103. Shotguns
1987
Acrylic and oil on canvas
42 x 49 ⅞" (106.7 x 126.7 cm)
Private collection

104. Shotguns, Fourth Ward
1987
Acrylic and oil on board
41 ¾ x 32" (106.1 x 81.3 cm)
*Hampton University Museum,
Hampton, Virginia*

105. Shotguns, Third Ward
1987
Acrylic and oil on canvas
24 x 18" (61 x 45.7 cm)
*Collection Mr. and Mrs. Kenneth
Bacon*

106. Four Seasons
1984
Lithograph
24 x 34" (61 x 86.4 cm)
Collection V. Michael McCabe

107. Song of the Drinking
Gourd *(mural sketch)*
1984
Graphite
30 ¹⁄₁₆ x 40" (76.3 x 101.6 cm)
*Department of Fine Arts, Texas
Southern University, Houston*

108. Upper Room
1984
Lithograph
36 x 48" (91.4 x 121.9 cm)
Collection Alva Baker

X. ASCENSION – ANCIENT ICONS REDISCOVERED

109. The Mammys
1979–80
Conté crayon
30 x 22 ⅛" (76.2 x 56.2 cm)
*Collection Dr. and Mrs. Joseph A.
Pierce, Jr.*

110. The House My Father Built
1983
Conté crayon
40 x 30" (101.6 x 76.2 cm)
*Collection Dr. and Mrs. Robert
Galloway*

111. Midnite Hour
1985

Conté crayon
39 x 29 ¼" (99.1 x 74.3 cm)
Collection the artist

112. Climbing Higher
Mountains
1986
Oil and acrylic on canvas
40 x 36" (101.6 x 91.4 cm)
*Hampton University Museum,
Hampton, Virginia*

113. Baptism
1989
Oil and acrylic on canvas
50 x 42" (127 x 106.7 cm)
*Hampton University Museum,
Hampton, Virginia*

114. Four Sisters
1986
Oil and acrylic on canvas
36 x 48" (91.4 x 121.9 cm)
*Hampton University Museum,
Hampton, Virginia*

115. Wheel in Wheel
1986
Oil and acrylic on canvas
50 x 30" (127 x 76.2 cm)
*Collection Dr. and Mrs. William
Harvey*

116. Family of Five
1987
Bronze
10 ¼ x 6 ¼ x 5"
(26 x 15.9 x 12.7 cm)
*Hampton University Museum,
Hampton, Virginia*

117. This Little Light of Mine
1987
Oil on canvas
40 ¼ x 67 ½"
(102.2 x 171.5 cm)
Bickerstaff, Heath, and Smiley

118. Seven Little Sisters
1987–89
Oil and acrylic on canvas
27 x 39" (68.6 x 99.1 cm)
Private Collection

119. Children of the Morning
1980s
Oil and acrylic on canvas
23 x 37 ¼" (58.4 x 94.6 cm)
Private Collection

120. Family Arc
1992

Lithograph
22 ⁷⁄₁₆ x 37 ⅞"
(57 x 96.5 cm)
*Brandywine Graphic Workshop,
Philadelphia, Pennsylvania*

121. Spring Renewal
(Path and Stream)
1994
Oil on canvas
36 x 30" (91.4 x 76.2 cm)
Collection Dr. Rahn Hall

122. Shadowing of the Wings
1974–78
Conté crayon
35 x 25" (88.9 x 63.5 cm)
Ed Anderson Collection

123. Creation
1964
Conté crayon
36 x 24" (91.4 x 61 cm)
*Department of Fine Arts, Texas
Southern University, Houston*

124. Starry Crown
1987
Acrylic on canvas
61 x 49" (154.9 x 124.5 cm)
*Dallas Museum of Art, Museum
League Purchase Fund*

125. Band of Angels: Weaving
the Seventh Word
1992–93
Oil and acrylic on canvas
48 ¼ x 72 ¹⁄₁₆"
(122.6 x 183 cm)
*Wadsworth Atheneum, Hartford,
Connecticut, The Ella Gallup
Sumner and Mary Catlin Sumner
Collection*

126. How I Got Over
1987
Oil and acrylic on Masonite
40¹¹⁄₁₆ x 30⅞" (103.3 x 78.4 cm)
Collection Mrs. Gloria J. Coleman

127. Study for View from the
Upper Room
1993–94
Conté crayon and pastel
48 ⅛ x 34" (122.2 x 86.4 cm)
*The Museum of Fine Arts,
Houston. Museum purchase with
funds provided by the African
American Art Advisory Association
and partial gift of the artist*

The Plates

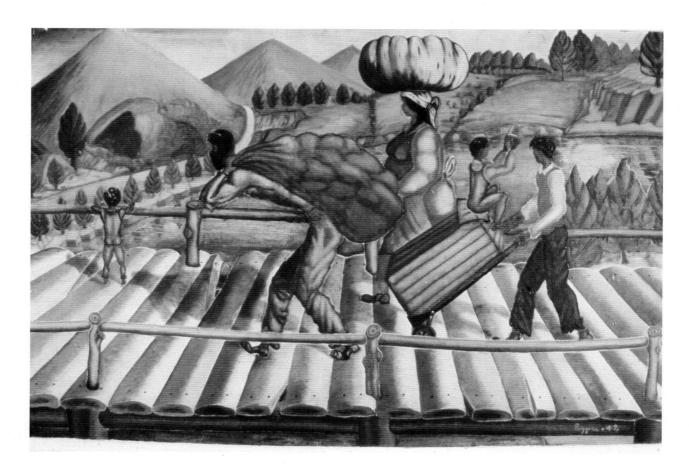

Crossing the Bridge, 1942
(Cat. no. 1)

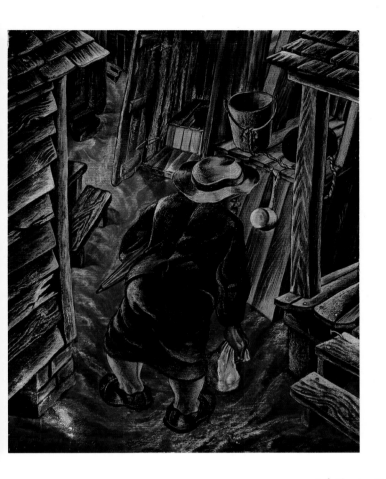 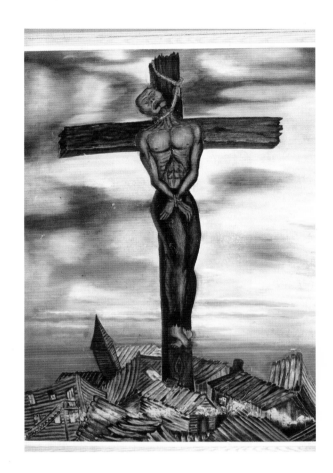

Left: Coming Home from Work, 1944
(Cat. no. 5)

Right: Crucifixion, 1942
(Cat. no. 19)

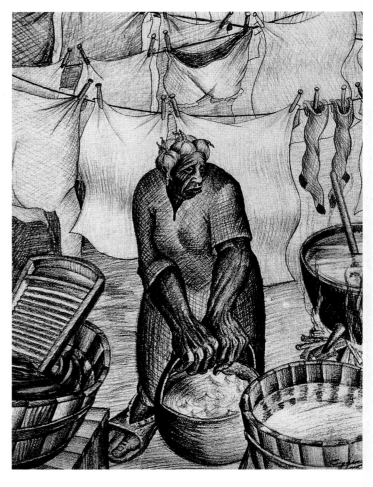

Above:
Laundry Woman, 1940s
(Cat. no. 42)

Below:
Country Preacher, 1943
(Cat. no. 52)

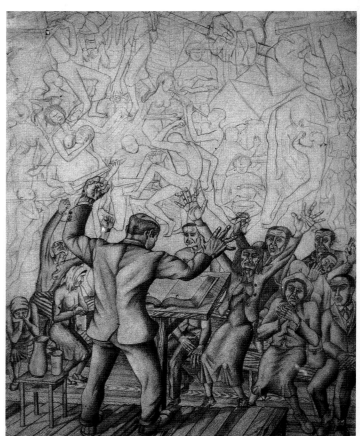

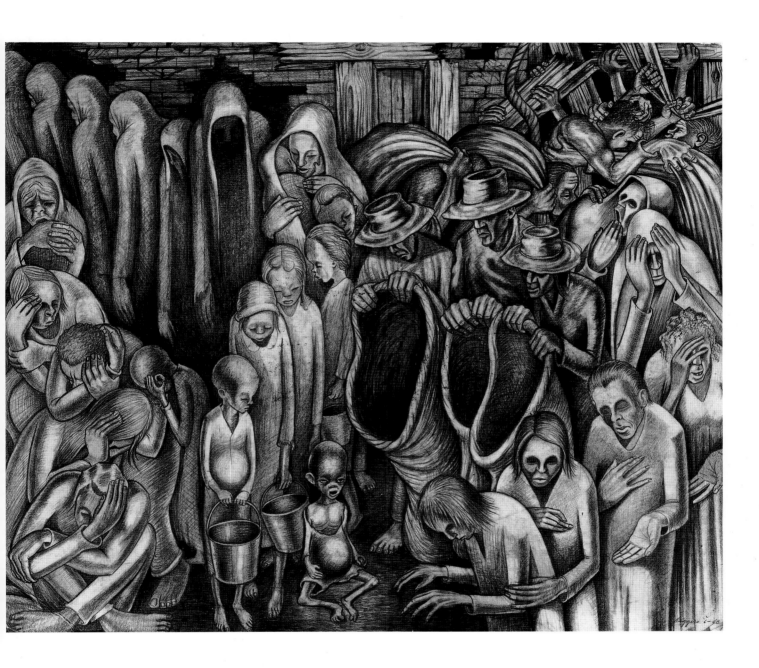

Night of the Poor, 1948
(Cat. no. 48)

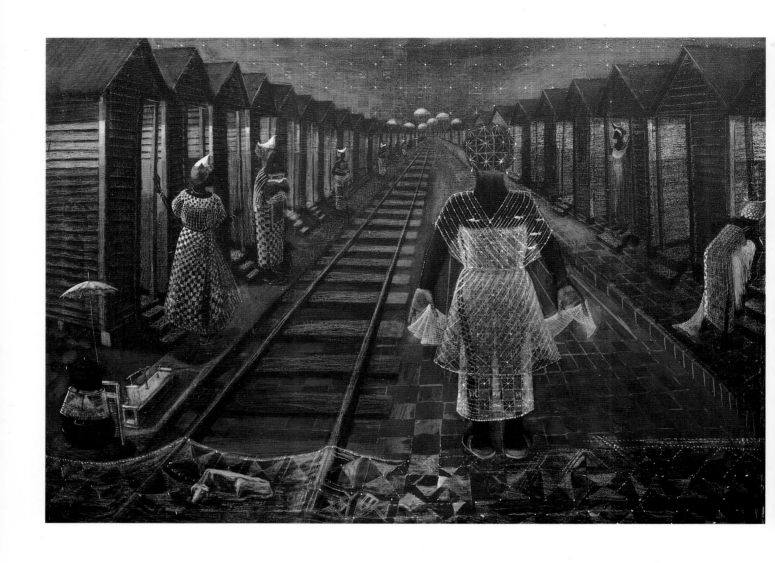

This Little Light of Mine, 1987
(Cat. no. 117)

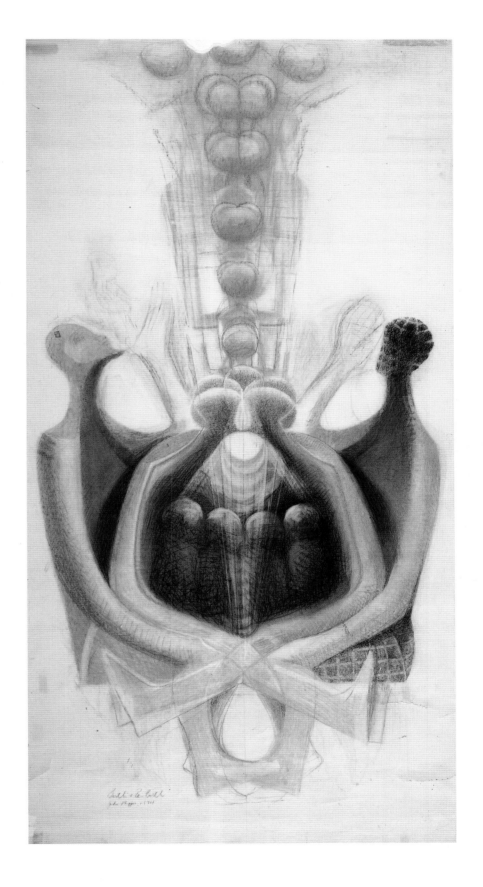

Metamorphosis—Birth and Rebirth,
1974 (Cat. no. 91)

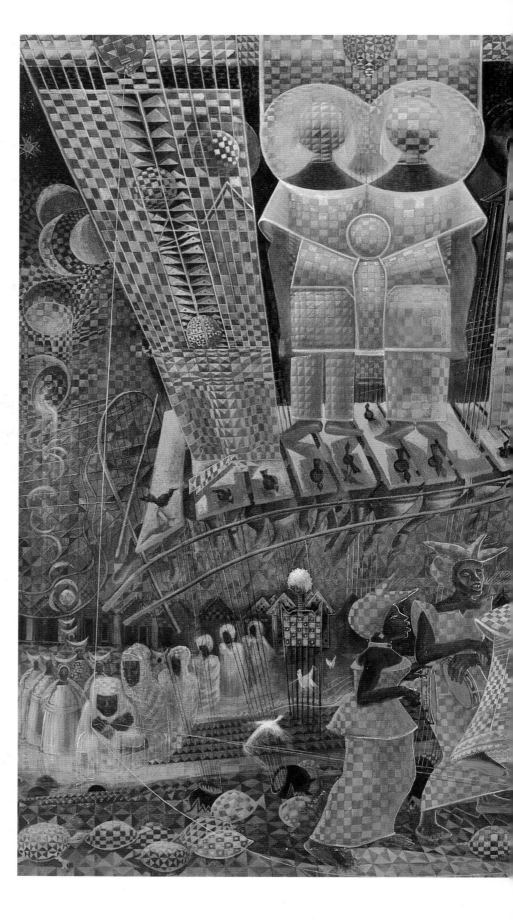

Quilting Party, 1980–81
(Cat. no.95)

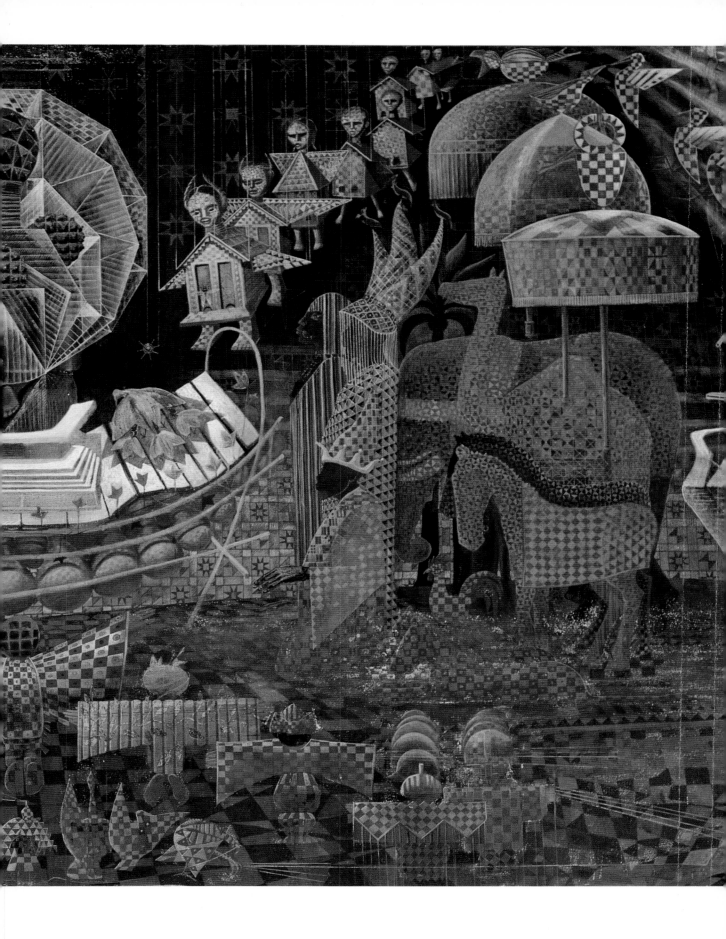

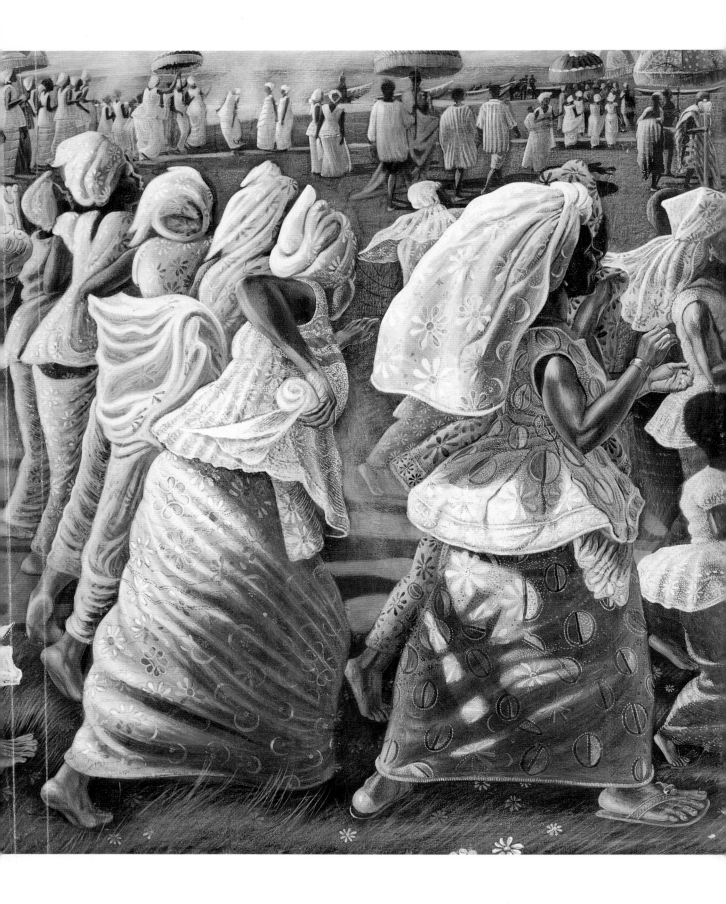

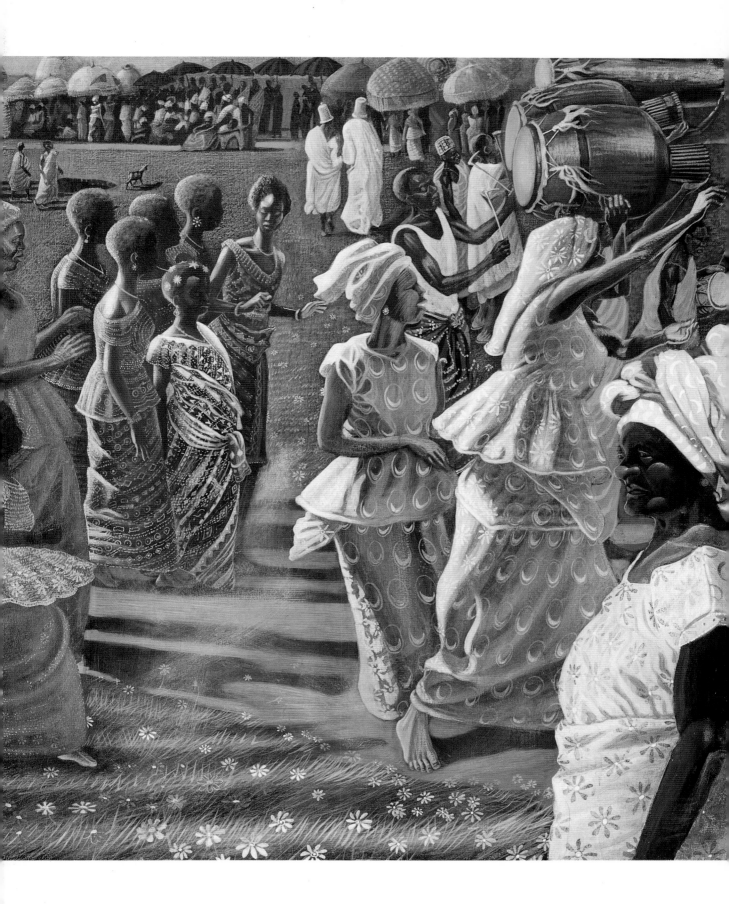

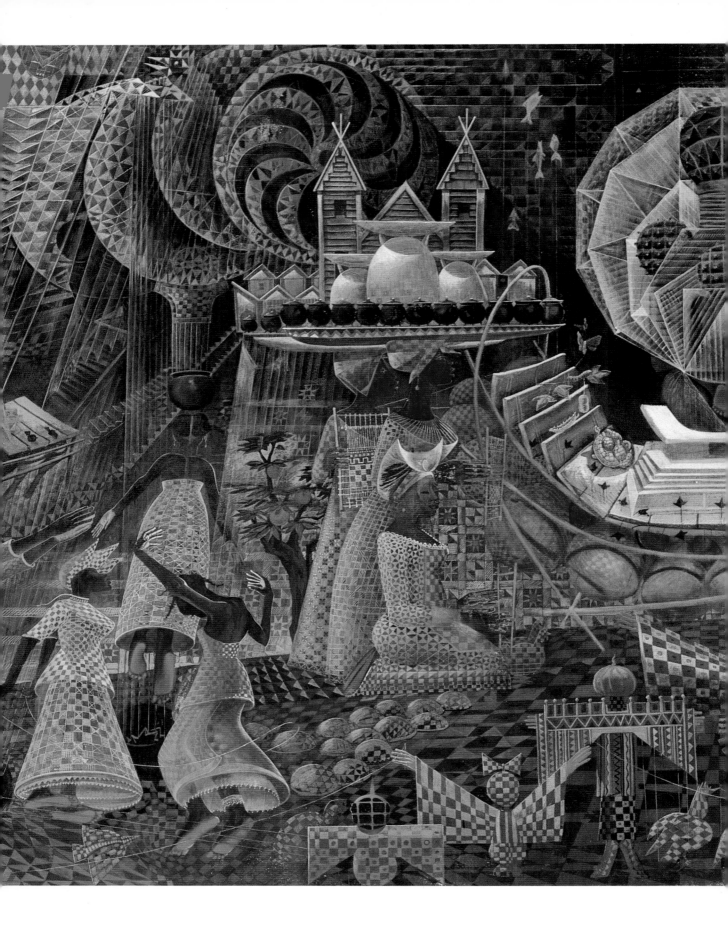

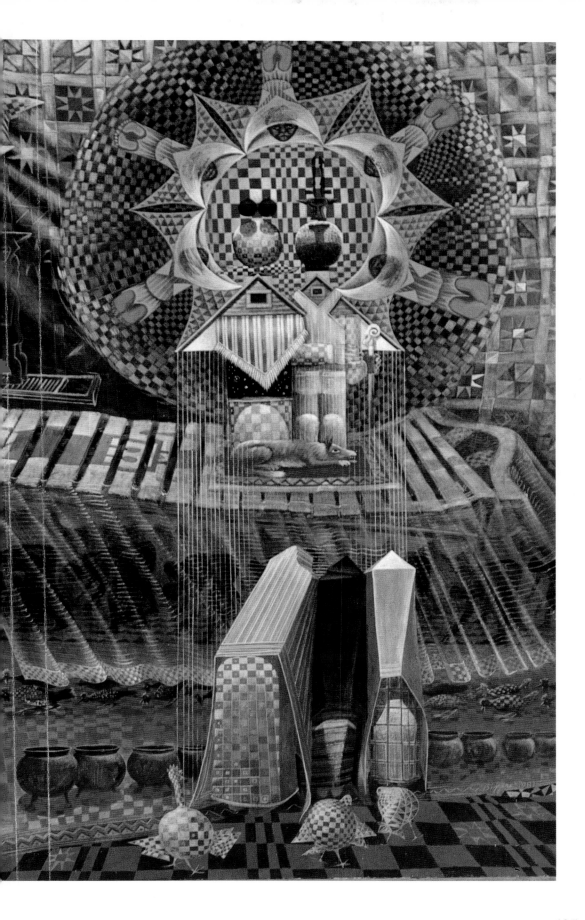

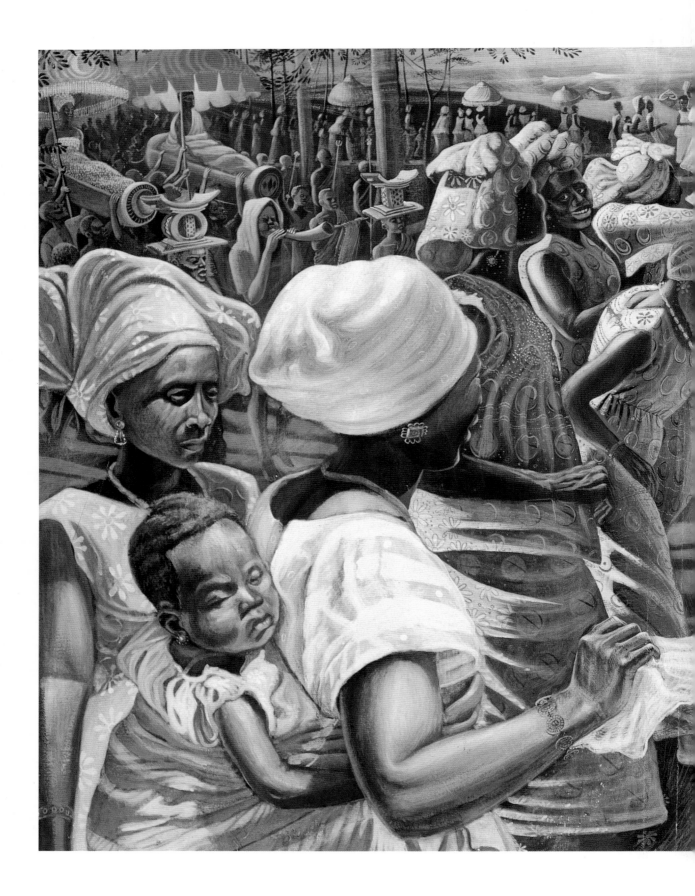

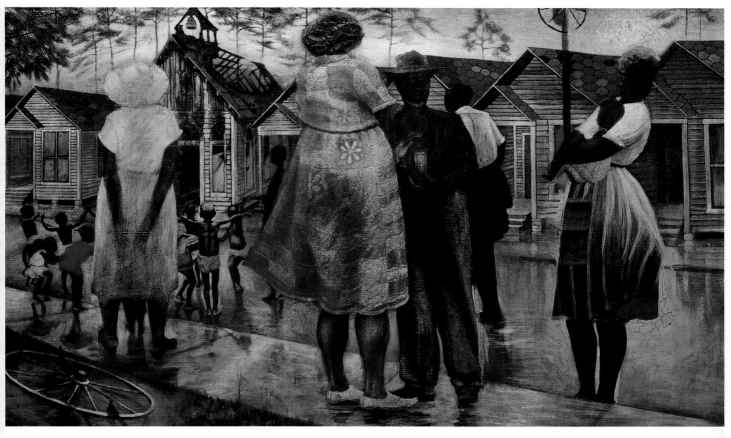

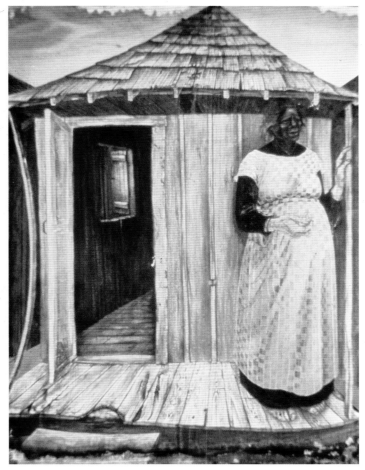

Gatefold:
Jubilee: Ghana Harvest Festival,
1959–63
(Cat. no. 64)

Above:
Shotgun, Third Ward, # 1, 1966
(Cat. no. 94)

Right:
First Shotgun, 1949–50
(Cat. no. 28)

129

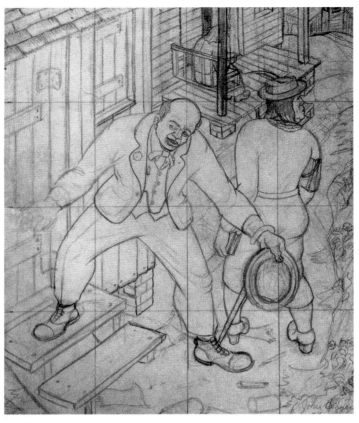

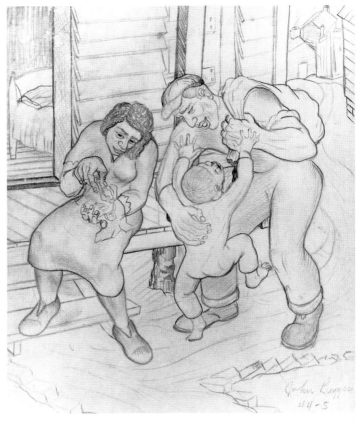

Clockwise, from upper left:
Going to Church, 1944
(Cat. no. 6)

Mother, Father, Child, 1944
(Cat. no. 10)

Going Through the Storm, 1942
(Cat. no. 18)

Rape and *Mother Scrubbing*,
from *Dying Soldier*, 1942
(Cat. nos. 16 and 17)

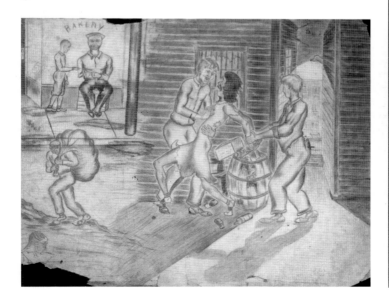

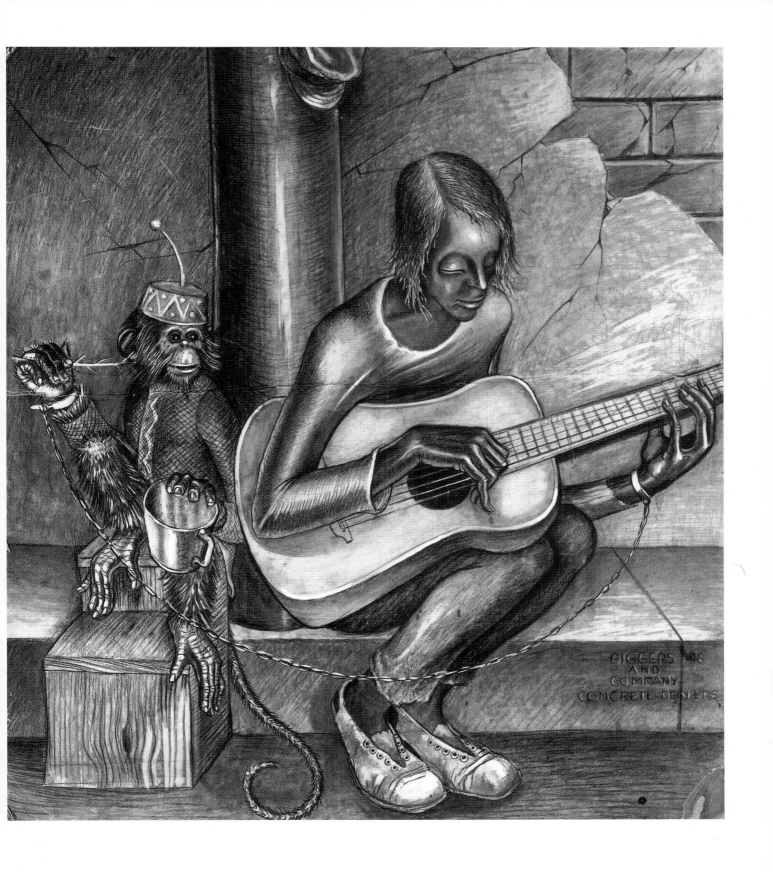

Above:
Blind Boy and Monkey, 1948
(Cat. no. 23)

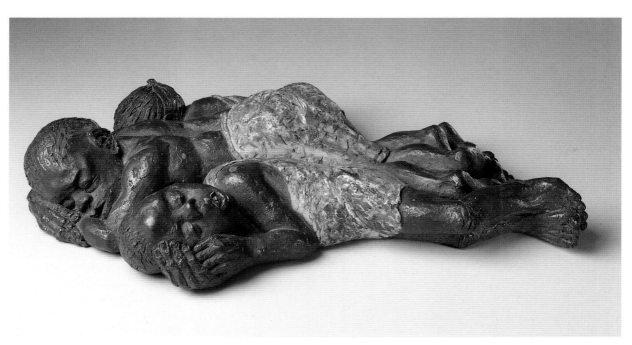

Above:
Sleeping Children, 1950
(Cat. no. 7)

Right:
Freedom March, 1952
(Cat. no. 54)

Opposite:
Nude Study—Tougalou, 1966
(Cat. no. 38)

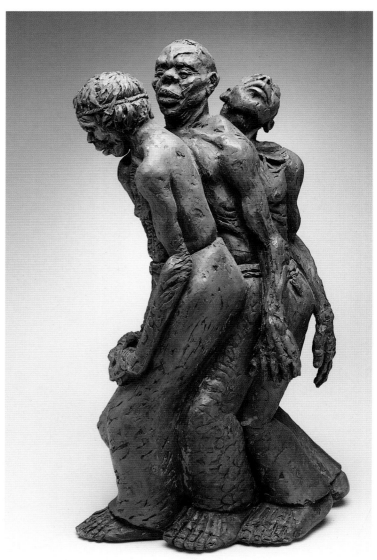

132

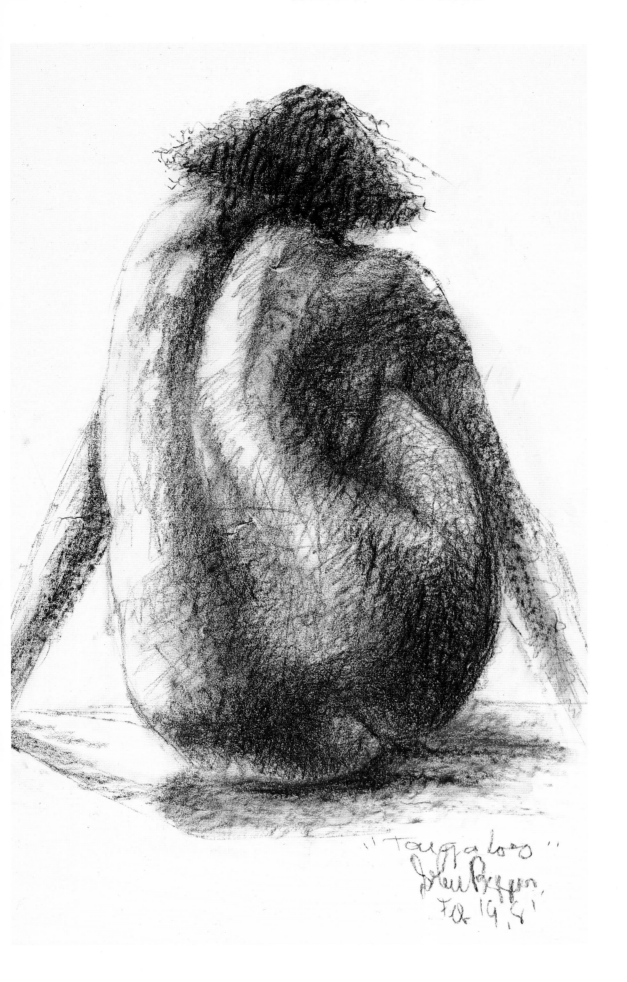

"Tougaloo"
John Biggers
Tx. 19, 81

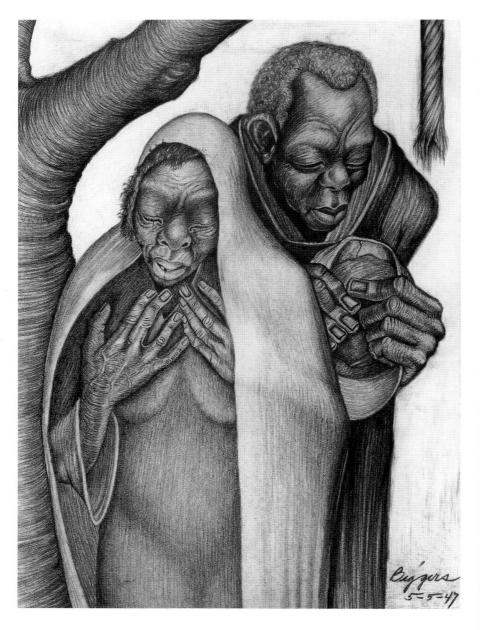

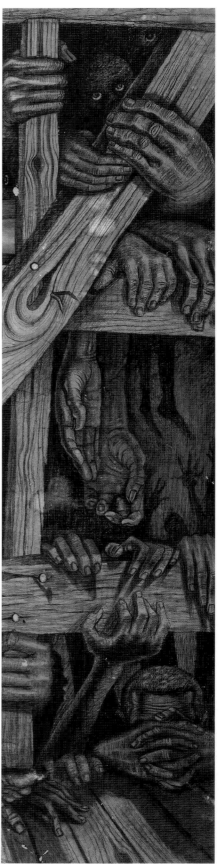

Above:
Old Couple, 1947
(Cat. no. 4)

Right:
Middle Passage, 1947
(Cat. no. 13)

134

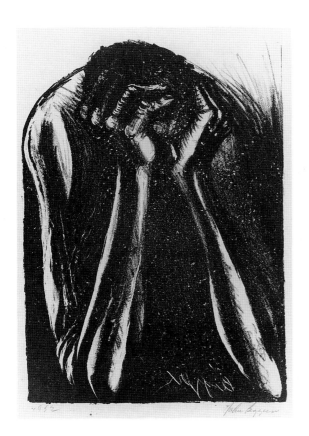
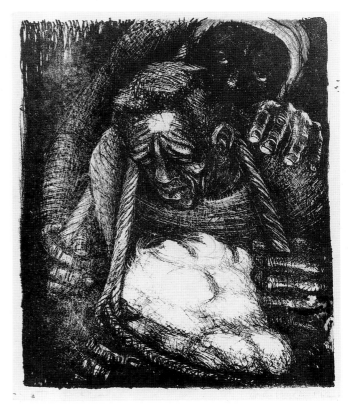

Left:
Despair, 1952
(Cat. no. 22)

Right:
Cotton Pickers, 1950s
(Cat. no. 44)

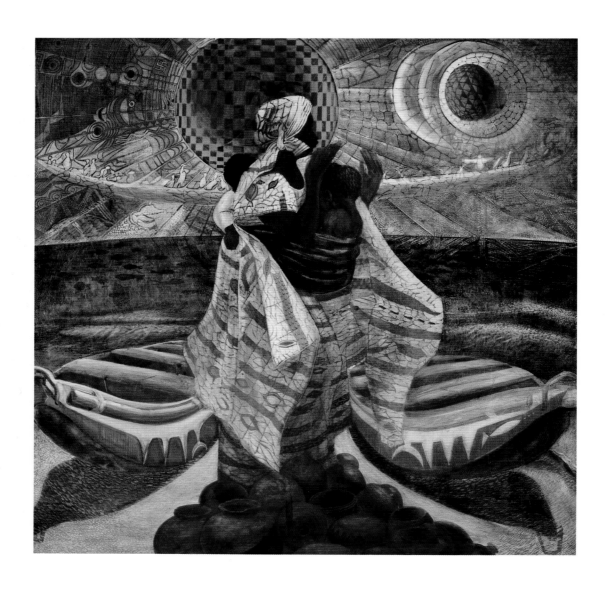

Woman and Twins with Boat,
mid–1970s
(Cat. no. 72)

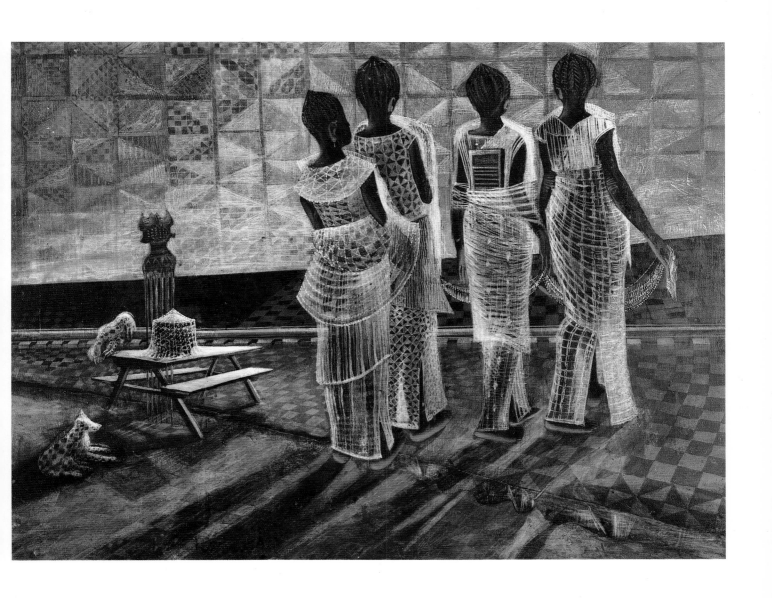

Four Sisters, 1986
(Cat. no. 114)

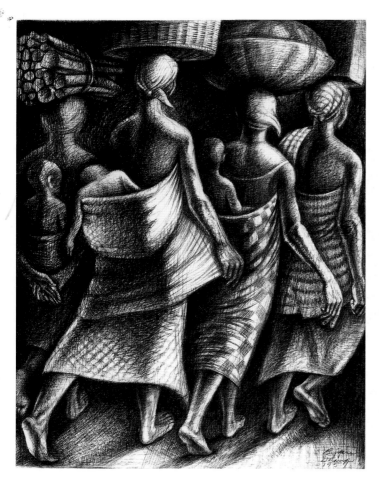

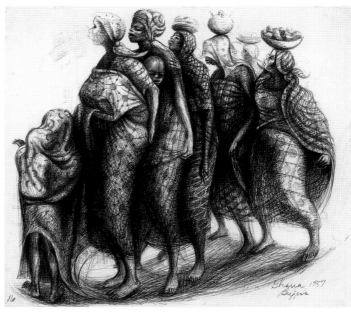

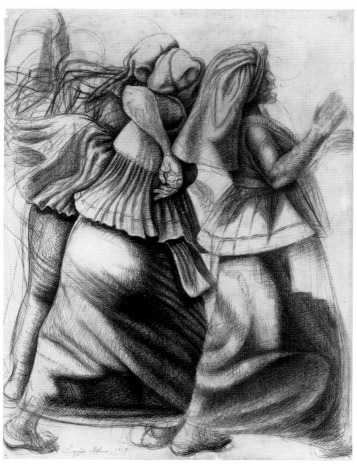

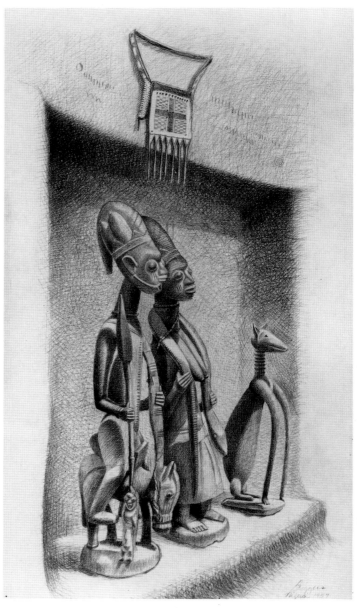

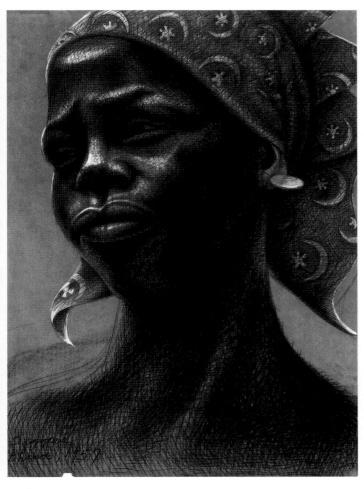

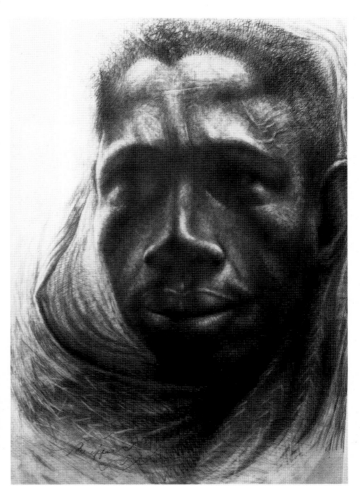

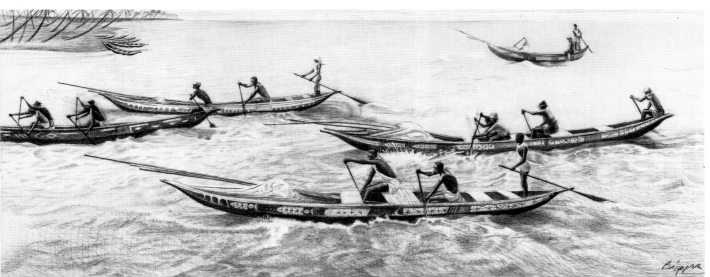

Opposite,
Clockwise from upper left: Women
Walking to Market,
1957 (Cat. no. 62);
Waiting Patiently, 1957
(Cat. no. 67);

Yoruba Shrine, 1957
(Cat. no. 82);
Dancers of the Ghana Harvest
Festival, 1957
(Cat. no. 60);
Above, left:

Daughter of the Moon, 1957
(Cat. no. 66)
Above, right:
Man, 1950s (Cat. no. 26)
Below: Returning Home, 1957
(Cat. no. 75)

139

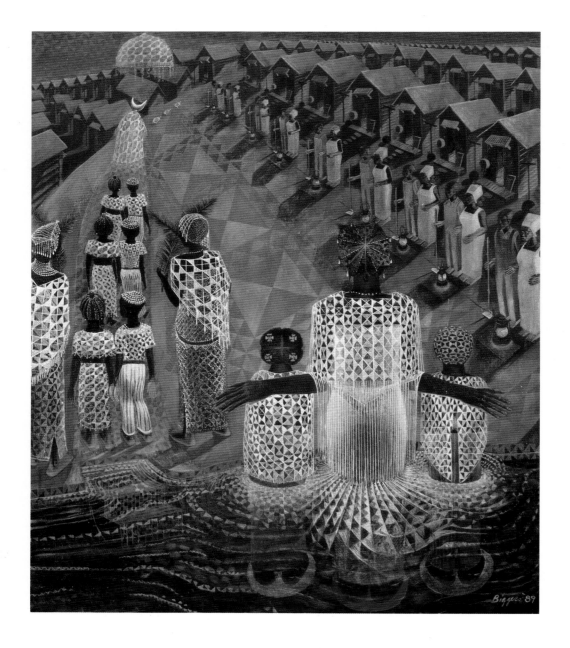

140

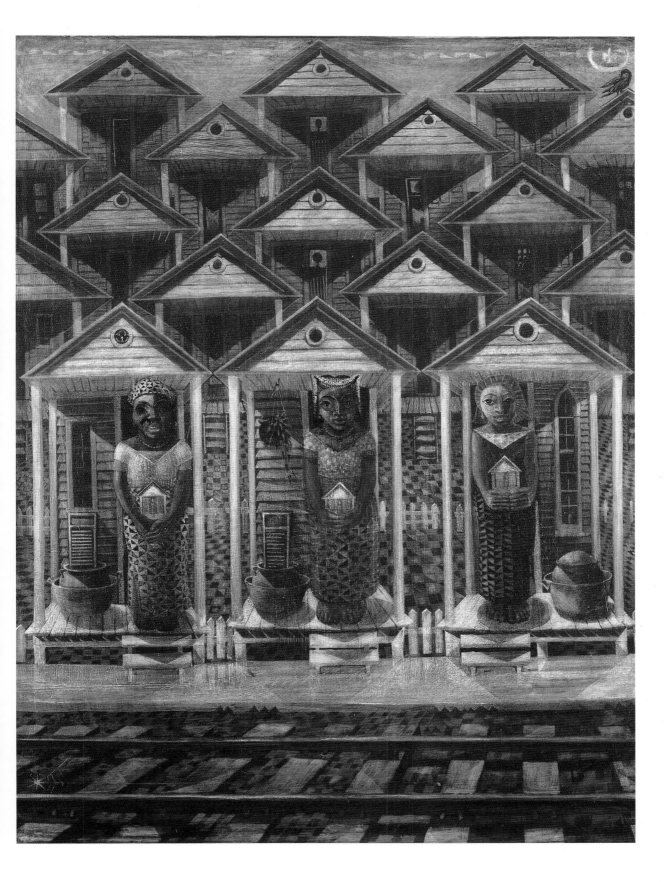

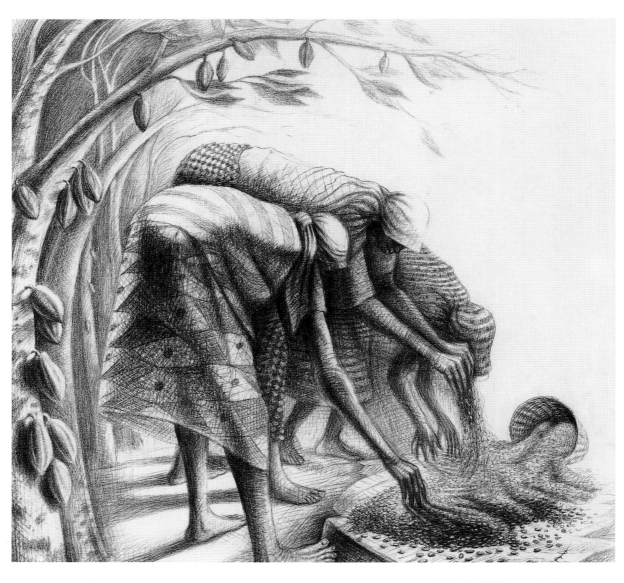

Above:
Cocoa Farm, 1957
(Cat. no. 77)

Right:
Prempe II (Ashanti Royalty), 1957
(Cat. no. 86)

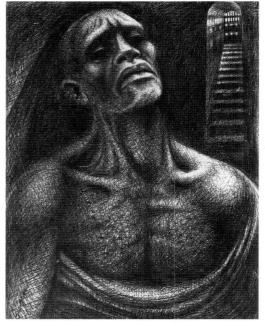

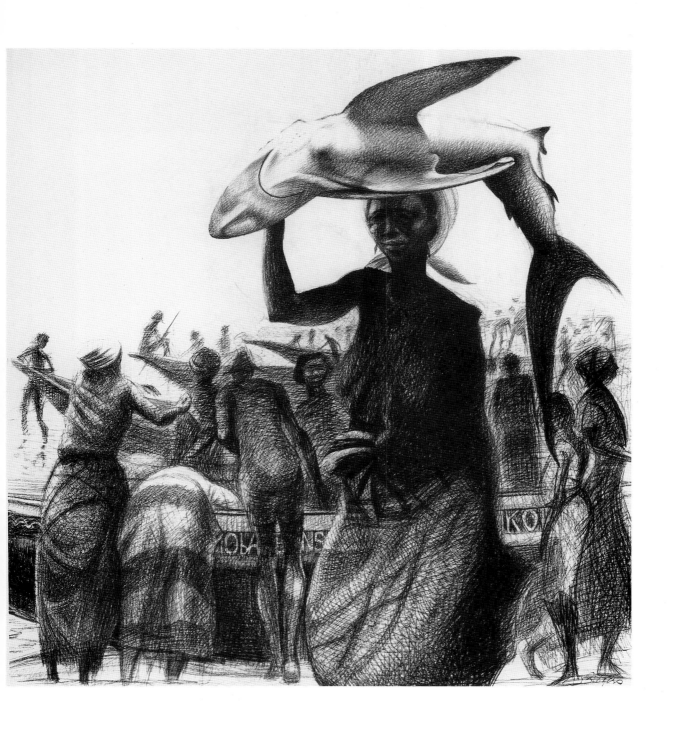

Above:
Harvest from the Sea, 1957
(Cat. no. 74)

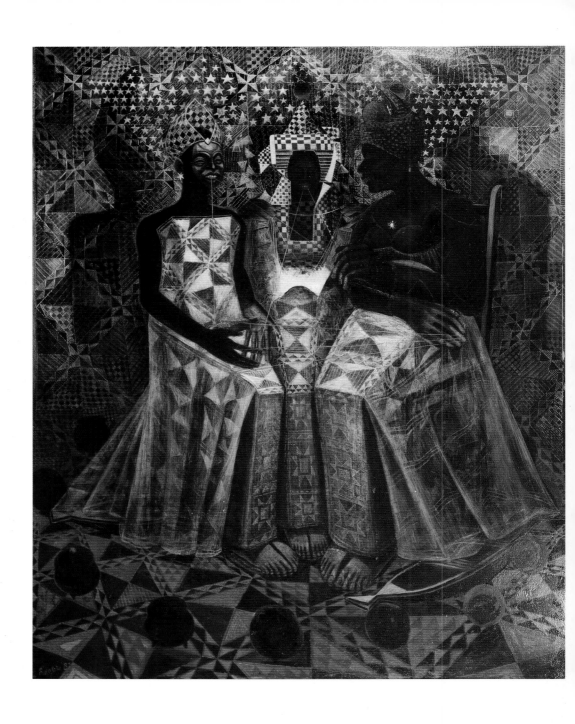

Above:
Starry Crown, 1987
(Cat. no. 124)

Opposite:
Study for View from the Upper Room,
1993–94
(Cat. no. 127)

144

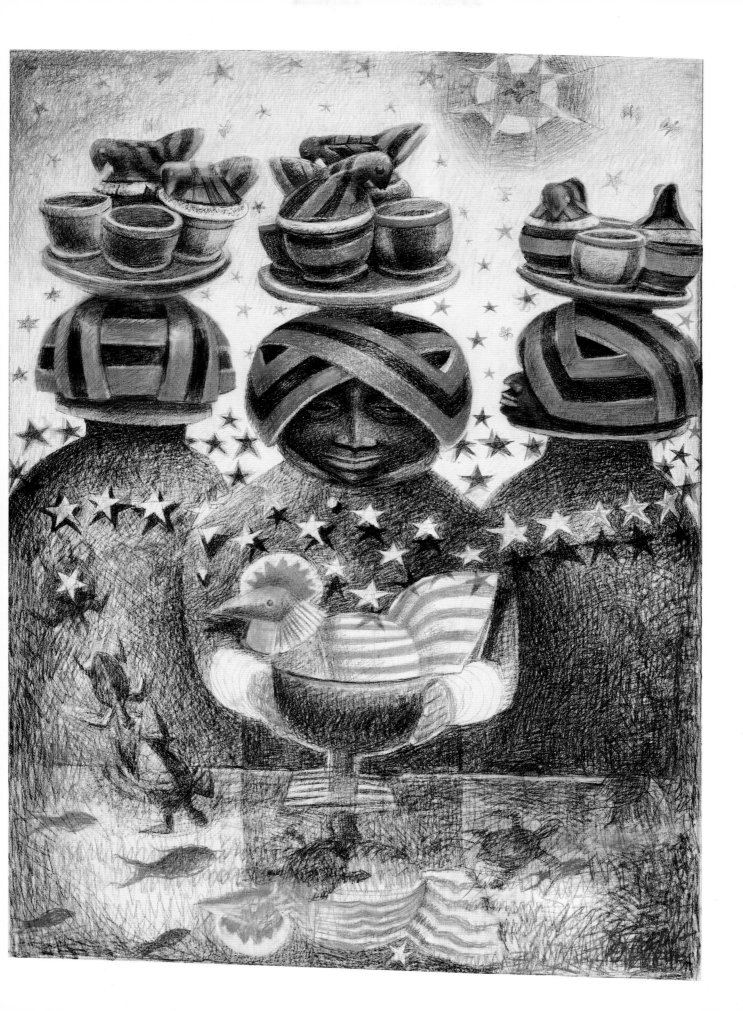

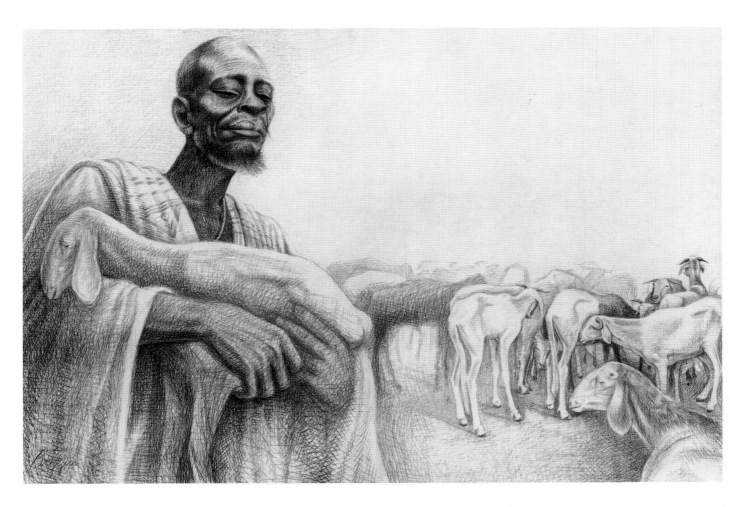

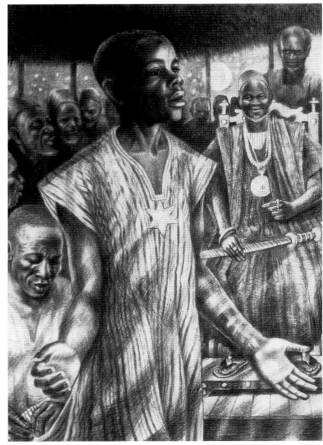

Above:
Shepherd, 1958–61
(Cat. no. 69)

Right:
Momolou Speaks, 1964
(Cat. no. 25)

Opposite:
His Highness the Timi of Ede, 1962
(Cat. no. 84)

146

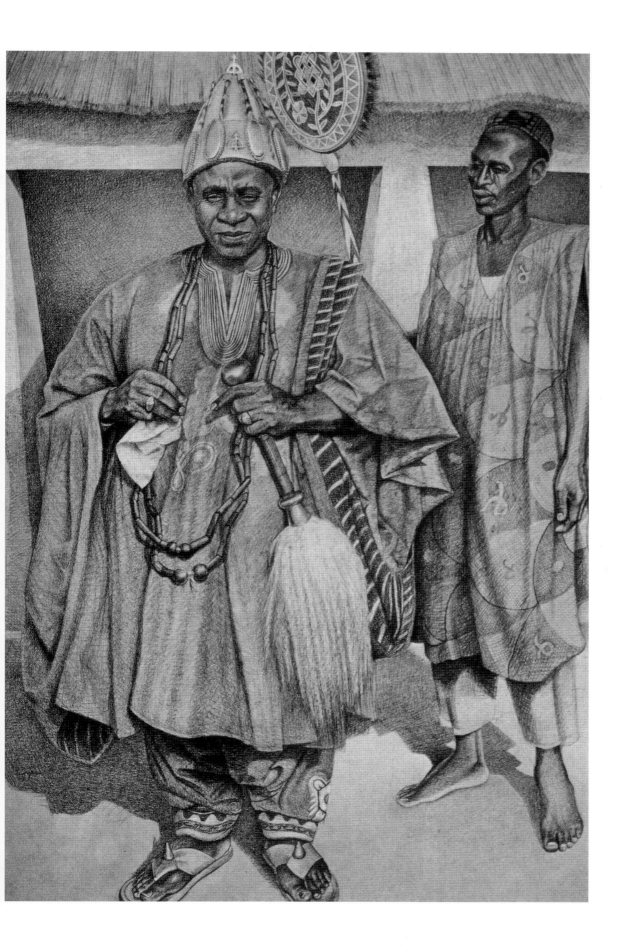

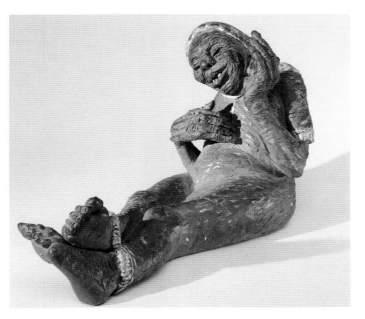

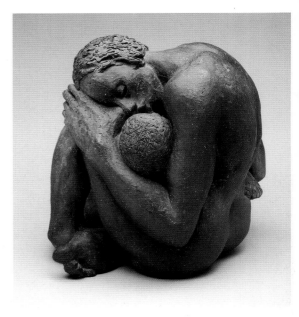

Above, left:
Aunt Dicy, 1950s
(Cat. no. 29)

Above, right:
Mother and Child, ca. 1951
(Cat. no. 37)

Right:
Woman Listening, 1950
(Cat. no. 30)

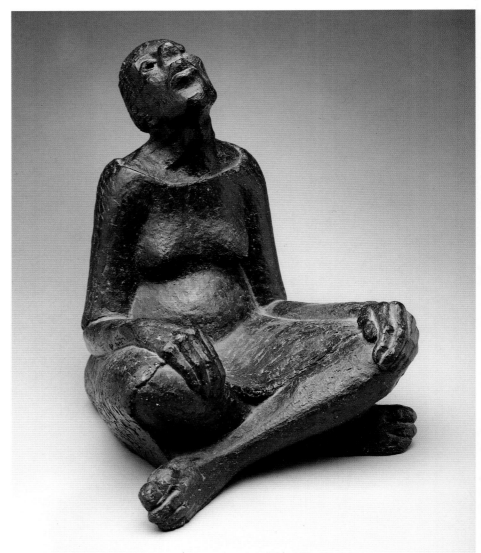

148

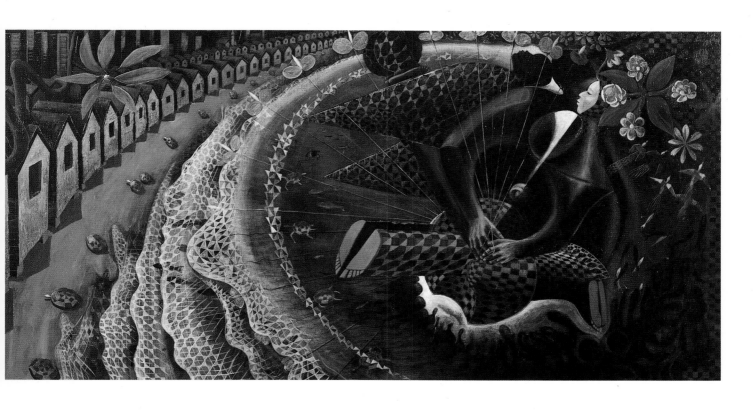

Spring Renewal (Path and Stream),
1994 (Cat. no. 121)

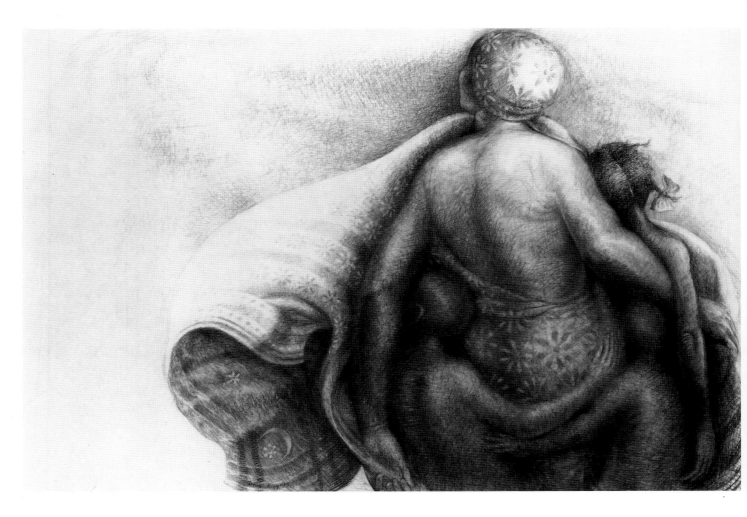

Above:
Mother and Three Children, 1947
(Cat. no. 9)

Right:
Creation, 1964 (Cat. no. 123)

Opposite:
Gondor Market: Ethiopian Mother, 1970
(Cat. no. 68)

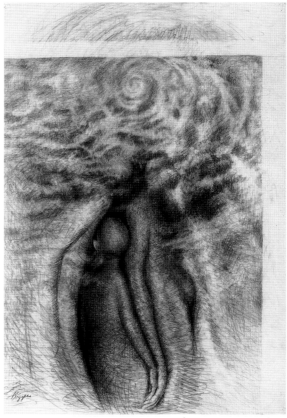

150

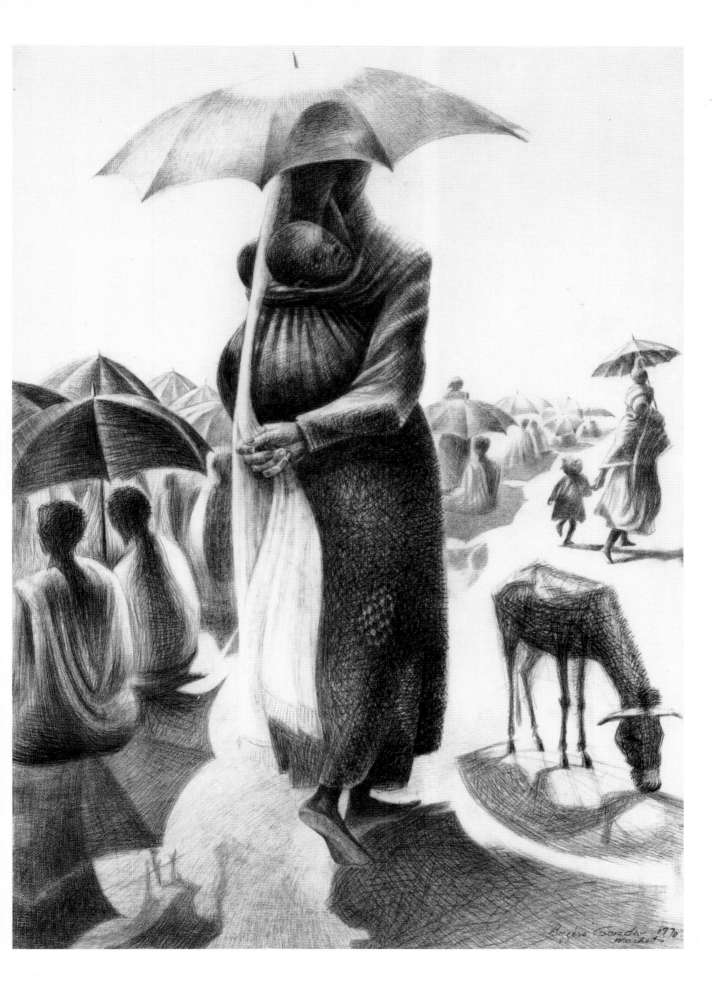

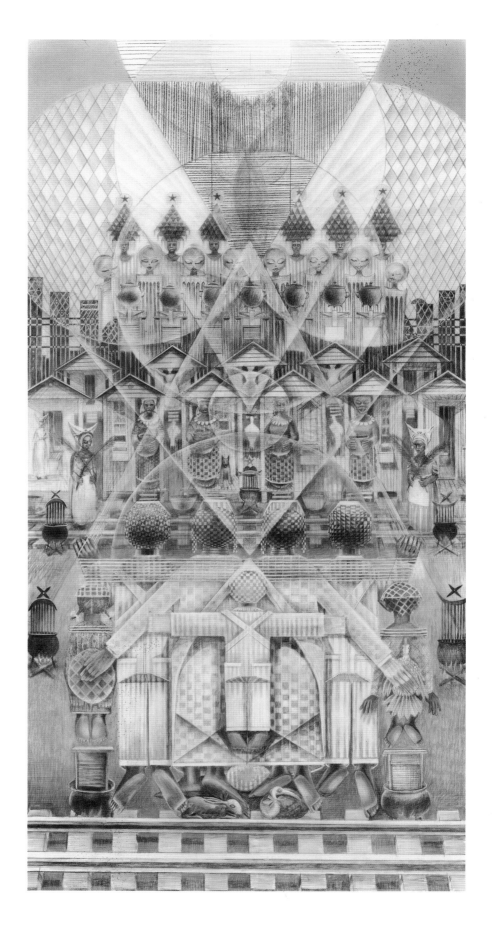

Ascension, 1988
(Cat. no. 99)

152

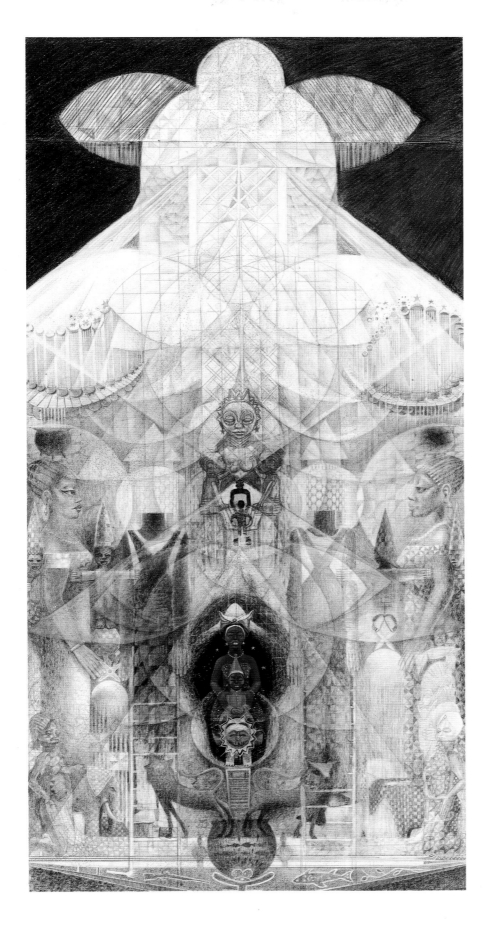

Origins, 1988 (Cat. no. 100)

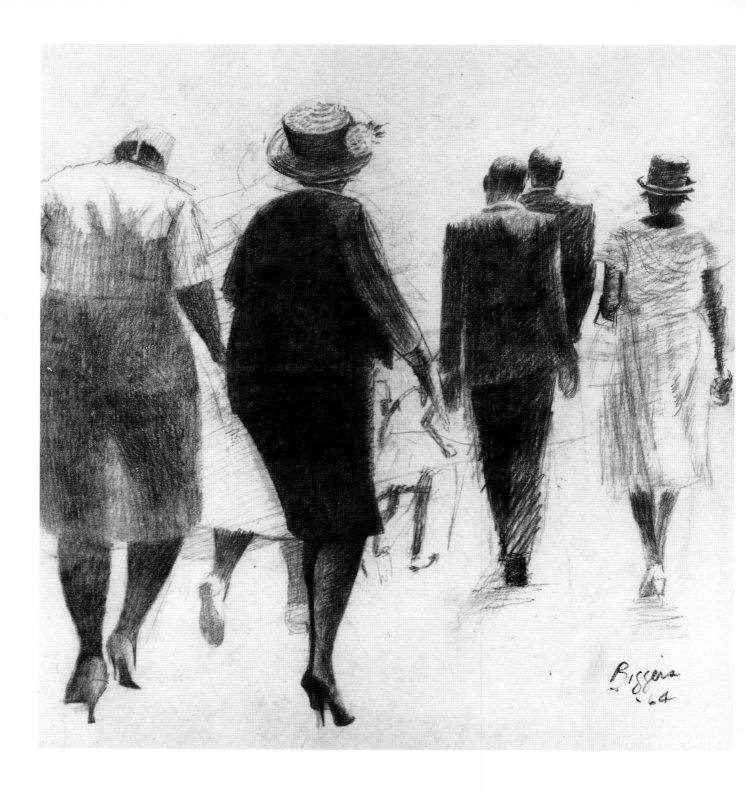

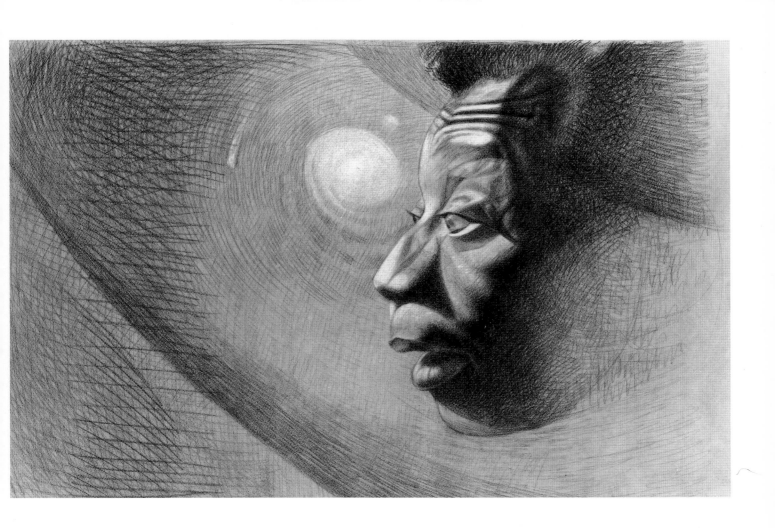

Opposite:
Going to Church, 1964
(Cat. no. 59)

Above:
James Baldwin, 1970s
(Cat. no. 89)

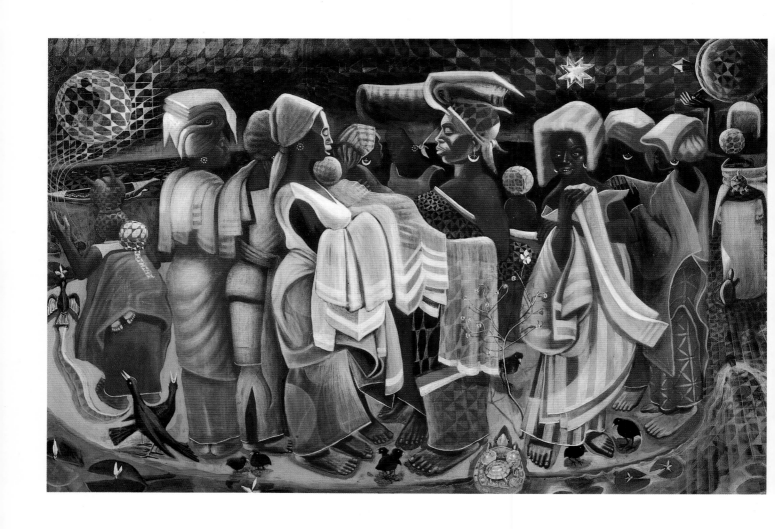

Band of Angels:
Weaving the Seventh Word, 1992–93
(Cat. no. 125)

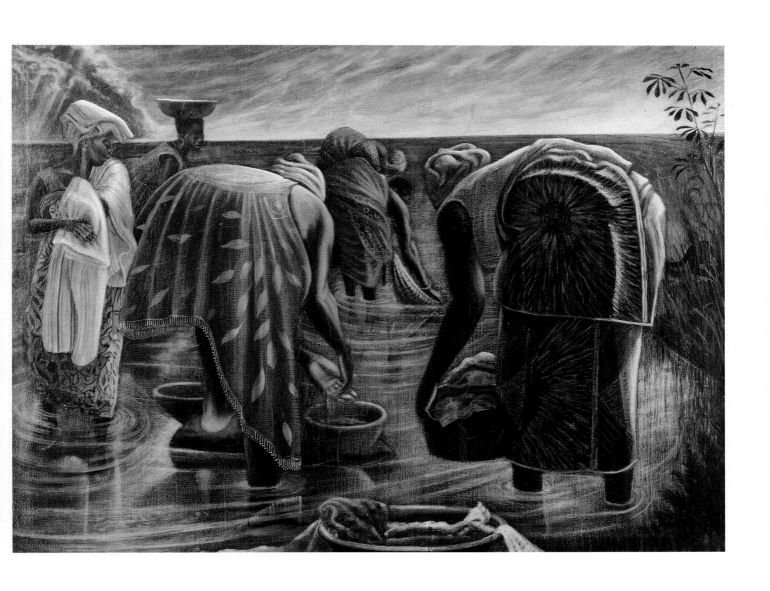

Laundry Women
(Washerwomen in Volta Region),1959
(Cat. no. 61)

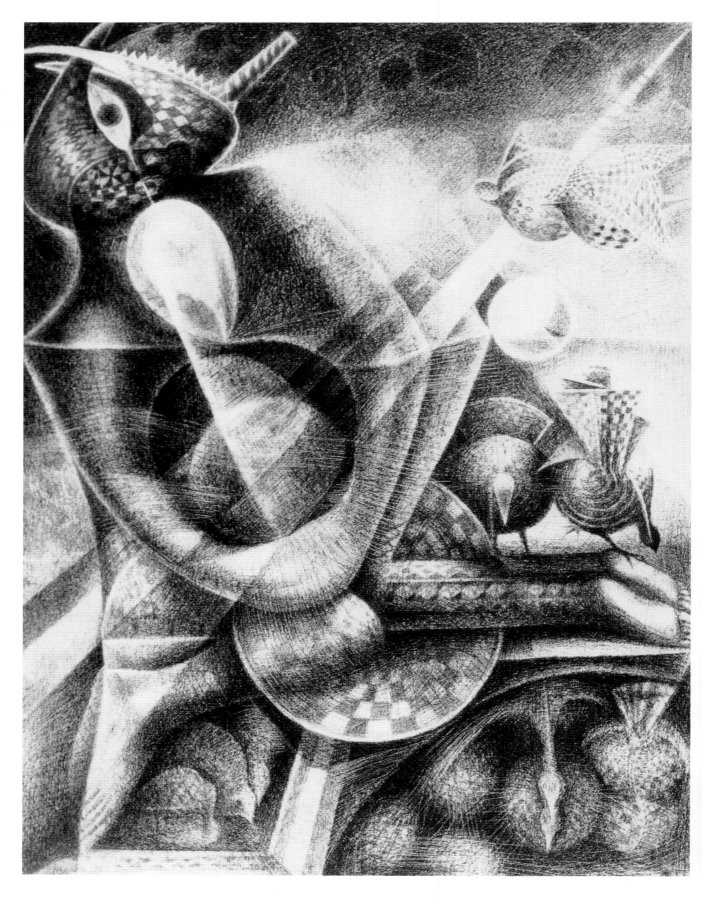

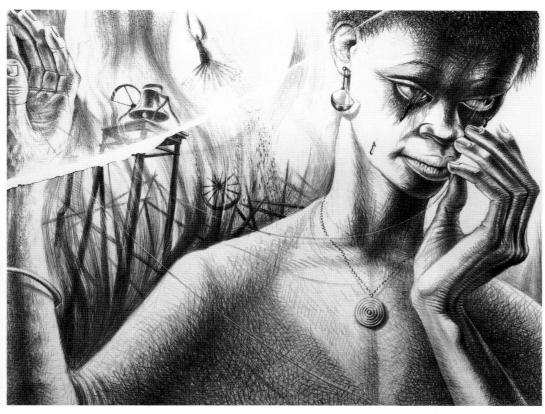

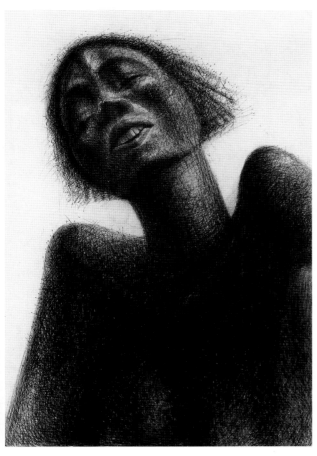

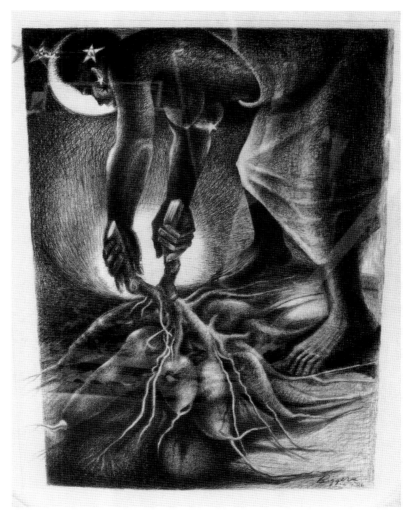

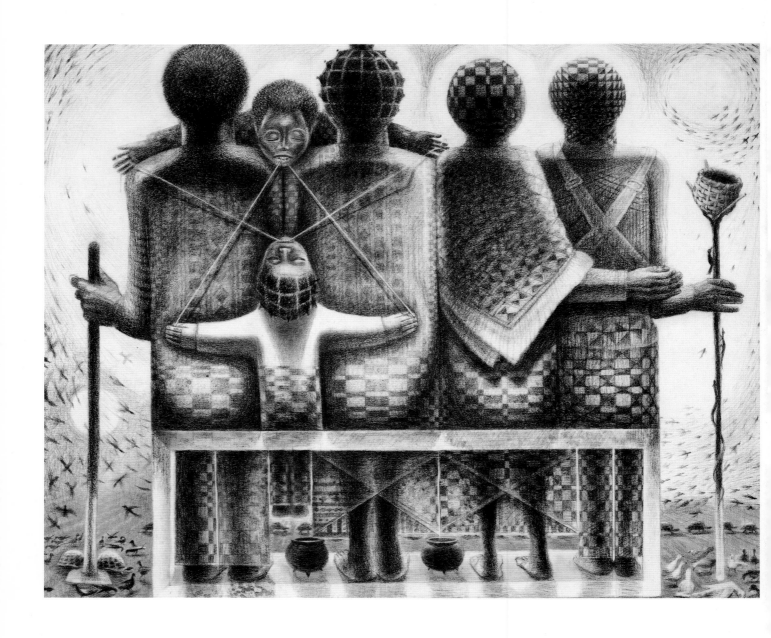

Three Generations, 1972
(Cat. no. 92)

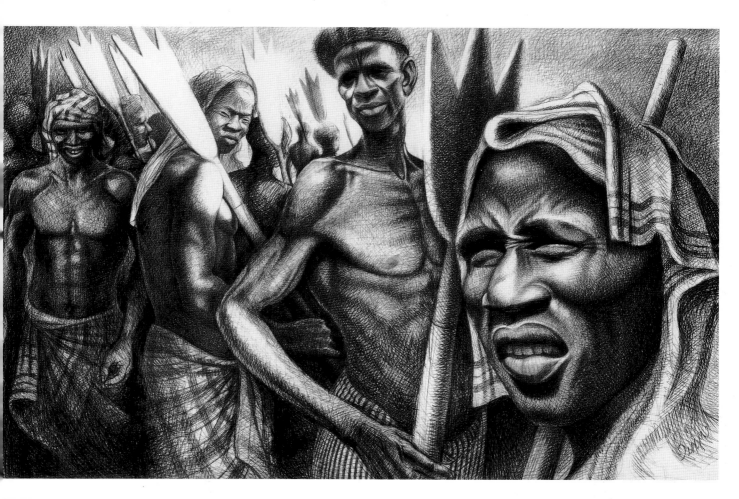

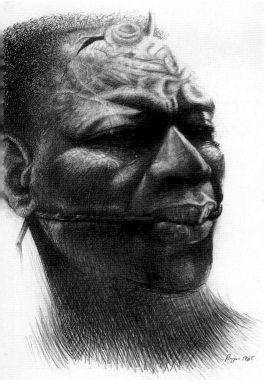

Above:
Oarsmen, 1962 (Cat. no. 76)
Left:
Man Throttled, 1968 (Cat. no. 90)

John Biggers: Chronology and Selected Exhibition History
Alison de Lima Greene and Alvia J. Wardlaw

Bibliographic note: Historical events (in italics) are drawn in large part from Kenneth Estell, ed., *The African-American Almanac* (Sixth edition; Detroit, Washington, D.C., and London: Gale Research Inc., 1994). Other sources include: Howard Beeth and Cary D. Wintz, eds., *Black Dixie: Afro-Texan History and Culture in Houston* (College Station: Texas A&M Press, 1992); Robert D. Bullard, *Invisible Houston: The Black Experience in Boom and Bust* (College Station: Texas A&M Press, 1987); Robert V. Rozelle, Alvia J. Wardlaw, and Maureen A. McKenna, eds., *Black Art—Ancestral Legacy: The African Impulse in African-American Art* (Dallas Museum of Art, 1990); Dr. William E. Terry, *Origin and Development of Texas Southern University, Houston, Texas* (Houston: D. Armstrong & Co., 1968); and conversations with the artist.

1912

Houston chapter of the National Association for the Advancement of Colored People (NAACP) founded.

1921

Negro Division of Education Act established in North Carolina.

1924

April 13: John Biggers is born to Paul and Cora Biggers, Gastonia, North Carolina. He is the youngest of seven children.

1925

Alain Locke publishes The New Negro.

1926

The New York Public Library purchases Arthur Schomburg's collection of historical documents, manuscripts, and artworks. This collection becomes the foundation of the Schomburg Center for Research in Black Culture at the 135th Street Branch Library.

Death of Lillian Biggers, the artist's sister.

1927

Houston Colored Junior College is founded.

1931

Alain Locke's essay "The African Legacy and the Negro Artist" appears in the annual exhibition catalogue of the Harmon Foundation, New York.

1934

Houston Colored Junior College is expanded into a four-year program, and is renamed Houston College for Negroes.

1935

Mary McLeod Bethune founds National Council of Negro Women in New York.

1936

As a part of the Texas Centennial, the Hall of Negro Life at the Fair Park in Dallas features 93 works by 38 artists.

1937

Death of Paul Biggers. John Biggers enters Lincoln Academy, Kings Mountain, North Carolina.

1939

September: Viktor Lowenfeld joins faculty of Hampton Institute (now Hampton University), Hampton, Virginia; establishes art program.

1940

Alain Locke publishes The Negro in Art: A Pictorial Record of the Negro Artist and of the Negro Theme in Art.

1941

September 1: Biggers enters Hampton Institute.

December 7: Bombing of Pearl Harbor; United States enters World War II.

1942

Hale Woodruff organizes first annual exhibition of black artists at Atlanta University, Atlanta, Georgia. Annual exhibitions continue through 1970.

Biggers meets Hazel Hales, an accounting major. Creates *Dying Soldier* mural and related studies.

Viktor Lowenfeld begins to organize an exhibition of Hampton student work for the Museum of Modern Art, New York; exhibition opens in 1943 and includes Biggers's *Dying Soldier*.

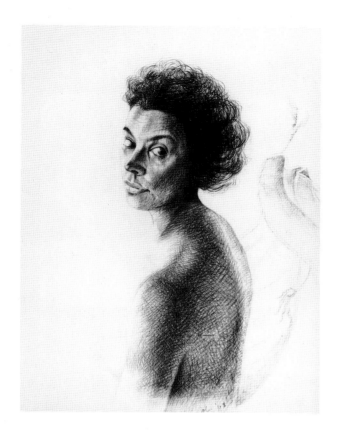

Hazel, 1963 (Cat. no. 34)

1943

James A. Porter publishes Modern Negro Art.

May: Biggers inducted into U.S. Navy; basic training at Great Lakes, Illinois. Stationed at Hampton's U.S. Navy training School after completing basic training. Creates murals in Officers' Training Mess and the Naval Gymnasium, depicting the horrors of war (destroyed).

Elizabeth Catlett joins the faculty at Hampton and her husband, Charles White, comes to Hampton as a Rosenwald Fellow; both Catlett and White become close friends with Biggers. White creates *The Contribution of the Negro to American Democracy* mural for Hampton, which is dedicated June 25, 1943. Biggers also meets other visiting artists and writers at Hampton, including Alain Locke, Hale Woodruff, and Harry Sternberg.

Group exhibitions: *Young Negro Art,* Museum of Modern Art, New York (October 6–November 28).

1944

April 3: The United States Supreme Court, in the case of Smith v. Allwright, *declares that any effort to exclude blacks from voting in a primary election is a violation of the Fifteenth Amendment of the United States Constitution. The suit was filed by Thurgood Marshall on behalf of Dr. Lonnie Smith, a Houston resident.*

Group exhibitions: *3rd Annual Exhibition of Paintings, Sculptures and Prints by Negro Artists,* Atlanta University (April 2-30); *Exhibition of Paintings, Sculpture by Art Departments of Virginia Colleges,* Virginia Museum of Fine Arts, Richmond (May 7-21)

1945

John H. Johnson begins publication of Ebony *magazine.*

Biggers is shipped to Norfolk, Virginia. October: During a visit to his brother Joe, Biggers enters the Philadelphia Naval Hospital. Granted honorable discharge in December.

Group exhibitions: *Tenth Exhibition of the Work of Virginia Artists,* Virginia Musuem of Fine Arts, Richmond (April 8-29); Baltimore Museum of Art, Maryland.

1946

Biggers returns to Hampton for one semester. Following Viktor Lowenfeld (who resigned from Hampton on June 1), transfers to Pennsylvania State University. United Transport Service Employees, CIO, Chicago, Illinois, acquires and installs the *Dying Soldier* and *Country Preacher* murals. Creates *Night of the Poor, Day of the Harvest,* and *Sharecropper* murals for Pennsylvania State University. Meets Henry Varnum Poor, who is completing a series of murals on the Penn State campus. During the years at Penn State, visits New York several times, staying with Catlett and White in their Greenwich Village apartment.

1947

January: Hazel Hales completes degree in accounting.

March 3: The Houston College for Negroes becomes a state-supported institution, and changes its name to Texas State University for Negroes.

Group exhibitions: *Sixth Annual Exhibition of Paintings, Sculpture, and Prints by Negro Artists,* Atlanta University (April 1–May 4).

1948

Biggers receives B.S. (January 31) and M.S. (September 18) in Art Education from Pennsylvania State University. Accepts one-year position as Teaching Fellow at Pennsylvania State University.

December 27: John Biggers and Hazel Hales marry in Philadelphia.

1949

July 17: Harris County Council of Organizations is founded. Promotes civil rights, voter registration, and municipal services in black communities in Houston.

Biggers accepts position as instructor at Alabama State Teachers College, Montgomery, during summer semester. Moves to Houston in August to join the faculty as Associate Professor and Department Head at Texas State University for Negroes; establishes art department.

1950

United Nations Undersecretary Ralph Bunche becomes first blackman to receive Nobel Peace Prize.

July 25: United States enters Korean War.

Christia V. Adair becomes executive secretary of the Houston Chapter of the NAACP. She serves through 1962.

Carroll Simms joins the faculty of Texas State University for Negroes.

Biggers awarded first prize for *The Cradle* at annual exhibition at the Museum of Fine Arts, Houston. Since segregationist policies allow black visitors into the museum only on Thursdays, he is unable to attend the opening of the exhibition. Subsequently, James Chillman, director of the museum, succeeds in abolishing discriminatory policies at the museum. Biggers meets Max Ernst through Dominique de Menil.

Group exhibitions: *25th Annual Exhibit of Works by Houston Artists,* The Museum of Fine Arts, Houston, Texas (March 12-26); *12th Annual Texas Painting and Sculpture Exhibition,* Dallas Museum of Art (October 7-29; additional venues: Witte Memorial Museum, San Antonio, November 12-December

3; Museum of Fine Arts, Houston, December 17, 1950-January 7, 1951); *Ninth Annual Exhibition of Paintings, Sculpture, and Prints by Negro Artists,* Atlanta University (April 2-30).

Awards: Purchase Prize, The Museum of Fine Arts, Houston; Purchase Prize for Prints, Atlanta.

1951

Texas State University for Negroes renamed Texas Southern University.

Biggers completes *Negro Folkways* mural, Eliza Johnson Home for the Aged, Houston, Texas. Visits Monterrey, Mexico, with Carroll Simms.

Solo exhibitions: Pennsylvania State University, University Park.

Group exhibitions: *26th Annual Exhibit of Works by Houston Artists,* The Museum of Fine Arts, Houston (April 22-May 6); *Student-Faculty Art Exhibit of Drawings, Ceramics, Sculpture and Paintings,* State Capitol Building, Austin, Texas (April).

Awards: Schlumberger Prize, The Museum of Fine Arts, Houston; Senate Resolution No. 135 Bracewell, April 4, Austin, Texas, in Honor of Art Students and Faculty Exhibitions in the State Capitol Building.

1952

July 27: American troops withdraw from Korea.

Biggers spends summer studying lithography and etching with Dr. Jules Heller at the University of Southern California, Los Angeles. Renews contact with Viktor Lowenfeld.

Group exhibitions: *Fifth Southwestern Exhibition of Prints and Drawings,* The Dallas Museum of Art, (January 20-February 17); *27th Annual Exhibit of Works by Houston Artists,* The Museum of Fine Arts, Houston (April 13-27); *Texas Contemporary Artists,* M. Knoedler & Company, New York (June 10-September 28; additional venue: Contemporary Arts Museum, Houston, October 11-November 2).

Awards: Neiman Marcus Company Prize for Drawing, Dallas Museum of Art; Ella Lyman Cabot Trust Stipend, Cambridge, Massachusetts, for special study of graphic arts at the University of Southern California and Pennsylvania State University

1953

Biggers completes *The Contribution of Negro Women to American Life and Education* mural, Blue Triangle YWCA, Houston, Texas. Illustrates Vivian Ayers's *Hawk*.

Group exhibitions: *28th Annual Exhibit of Works by Houston Artists,* The Museum of Fine Arts, Houston (February 1-22); *Painting Sculpture Ceramics from Texas Southern University,* Contemporary Arts Museum, Houston (March 1-15); *Twelfth Annual Exhibition of Paintings, Sculpture, and Prints by Negro Artists,* Atlanta University (March 29–April 26); *Integration: The Use of Painting and Sculpture with Architecture in Daily Life,* Contemporary Arts Museum, Houston (November 8-December 6).

Awards: Purchase Prize for Prints and Purchase Prize for Sculpture, Atlanta University.

1954

May 17: The United States Supreme Court, in the case of Brown v. Board of Education, *declares that separate but equal educational facilities are inherently unequal and that segregation is therefore unconstitutional.*

June 7: Biggers receives Ph.D., Education, Pennsylvania State University, University Park. Doctoral thesis: *The Negro Woman in American Life and Education.* Promoted to Full Professor at Texas Southern University.

Group exhibitions: *Drawings and Paintings by John Biggers and Jack Boynton,* The Museum of Fine Arts, Houston (January 13-February 14); Architectural League, New York.

1955

December 1: Rosa Parks takes a seat in the front of a city bus in Montgomery, Alabama; following her arrest for refusing to give up her seat to a white man, the city's black community led by Dr. Martin Luther King, Jr. organizes the Montgomery bus boycott.

Biggers completes *The History of Negro Education in Morris County, Texas* mural, Paul Pewitt Elementary School, Naples, Texas.

Group exhibitions: *30th Annual Exhibit of Works by Houston Artists,* The Museum of Fine Arts, Houston (March 5-27); *31st Annual Exhibit of Works by Houston Artists,* The Museum of Fine Arts, Houston (December 4-24); Architectural League, New York; Pennsylvania State University, University Park.

Awards: Contemporary Arts Museum Rental Service Award for *Grace.*

1956

May 14: Rufino Tamayo's América *mural is installed in the lobby of the Bank of the Southwest, Houston.*

Biggers begins initial studies for *Web of Life* mural, Nabrit Science Hall, Texas Southern University; completed 1962. Illustrates J. Mason Brewer's *Aunt Dicy Tales.*

Group exhibitions: Howard University Art Museum, Washington, D.C.

1957

March 6: Ghana achieves independence from the United Kingdom.

September 24: President Dwight Eisenhower issues an Executive Order authorizing the use of federal troops to assist in the integration of Little Rock Central High School, Little Rock, Arkansas.

Biggers completes *History of I.L.A. Local 872* mural, International Longshoreman's Temple, Houston, Texas. Receives UNESCO fellowship to study traditional cultural patterns in West Africa; during a six-month sojourn from July through December John and Hazel Biggers visit Ghana, Nigeria, Togo, and Dahomey (now the Republic of Benin). Returns via Rome, Paris, and London.

1958

Biggers illustrates J. Mason Brewer's *Dog Ghost and Other Texas Negro Folk Tales.*

Group exhibitions: *Ford Foundation Invitational Art Exhibit,* Fort Worth Art Center, Texas.

1959

Biggers attends first National Conference of Artists (an organization of African-American artists, teachers, and administrators) at Atlanta University.

Group exhibitions: *Ford Foundation Invitational Art Exhibit,* Fort Worth Art Center, Texas.

1960

February 1: Four black students refuse to leave a segregated lunch counter in Greensboro, North Carolina, marking the beginning of sit-in protests throughout the South.

Spring: Texas Southern University students stage sit-in at Weingarten's lunch counter in Houston's Third Ward; later protests are held at counters of Walgreens, Woolworth's, Grant's, and the City Hall cafeteria.

April 27: Togo achieves independence from French jurisdiction and United Nations trusteeship.

August 1: Dahomey (now the Republic of Benin) achieves independence from French rule.

Elton Fax publishes West African Vignettes, *documenting the artist's tour of Africa.*

Biggers completes *Red Barn Farm* mural, Dowling Veterinary Clinic, Houston.

Group exhibitions: *Life in West Africa*, City of Philadelphia Commercial Museum, Philadelphia, Pennsylvania (June).

1962

May 4: Several busloads of Congress of Racial Equality (CORE) Freedom Riders embark on a journey across the South to promote desegregation of public transportation.

Biggers publishes *Ananse: The Web of Life in Africa*. Completes *Web of Life* mural at Texas Southern University. Drives to Mexico City from Houston, visits Elizabeth Catlett and Vivian Ayers and meets Pablo Higgins, former mural assistant to Diego Rivera.

Solo exhibitions: *Paintings by Dr. John Biggers*, Jewish Community Center, Houston (February 4-March 31); *Drawings of West Africa: Dr. John Biggers*, The Museum of Fine Arts, Houston (April 11-29); *Illustrations*, Fort Worth Art Center, Texas (July 17-August 19).

1963

June 12: Civil rights leader Medgar Evers is assassinated in Jackson, Mississippi.

August 28: Nearly 250,000 people gather on the Mall in Washington, D.C., to protest for civil rights. Dr. Martin Luther King, Jr. delivers "I Have a Dream" oration.

November 22: President John F. Kennedy is assassinated in Dallas, Texas.

Solo exhibitions: *Drawings by John Biggers*, Dallas Public Library, Texas (January 9–24); Shreveport Public Schools, Louisiana; Houston Jewish Community Center, Texas; Laguna Gloria Art Museum, Austin, Texas; Lubbock

Museum of Fine Arts, Texas; United States Information Agency, traveling exhibition to African countries.

Awards: Excellence of Design Award for *Ananse: The Web of Life in Africa*, Chicago Book Clinic, Illinois; Excellence of Design Award for *Ananse: The Web of Life in Africa*, Southern Book Competition. Best Texas Book Design for *Ananse: The Web of Life in Africa*, Dallas Museum of Art, Texas.

1964

July 2: President Lyndon B. Johnson signs Civil Rights Bill protecting voting rights, promoting desegregation of schools, and forbidding discrimination in public accommodations and employment.

December 10: Dr. Martin Luther King, Jr. is awarded the Nobel Peace Prize.

Awards: Minnie Stevens-Piper Foundation Professor Award for Outstanding Scholarly and Academic Achievement.

1965

February 21: Malcolm X is assassinated in New York, New York.

March 7: United States involvement with Vietnamese War escalates with the first Marine troops landing in Da Nang.

Biggers accepts position as Visiting Professor, University of Wisconsin, Madison, for one year.

Group exhibitions: Houston Baptist College, Texas; Architectural League, New York; *Creativity and the Negro*, Burpee Center, Rockford College, Rockford, Illinois (March 3-7).

1966

Barbara Jordan is elected to the Texas Senate.

Biggers completes *Birth from the Sea* mural, W. L.D. Johnson Branch, Houston Public Library, Texas. Illustrates Lorenz Graham's *I, Momolou* and Pearl Buck's *The Good Earth* (Readers' Digest Edition).

Group exhibitions: *New Art Faculty Exhibition*, Wisconsin Union Galleries, University of Wisconsin-Madison (January 7-31).

1967

May 16: Black protesters gather on the campus of Texas Southern University; resulting police action instigates a riot during which one police officer is killed, 488 students are arrested, and several thousand dollars' worth of student property is destroyed.

Biggers named Distinguished Professor, Texas Southern University.

Solo exhibitions: Huston-Tillotson College, Austin, Texas.

1968

April 4: Dr. Martin Luther King, Jr. is assassinated in Memphis, Tennessee.
June 6: Robert Kennedy is assassinated in Los Angeles, California.
Solo exhibitions: *John Biggers: One Man Show,* Winston-Salem State University, Fine Art Department, North Carolina; River Oaks Garden Club, Houston, Texas.

Group exhibitions: *Sphere of Art in Texas,* University of Texas, Institute of Texan Cultures, San Antonio (April 6–October 6); *Benin,* The Museum of Fine Arts, Houston (September 21-November 24); *Festival of the African Peoples,* Los Angeles, California.

Awards: Danforth Foundation E. Harris Harbison Award for Distinguished Teaching.

1969

July 20: NASA astronauts land on the moon.

Danforth award allows John and Hazel Biggers to return to Europe and Africa. Beginning in September they first visit England; during the following six months they visit Egypt, the Sudan, Ethiopia, Kenya, Tanzania, and return to Ghana.

Solo exhibitions: *John Biggers,* Graceland College, Lamoni, Iowa (February 1-28).

Group exhibitions: *Twelve Black American Artists,* University of Wisconsin, Madison.

1970

Group exhibitions: *An Exhibition of Black American Art from Times of Slavery to the Present,* Muskingum College, New Concord, Ohio (April 12-30); *First Annual Black Arts Festival: Operation Breadbasket,* 2413 Dowling Street (December 18–20).

1971

Group exhibitions: *Texas Painting and Sculpture: The Twentieth Century,* Pollock Galleries, Owen Arts Center, Southern Methodist University, Dallas (January 17-March 7); *Home Folk Africa,* Museum of the National Center of Afro-American Artists, Boston (March 26-April 16).

1972

Group exhibitions: *Reflections: The Afro-American Artist,* Benton Convention Center, Winston-Salem Delta Fine Arts, Inc., Winston-Salem, North Carolina (October 8-15).

Awards: Distinguished Alumnus Award, Pennsylvania State University, University Park.

1974

Alex Haley publishes excerpts of Roots *in Readers' Digest; the book is published in full in 1976 and serialized on ABC-TV in 1977.*

Exhibition of *African Art of the Dogon: The Lester Wunderman Collection* organized by the Brooklyn Museum and hosted by Museum of Fine Arts, Houston (April 11-May 12) inspires Biggers to renewed creativity.

1975

April 30: Final withdrawal of United States armed forces from Vietnam.

May 19: Death of Cora Finger Biggers, the artist's mother.

Solo exhibitions: *The Art of John Biggers,* Texas A&M University, College Station (November 10-28).

Group exhibitions: *Celebrating the Fiftieth Anniversary of the Golden State Mutual Insurance Company, Exhibition of Afro-American Art Collection,* California State Museum of Science and Industry, Los Angeles (April 12-May 25).

1976

Group exhibitions: *Two Centuries of Black American Art: 1750-1950,* Los Angeles County Museum of Art, California (September 30-November 21; additional venues: High Museum of Art, Atlanta, January 8-February 20, 1977; Dallas Museum of Art, March 30-May 15, 1977; and the Brooklyn Museum, June 25-August 21, 1977); *Bearden, Biggers, Gilliam, Hayes, Stovall, Erwin, Hill,* Taylor Art Gallery, North Carolina A&T State University, Greensboro (November 17-20)

1977

Alex Haley's Roots *becomes the most popular drama in television history.*

In honor of Christia Adair's 84th birthday, Harris County Commissioners Court dedicates the Christia V. Adair County Park, south of Houston.

Biggers completes *Family Unity* mural, Sterling Student Life Center, Texas Southern University.

1978

Biggers publishes with Carroll Simms and John Edward Weems, *Black Art in Houston.*

Solo exhibition: *The Web of Life in Africa, An Exhibition of Drawings and Paintings by John T. Biggers,* African-American Cultural Center, Dallas (November 19-December 8).

Group exhibitions: *Great Kings of Africa,* Southern University, Baton Rouge; *Fire! An Exhibition of 100 Artists,* Contemporary Arts Museum, Houston (February 16-April 15).

1980

Visits Haiti with other faculty members from Texas Southern University.

Solo exhibition: *Ceremonies and Visions: The Art of John Biggers,* Laguna Gloria Museum, Austin, Texas (February 21-March 27).

Group exhibitions: *Houston Area Exhibition: Recapitulation 1928-1960,* Blaffer Gallery, University of Houston, Houston (June 7-July 27).

1981

Biggers completes *The Quilting Party* mural, Music Hall, Houston, Texas.

Awards: Mayor's Award for Outstanding Contributions as Visual Artist, Houston, Texas.

1983

May 31: Biggers retires from teaching.

Completes *Christia Adair* mural, Christia V. Adair Park, Harris County, Texas.

Solo exhibitions: *John Biggers: Bridges,* California Museum of Afro-American History and Culture, Los Angeles (March 11-May 13); *Boats and Bridges,* Sutton's Black Heritage Gallery, Houston (December 3-31).

Group exhibitions: *Images of Texas,* Archer M. Huntington Art Gallery, The University of Texas at Austin (February 25-April 10; additional venues: Art Museum of South Texas, Corpus Christi, July 1-August 14; Amarillo Art Center, Amarillo, September 3-October 30).

1984

Summer: Biggers attends National Conference of Artists in Dakar, Senegal. This is the first international meeting of the NCA.

Solo exhibition: *Dr. John T. Biggers,* Traditional African Art Gallery, Texas Southern University (September 4-October 1).

1985

Group exhibitions: *Fresh Paint: The Houston School,* The Museum of Fine Arts, Houston (January 26-April 7; additional venues: The Institute for Art and Urban Resources, Inc., P.S. 1, New York, May 5-June 21; Oklahoma Art Center, Fair Park, Oklahoma City, July 18-September 1); *America at Work: Realism Between the World Wars,* Transco Energy Company, Houston (October 10-November 22).

1986

Group exhibition: *Artists Select: Contemporary Perspectives by Afro-American Artists,* University Art Museum, Arizona State University, Tempe, Arizona (February 16-March 16).

1987

Biggers visits Amsterdam and Kenya. Completes *East Texas Patchwork* mural, Paris Public Library, Paris, Texas. Completes *Song of the Drinking Gourd* mural, Tom Bass Regional Park, Harris County, Texas. Visits Mexico and tours archeological sites from Mexico City to Merida.

Solo exhibitions: *John Biggers: Patchwork Quilts and Shotguns,* Transco Energy Company, Houston, Texas (January 19-February 28); *Selected Prints of John Biggers, 1950 to the Present,* Balene Inc., Houston, Texas (January 21–February 28).

1988

Biggers attends National Conference of Artists in Rio de Janeiro, Brazil.

Awards: Texas Artist of the Year, The Art League of Houston. Award for Achievement, Metropolitan Arts Foundation, Inc.

1989

November 5: The first memorial dedicated to the civil rights movement is unveiled in Montgomery, Alabama. Commissioned by the Southern Poverty Law Center, the memorial is designed by Maya Lin.

Biggers returns to Gastonia, North Carolina, which in 1990 becomes his second home and studio. Hampton University Museum purchases a survey of works spanning Biggers's career and the artist also makes a major donation of works.

Solo exhibitions: *John Biggers: Paintings and Drawings: 1949-1988,* Delta Fine Arts Center and Sawtooth Center for Visual Arts, Winston-Salem, North Carolina (February 11-March 9).

Group exhibitions: *The Private Eye: Selected Works from Collections of Friends of the Museum of Fine Arts, Houston,* Museum of Fine Arts, Houston (June 11-August 13); *Forerunners and Newcomers: Houston's Leading African-American Artists,* Art Gallery, University of Houston, Clearlake (November 1–30); *Messages from the South,* Sewall Art Gallery, Rice University, Houston (November 7-December 20); *Black Art—Ancestral Legacy: The African Impulse in African-American Art,* Dallas Museum of Art (December 3, 1989-February 25, 1990; additional venues: High Museum of Art, Atlanta, May 22-August 5, 1990; Milwaukee Art Museum, Milwaukee, September 14-November 18, 1990; Virginia Museum of Fine Arts, Richmond, January 28-March 24, 1991).

1990

October 22: President George Bush vetoes the Civil Rights Act of 1990.

Solo exhibitions: *Five Decades: John Biggers and the Hampton Art Tradition,* Hampton University Museum, Hampton, Virginia (April 13-June 11); *John Biggers: Selected Works,* Pyramid Gallery, Little Rock, Arkansas (October 19-November 17).

Group exhibitions: *Tradition and Innovation: A Museum Celebration of Texas Art,* Museum of Fine Arts, Houston (February 17-April 29); *The Blues Aesthetic: Black Culture and Modernism,* The Blaffer Gallery, University of Houston, (June 8-July 29).

Awards: Honorary Doctor of Humane Letters, Hampton University, Hampton, Virginia.

1991

Biggers completes *Ascension* and *Origins* murals, Winston-Salem State University Library, North Carolina. Completes *House of the Turtle* and *Tree House* murals, Harvey Library, Hampton University, Hampton, Virginia.

Solo exhibitions: *John Biggers: Mural Sketches,* Diggs Gallery, Winston Salem University (April 14-June 30).

Group exhibitions: *Black Heritage,* Huntington Art Gallery, University of Texas, Austin (February 11-27); *Forerunners and Newcomers Revisited: Houston's African-American Artists in the Lead,* Dishman Art Gallery, Lamar University, Beaumont, Texas (October 25–November 25).

1992

Group exhibitions: *Alone in a Crowd: Prints of the 1930s and 1940s by African-American Artists from the Collection of Reba and Dave Williams,* The American Federation of Arts, New York, New York.

Awards: Van Der Zee Award, Brandywine Graphic Workshop of Philadelphia, Pennsylvania.

1993

January 20: Maya Angelou reads her poem "On the Pulse of the Morning" at the inauguration of President Bill Clinton.

Solo exhibitions: *John Biggers: Cultural Legacy, from 1950-1992,* Northeast Texas Community College, Mount Pleasant (February 5-28); *John Biggers: Paintings and Drawings,* Fayetteville Museum of Art, Fayetteville, North Carolina (May 2-June 13).

1994

Biggers illustrates Maya Angelou's poem "Our Grandmothers."

Group exhibitions: *The Harmon and Harriet Kelley Collection of African-American Art,* San Antonio Museum of Art, San Antonio, Texas (February 4-April 3).

Awards: Margaret Hawkins Arts Award for 1994, The Links

Hampton Centennial Seal, 1966
(Cat. no. 58)

170

Notes

Metamorphosis:
The Life and Art of John Biggers
by Alvia J. Wardlaw

1. John Biggers, Carroll Simms, and John Edward Weems, *Black Art in Houston: The Texas Southern University Experience* (College Station and London: Texas A&M Press, 1978), 6.

2. Dwight Billings, Jr., *Planters and the Making of a "New South": Class Politics and Development in North Carolina, 1865–1900* (Chapel Hill: University of North Carolina Press, 1979), 117.

3. Ibid., 112–13.

4. Herbert R. Northrup and Richard L. Rowan, *Negro Employment in Southern Industry* (Philadelphia: University of Pennsylvania, Industrial Research Unit, Wharton School of Finance and Commerce, 1970), 59.

5. John T. Biggers, interview by author, tape recording, Houston, Texas, November 24, 1986.

6. Ibid.

7. Ibid.

8. Personal correspondence from the artist, February 21, 1994.

9. Ibid.

10. Hugh Victor Brown, *History of the Education of Negroes in North Carolina* (Raleigh, North Carolina: Irving Swain Press, Inc., 1961), 38.

11. John T. Biggers, interview by author, tape recording, Houston, Texas, November 25, 1986.

12. Ibid.

13. Louis R. Harlan, *Booker T. Washington: The Making of A Black Leader 1856–1901* (New York: Oxford University Press, 1972), 74.

14. Ibid., 61.

15. Biggers, interview, November 25, 1986.

16. *The Hampton Bulletin,* 75th Annual Catalogue (Hampton, Virginia: Hampton Institute Press, 1943), 46.

17. Biggers, interview, November 25, 1986.

18. "Work of Young Artists Exhibited at Museum of Modern Art," MoMA news release, 1943.

19. "The Passing Shows," *Art News* (November 15, 1943), 22.

20. Ritter, *Five Decades: John Biggers and the Hampton Art Tradition,* 15.

21. John Biggers, interview by author, tape recording, Houston, Texas, June 13, 1991.

22. Ibid.

23. Ibid.

24. W. E. B. DuBois, *Souls of Black Folks* (New York: International Publishers Co., 1903), 22.

25. United States Transport Service Employees, Mural Dedication Program, Chicago, November 3, 1946.

26. Ira Bryant, *Texas Southern University: Its Antecedents, Political Origin, and Future* (Houston: Ira Bryant, 1975), 33–36.

27. Ibid., 36.

28. Biggers, Simms, and Weems, *Black Art in Houston,* 30-31.

29. In a lecture for the Dallas Museum of Art exhibition *Black Art—Ancestral Legacy: The African Impulse in African-American Art,* Biggers discusses this incident in his introductory remarks to illustrate the advances that have been made as part of the cultural climate in the state. Biggers's painting *Starry Crown* was featured in *Black Art—Ancestral Legacy: The African Impulse in African-American Art* and was added to the permanent collection of the Dallas Museum of Art.

30. Lowell Collins, interview by author, Houston, Texas, February 1994.

31. Biggers, Simms, and Weems, *Black Art in Houston,* 62.

32. NCA conference program, Houston, 1965.

33. Dr. Samuel Nabrit, interview by author, tape recording, Atlanta, Georgia, August 13, 1993.

34. W. E. B. DuBois, *The World and Africa,* 2nd edition (New York: International Publishers, 1971), vii.

35. In an essay on Biggers, Frank Wardlaw relates how he took the *Ananse* drawings to a *Life* magazine editor and African specialist to be considered for possible publication, and the editor "objected because there were no hospitals, schools, bridges, etc., the symbols of modern progress in Africa. 'We don't want to depict Africa in terms of a primitive people,' he said." Frank Wardlaw, *Black Leaders, Texans for Their Times,* Alwyn Barr and Robert Calvert, eds. (Austin: Texas State Historical Association, n.d.), 211.

36. Sylvia Boone, *Radiance from the Waters* (New Haven: Yale University Press, 1986), 138.

37. Charles Culhane, "TSU Student Says Police Started Riot," *Houston Post,* November 30, 1967.

38. Patricia C. Johnson, "The Mural of the Story," *Houston Chronicle,* May 29, 1983, 16.

39. The development of the Hampton University murals *House of the Turtle* and *Tree House* have been documented in the video.

40. "Conversations with Oprah: Maya Angelou," CBS television, HARPO Productions, July 13, 1994.

41. "Our Grandmothers," a poem by Maya Angelou, was published in 1994 in a limited-edition book with five accompanying lithographs by John Biggers.

John Biggers:
A Perspective
by Edmund Barry Gaither

1. John Biggers, *Ananse: The Web of Life in Africa* (Austin: University of Texas Press, 1962), 4. Biggers states the view that "many of my American brothers, in their flight from the stereotyped concepts of our race, had . . . flown from their real selves and . . . created a grotesque, unattainable image based on Caucasoid attributes, a development that must surely prove a hindrance in the struggle to achieve dignity and self-respect."

2. Edmund Barry Gaither, *The Inverse Impact of Racism on Afro-American Art* (lecture presented at the Whitney Museum of American Art at Champion, Connecticut, 1992, during the presentation of the exhibition *Edward Mitchell Bannister*).

3. Carolyn J. Weekley and Stiles Tuttle Colwill, *Joshua Johnston: Freeman and Early American Portrait Painter* (Baltimore: Maryland Historical Society, 1987). Two black sitters appear among the nearly 125 catalogued.

4. Guy McElroy, *Robert Scott Duncanson: A Centennial Exhibition* (Cincinnati: Cincinnati Art Museum, 1972), 11.

5. Dewey F. Mosby and Darrell Sewell, *Henry Ossawa Tanner* (Philadelphia: Philadelphia Museum of Art, 1991). In this definitive volume on this master, *The Thankful Poor,* 1893–94, Collection William H. and Camille Cosby, New York, and *The Banjo Lesson,* 1893, Hampton University Museum, are among other black subjects cited.

6. Nathan Irvin Huggins, "Art: The Black Identity," in *Harlem Renaissance* (New York: Oxford University Press, 1971), explores the argument put forth by black cultural advocates that only art-producing groups could lay claim to being fully civilized.

7. Alain L. Locke, *The New Negro* (New York: Albert and Charles Boni, 1925), 264.

8. Ibid.

9. The following artists are representative participants in each of these directions: Sargent Johnson and Aaron Douglas addressing African reclamation; Augusta Savage and Archibald Motley portraying ordinary blacks as fully realized humans; William Edouard Scott focusing on Caribbean subjects; and Malvin Gray Johnson presenting southern country life.

10. John Biggers, Carroll Simms, and John Edward Weems, *Black Art in Houston: The Texas Southern University Experience* (College Station and London: Texas A&M Press, 1978), 18.

11. Locke, "The Legacy of the Ancestral Arts," *The New Negro,* 254ff.

12. Locke continued to call for a racially grounded art in later publications such as *Negro Art: Past and Present* (Washington, D.C.: Associates in Negro Folk Education, 1936).

13. Edmund B. Gaither, "Building on Porter," in *James A. Porter, Artist and Art Historian/ The Memory of the Legacy* (Washington, D.C.: Howard University Gallery of Art, 1992), 57ff.

14. Biggers, Simms and Weems, *Black Art in Houston,* 7.

15. E. P. Richardson, *Short History of Painting in America: The Story of 450 Years* (New York: Thomas Y. Crowell, 1963), 300.

16. John W. McCoubrey, *American Tradition in Painting* (New York: George Braziller, 1963), 44.

17. Milton Brown, *American Painting from the Armory Show to the Depression* (Princeton: Princeton University Press, 1955), 195.

18. John I.H. Baur, *Revolution and Tradition in Modern American Art* (New York: Frederick A. Praeger, 1951), 20.

19. Ibid.

20. Ibid., 22.

21. *The People's Art: Black Murals, 1967–1978* (Philadelphia: The Afro-American Historical and Cultural Museum, Pennsylvania, 1986). This catalogue offers a useful discussion of the mural movement during the black power era.

22. Other muralists in this era include William Edouard Scott (1884–1964) and Archibald Motley, Jr. (1891–1981).

23. Biggers, Simms, and Weems, *Black Art in Houston,* 8.

24. *Stories of Illumination and Growth: John Biggers's Hampton Murals,* produced by Jeanne Zeidler and Barbara Forst, directed by Sherri Fisher Staples, Cinnabar Productions in conjunction with Hampton University

Museum, 1992, videotape. See also John Biggers, "His Influence Caused Me to Turn Out Little Charles Whites," *Freedomways* 20, No. 3 (1980), 175–76.

25. *Images of Dignity: The Drawings of Charles White* (Los Angeles: Ward Ritchie Press, 1967), 5.

26. Ernest Gaines, *A Lesson for Dying* (New York: Alfred A. Knopf, 1993). Gaines creates strikingly moving, unvarnished black rural characters distinguished for their wit and wisdom.

27. Ernest Gaines, *The Autobiography of Miss Jane Pittman* (New York: Bantam, 1982). This fictional, composite character embodies the wisdom of black elders who, without pretense, distill meaning and guidance for the epic stretch of their own lives.

28. Locke, *The New Negro,* 47.

29. James D. Anderson, *The Education of Blacks in the South: 1960–1935* (Chapel Hill: University of North Carolina Press, 1988), 5.

30. Ibid., 183.

31. Biggers, Simms, and Weems, *Black Art in Houston,* 63. Biggers elaborates on the symbolic program for this mural.

32. Biggers, *Ananse,* 4.

33. Ibid., 30.

34. Ibid., 29.

35. Ibid., 18.

36. Ibid., 29.

37. Ibid.

38. Ibid., 30ff. Kojo, Kwasi, etc. are common West African names.

39. Biggers, Simms, and Weems, *Black Art in Houston,* 5.

40. Ibid., 76.

41. Biggers, *Ananse,* 4.

42. Julie Dash, *Daughters of the Dust* (New York: New Press, 1992), 94. This film strongly parallels Biggers's belief regarding the use of black women as icons or symbols of comprehensive generative power that may be manifested positively or negatively.

43. Quoted from *Stories of Illumination and Growth,* 1992, videotape.

44. Biggers, *Ananse,* 25.

45. *John Biggers: A Cultural Retrospective for 1950–1992* (Mt. Pleasant, Texas: Whatley Center for the Performing Arts Gallery, 1993), n.p

John Biggers:
American Muralist
by Alison de Lima Greene

1. Robert Goldwater, "Reflections on the New York School," *Quadrum* 8 (1960), 20.

2. Irving Sandler, *The Triumph of American Painting* (New York: Harper & Row, 1970).

3. For example, the Equitable Center, New York, has done an outstanding job in preserving Thomas Hart Benton's 1930 *America Today,* but the mural has lost much of its dynamism by being reinstalled out of context. *America Today* was commissioned by Alvin Johnson for the third-floor boardroom of the New School for Social Research; in their original location the panels filled all four walls. The mural was removed and sold in 1982; it currently hangs in the vast Equitable lobby on a single mural sur-

face. See Erika Doss, *Benton, Pollock, and the Politics of Modernism: From Regionalism to Abstract Expressionism* (Chicago: The University of Chicago Press, 1991), 68–69, 139, n. 8.

4. See Marlene Park and Gerald E. Markowitz, *New Deal for Art* (Hamilton: The Gallery Association of New York State, 1977), 19, 51–52.

5. Ibid., 51–52; 71, n. 224.

6. John Biggers, Carroll Simms, and John Edward Weems, *Black Art in Houston: The Texas Southern University Experience* (College Station and London: Texas A&M Press, 1978), 7–8.

7. "U.S. Scene," *Time* (December 24, 1934), 25; reproduced in Doss, *Benton, Pollock, and the Politics of Modernism*, 119.

8. Stuart Davis, "A Rejoinder to Thomas Benton," *Art Digest* 1 (April 1935), 32; reprinted in Doss, *Benton, Pollock, and the Politics of Modernism*, 121.

9. Romare Bearden and Harry Henderson, *A History of African-American Artists: From 1792 to the Present* (New York: Pantheon, 1993), 233–34.

10. James A. Porter, *Modern Negro Art* (New York: Dryden Press, 1943; revised edition, Washington, D.C.: Howard University Press, 1992), 110.

11. Illustrated in Biggers, Simms, and Weems, *Black Art in Houston*, 77.

12. African-American sources for the Pennsylvania State University murals can be cited as well, from Augusta Savage's 1939 monument for the World's Fair, *Lift Every Voice and Sing* (destroyed; illustrated in Bearden and Henderson, *History*, 177) to Charles White's Illinois Federal Art Project drawing, *There Were No Crops This Year*, 1940 (illustrated in Alain L. Locke, *The Negro in Art* [Washington, D.C.: Associates in Negro Folk Education, 1940], 121).

13. As quoted by Brooker Stephen Carpenter, "John Biggers and the Burrowes Building Murals: A Case for Oral History in Art Education" (unpublished paper, Pennsylvania State University, Autumn 1992). I am indebted to Joey Kuhlman, Project Archivist, the Museum of Fine Arts, Houston, and Jim Stephenson, Director of the School of Visual Arts, Pennsylvania State University, for bringing this paper to my attention.

14. Texas State University for Negroes was a segregated campus, and Biggers had repeated encounters with the humiliations of segregation in both his personal and professional life. See Biggers, Simms, and Weems, *Black Art in Houston*, 13–17, 58–59.

15. Biggers, Simms, and Weems, *Black Art in Houston*, 60.

16. Ibid.

17. With Lowenfeld's encouragement, Biggers also developed a dissertation through the documentation of this mural. John Biggers, *The Negro Woman in American Life and Education: A Mural Presentation* (Ph.D. dissertation, Pennsylvania State University, 1954).

18. See Edmund Barry Gaither's essay in this catalogue for a more detailed description of the figures in this mural.

19. For example, Hogue's *Oil Industry Mural* for the Graham Post Office and Bywaters's *Houston Ship Channel Mural* for the Houston Post Office; illustrated in Rick Stewart, *Lone Star Regionalism: The Dallas Nine and Their Circle, 1928–1945* (Austin: Texas Monthly Press and Dallas Museum of Art, 1985), 110, 123.

20. For a detailed reminiscence by Biggers on his African experience see John Biggers, *Ananse: The Web of Life in Africa* (Austin: University of Texas Press, 1962); also see Alvia J. Wardlaw's essay in this catalogue.

21. John Biggers, "Man and the World of Science" (unpublished statement, March 1957); reprinted in Biggers, Simms, and Weems, *Black Art in Houston*, 75.

22. Biggers, *Ananse*, 31.

23. Linda Downs and Ellen Sharp, *Diego Rivera: A Retrospective* (New York: W.W. Norton and Detroit Institute of Arts, 1986), 290.

24. Biggers, *Ananse*, 28.

25. The anatomy of Biggers's *Night* figure also echoes Michelangelo's 1511 *Study for the Libyan Sibyl*, (Metropolitan Museum of Art, New York).

26. See Biggers, *Ananse*, 29.

27. Biggers, Simms, and Weems, *Black Art in Houston*, 76.

28. Biggers has stressed the importance of his seeing the Sistine Chapel, as well as the Louvre and National Gallery collections, at the end of his African trip. Conversation with the author, April 20, 1994.

29. *African Art of the Dogon: The Lester Wunderman Collection* (The Museum of Fine Arts, Houston, April–May, 1974).

30. *Stories of Illumination and Growth: John Biggers's Hampton Murals*, produced by Jeanne Zeidler and Barbara Forst, directed by Sherri Fisher Staples, Cinnebar Productions in conjunction with Hampton University Museum, 1992, videotape.

31. Rebecca N. Felts and Marvin Moon, "An Interview with John Biggers," *Texas Trends in Art Education* 2:8 (Fall 1983), 9.

32. Gloria Naylor, *Mama Day* (New York: Vintage 1989), 135–39.

33. As quoted in Barbara Rose and Susie Kalil, *Fresh Paint: The Houston School* (Austin: Texas Monthly Press and Museum of Fine Arts, Houston, 1985), 104.

34. Perhaps the most famous failed commission of this era is Mark Rothko's cycle of paintings created in 1958–59 for the Four Seasons restaurant in the Seagram's Building, New York. Uncomfortable with his work's being placed in a restaurant setting, the artist ultimately withdrew from the commission.

35. Illustrated in Marjory Jacobson, *Art for Work: The New Renaissance in Corporate Collecting* (Boston: Harvard Business School Press, 1993), 122–25.

36. Tanguma's mural is illustrated in Rose and Kalil, *Fresh Paint*, 43, 44. Also see *América: A Mural by Rufino Tamayo* (New York: Christie's Special Sale Catalogue, May 17, 1993), lot 30.

37. Felts and Moon, "An Interview with John Biggers," 8.

John Biggers's *Shotguns* of 1987: An American Classic
by Robert Farris Thompson

1. James M. Dennis, *Grant Wood: A Study in American Art and Culture* (New York: Viking, 1975), 85.

2. See Robert Farris Thompson, "The Song That Named the Land," in *Black Art—Ancestral Legacy*, ed. Alvia J. Wardlaw (Dallas: Dallas Museum of Art, 1989), 118–22. See also John Vlach, *Sources of the Shotgun House: African and Caribbean Antecedents for Afro-American Architecture*, vol. 1 (Ann Arbor: Univer-sity Microfilms, 1975) and William R. Ferris, *Mississippi Folk Architecture* (Jackson: Mississippi Department of Archives and History, 1973), 16.

3. Thompson, "The Song," 117.

4. Ibid, 125.

5. Interview with John Bigggers, Houston, fall 1993.

6. For evidence on the *nkisi* and its role in African art and philosophy, see Wyatt MacGaffey, *Astonishment and Power* (Washington, D.C.: National Museum of African Art, 1993).

7. Grey Gundaker, "Tradition and Innovation in African-American Yards," *African Arts,* 26, (April 1993), 64.

8. Interview with John Biggers, Houston, fall 1993. All subsequent quotations of Biggers stem from this interview. I am very grateful to John Biggers for his time and blessing in the research that generated this cameo study. I also thank, most affectionately, Alvia Wardlaw, without whom nothing would have been possible, and David Robinson for driving us around the wards of Houston.

9. I am grateful to Pam McClosky of the Seattle Art Museum and to her husband for bringing to my attention a fascinating West Coast chapter in the history of African-American vernacular architecture. In a text-in-preparation on world black architecture I return to the African-American buildings of Tacoma.

Selected Bibliography

"Africa Impressions." *Texas A&M Review*, Summer 1964.

Alone in a Crowd: Prints of the 1930s and 1940s by African-American Artists from the Collection of Reba and Dave Williams. New York: The American Federation of Arts, 1992.

Alspaugh, Leann Davis. "The Storyteller: The Work of Dr. John T. Biggers." *Museum and Arts Houston*, November 1992, 20–25.

"American Artist Wins UNESCO Fellowship." *United States Commission for UNESCO News*, December 28, 1956.

Anderson, Adrian, and Ralph A. Wooster. *Texas and Texas Artists.* Austin: Steck-Vaughn, 1972.

Atkinson, J. Edward. *Black Dimension in Contemporary American Life.* New York: New American Library, 1971.

The Barnett-Aden Collection. Washington: Anacostia Neighborhood Museum, Smithsonian Institution, 1974.

Barr, Alwyn. *Black Texas: A History of Negroes in Texas, 1528–1971.* Austin: Jenkins, 1973.

Bearden, Romare, and Harry Henderson. *A History of African-American Artists: From 1792 to the Present.* New York: Pantheon Books, 1993.

Biggers/Boynton, Exh. cat. Houston: The Museum of Fine Arts, January 1954.

Biggers, John, Carroll Simms, and John Edward Weems. *Black Art in Houston: The Texas Southern University Experience.* College Station and London: Texas A&M University Press, 1978.

Biggers, John. "Searching for Roots." *Impressions*, Fall 1958.

_____. "The Negro Woman in American Life and Education: A Mural Presentation." Dissertation, Pennsylvania State University, 1954.

_____. *Ananse: The Web of Life in Africa.* Austin: The University of Texas Press, 1962.

Black Art: An International Quarterly, Winter 1976.

Chase, Judith Wragg. *Afro-American Art.* New York: Van Nostrand, 1972.

Clark, John H. *Harlem U.S.A.* New York: Macmillan, 1971.

David, Beverly G. *Chant of the Centuries.* Austin: W. S. Benson, 1984.

"Dog Ghost . . ." *Interracial Review*, April 1959.

Dover, Cedric. *American Graphic Art.* New York: New York Graphic Society, 1960.

"Dr. Biggers' Art is Exhibited in L.A." *TSU Today*, no. 2 (April 1983), 5.

"Emblems of Membership in Traditional Africa." Beaumont, Texas: Lamar University, 1976.

Fax, Elton. *Seventeen Black Artists.* New York: Dodd, Mead, 1971.

_____. *Black Artists of the New Generation.* New York: Dodd, Mead, 1977.

"Fresh Paint: The Houston School." *Art Talk*, January 1985, 15.

Fuermann, George. *Houston, the Once and Future City.* New York: Doubleday, 1971.

Greene, Carroll. "Afro-American Artists: Yesterday and Now." *Humble Way* (Third Quarter, 1968).

Grigsby, J. Eugene. *Art and Ethnics.* Dubuque, Iowa: William C. Brown, 1977.

"Harlem's Artists." *Harlem U.S.A.*, 1965.

Hauser, Reine. "Hometown Bravura." *ArtNews*, Summer 1987. 103–4.

"Interview with Barbara Rose." *Artspace*, Winter 1984–85, 8–12.

Jankowski, Patrick. "Fresh Paint: The Houston School." *Houston*, January 1985, 25–29.

"John Biggers: Artist Who Influenced a Generation." *Ebony*, March 1984.

"John Biggers: Bridges, A Retrospective." *In the Arts*, no. 3 (1983).

"John Biggers: Building Bridges." *Afro*Am 2, (January–March 1983).

Johnson, Patricia C. "Artist Series: An Interview with John Biggers." *Trends: Journal of Texas Art Association*, Fall 1983.

Kalil, Susie. "Fresh Paint." *Ultra*, January 1985.

"Lone Star Artist." *Time*, June 30, 1952.

Lowenfeld, Viktor. *Creative and Mental Growth.* New York: Macmillan, 1947.

McCombie, Mel. "Local Talent." *Houston Home and Garden*, January 1985, 16–19.

The Negro in Music and Art, International Library of Negro Life and History. New York: Publishers Co., 1965.

"New Negro Art in America." *Design Magazine*, September 1944.

Patchwork Quilts and Shotguns. Houston: Transco Energy Company, 1987.

Reese, Becky Duval, Susan M. Mayer, and Arthur J. Mayer. *Texas.* Austin: Archer M. Huntington Gallery at the University of Texas, 1983.

Reflections: The Afro-American Artist. Winston-Salem, North Carolina: The Winston-Salem Alumnae Chapter of Delta Sigma Theta, Inc., and Hunter Publishing Company, 1972.

Ritter, Rebecca, et al. *Five Decades: John Biggers and the Hampton Art Tradition.* Hampton, Virginia: Hampton University Museum, 1990.

Rose, Barbara, and Susie Kalil. *Fresh Paint: The Houston School.* Houston: The Museum of Fine Arts, Houston, 1985.

Rozelle, Robert V., Alvia J. Wardlaw, and Maureen A. McKenna. *Black Art—Ancestral Legacy: The African Impulse in African-American Art.* Dallas: Dallas Museum of Art and Harry N. Abrams, Inc., 1989.

Shikes, Ralph. *The Indignant Eye: The Artist as Social Critic in Prints and Drawings from the Fifteenth Century to Picasso.* Boston: Beacon Press, 1969.

Short, Alvia J. Wardlaw. "Strength, Tears, and Will: John Biggers's *Contribution of the Negro Woman to American Life and Education*." *Callaloo*, no. 5 (1979).

"Texas Artists." *Texas Architect*, May 1964.

"The Art Department at Texas Southern University." *American Artist*, November 1959.

"The Negro Woman in American Life and Education." *Penn State Review of Education Research*, December 1954.

"The Stories They Tell." *New York Times Book Review*, November 23, 1958.

"Tracing the Rise of Afro-American Art in North Carolina." *Art Voices South*, Fall

1978.

"Tradition and Innovation." *Houston Chronicle,* February 11, 1990, 6–9.

Voorhies, Jerome Jeffrey.

"Houstonian Art." *The Continental,* March 1985, 16–19.

Wardlaw, Alvia J. "The John Biggers Profile: Patchwork Quilts and Shotguns." *Wave,* February 1987.

_____. *John Biggers: Bridges.* Los Angeles: Loker Gallery, 1983.

_____. "John Biggers: Filling the Sacred Vessel." *The Texas Humanist,* July–August 1984, 34–36.

Index

Pages in *italics* refer to illustrations. Works of art without artist indicated are by John Biggers.

A

According to Where the Drop Falls (Aunt Dicy Making Biscuits), 46; *45*

Adair, Christia V., 58; *63; Christia Adair,* 58, 105; *63; Double Portrait of Christia Adair, 107*

Aderholt, O. A., 18

Africa and African art, 24, 26, 28, 30, 40, 41, 43, 46–53, 54–55, 58, 60, 62, 63, 65, 73, 75, 79, 83, 86–87, 88–92, 96, 98, 103, 104, 105, 110, 111

African Art of the Dogon: The Lester Wunderman Collection, 54–55, 105

Africobra, 106

Akbar, Naim, 73

Alabama State University, 39

Allport, Gordon, 26

Almaraz, Carlos, 106

Alston, Charles, 47, 81, 96

American Gothic (Wood), 108, 111; *108*

American Missionary Association, 23, 28

América (Tamayo), 107

America Today (Benton), 98; *80*

Amistad murals (Woodruff), 29, 82, 99; *82*

Anacalypsis (Higgins), 63

Ananse: The Web of Life in Africa, 48, 50, 51, 53, 63, 83, 86, 88, 103

Angelou, Maya, 62, 75

animals, as symbols, 55, 58, 63, 90, 92

anvil, as symbol, 48, 63

Armory Show of 1913, 76

Armstrong, Samuel, bust of, 25, 31

Arnold, Ferrie Elizabeth Biggers, 11. *See also* Biggers, Ferrie Elizabeth

Arnold, James, 11

Art Institute of Chicago, 38

Artis, William, 29

Art League of Houston, 62

Art of the Negro, The (Woodruff), 82

Arts of Life in America, The (Benton), 98

Arts of the South (Benton), 98

Ascension, 58, 73, 95, 106; *152*

ascension, spiritual, 48, 55, 58, 62–75

Ashanti Architecture, 50; *49*

Ashanti Royalty. See Prempe II

Aspects of Negro Life: From Slavery Through Reconstruction (Douglas), 81; *81*

Atlanta University, 41, 44, 82

Aunt Dicy, 83; *148*

Aunt Dicy Making Biscuits. See *According to Where the Drop Falls*

Aunt Dicy Tales (Brewer), Biggers's drawings for, 46; *45*

"Availability of Education to Negroes in Rural Communities," 23

Ayers, Vivian, 44

B

Back of the Big House: The Architecture of Plantation Slavery (Vlach), 108

Baker, Annabelle, 30

balaphon, as symbol, 55, 86, 91–92

Baldwin, James, 155

Band of Angels: Weaving the Seventh Word, 156

Banjo Lesson, The (Tanner), *78*

Bannister, Edward Mitchell, 76

Baptism, 100; *102, 140*

Barber Scotia College, 19

Barnett-Aden Collection, 29

Barr, Alwyn, 51

Battle of San Romano, (Uccello), 86

Bauhaus, 28

Beal, Fred, 18

Bean, John, 30

Bearden, Romare, 99

Before the Shrine (Queen Mother), 51; *52*

Ben-Jochannan, Yosef, 65, 73

Benton, Thomas Hart, 27, 80, 82, 98–99, 103; *80*

Berker, Larry, 11

Bethune, Mary M., 86

Biggers, Cora Finger, 16, 19, 20, 21, 22, 23; *20*

Biggers, Ferrie Elizabeth, 16, 19–20, 23. *See also* Arnold, Ferrie Elizabeth Biggers